DRAWING AND PAINTING
ANIMALS
THE ESSENTIAL GUIDE

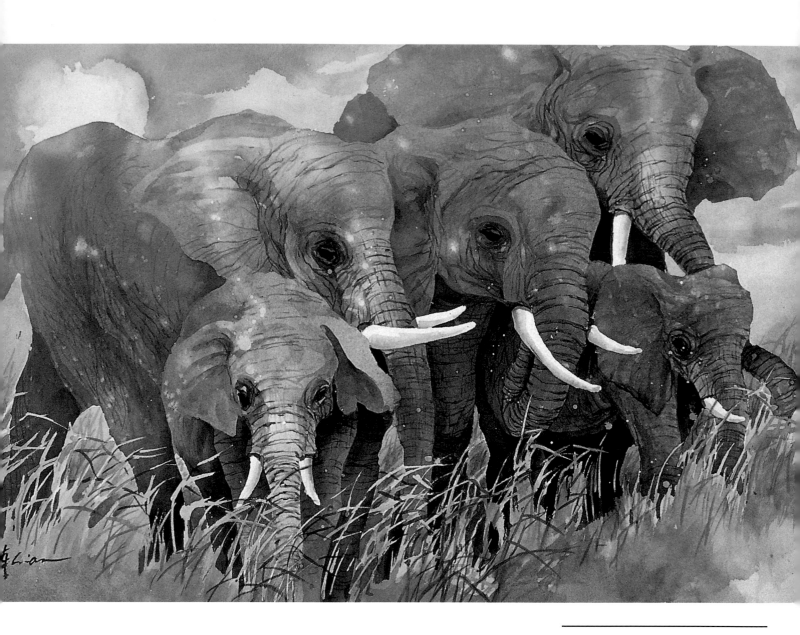

Elephants
Lian Quan Zhen
Watercolor on paper
11" × 15" (28cm × 38cm)

DRAWING AND PAINTING
ANIMALS
THE ESSENTIAL GUIDE

Edited by Jeffrey Blocksidge

NORTH LIGHT BOOKS
CINCINNATI, OHIO
www.artistsnetwork.com

Drawing and Painting Animals: The Essential Guide.
Copyright © 2008 by North Light Books. Printed in China.
All rights reserved. The patterns and drawings in this book are
for the personal use of the reader. By permission of the author and
publisher, they may be either hand-traced or photocopied to make
single copies, but under no circumstances may they be resold or
republished. It is permissible for the purchaser to paint the designs
contained herein and sell them at fairs, bazaars and craft shows.
No other part of this book may be reproduced in any form or by
any electronic or mechanical means including information stor-
age and retrieval systems without permission in writing from

fw
F+W PUBLICATIONS, INC.
the publisher, except by a reviewer who may quote
brief passages in a review. Published by North Light
Books, an imprint of F+W Publications, Inc., 4700
East Galbraith Road, Cincinnati, Ohio, 45236. (800)
289-0963. First Edition.

Other fine North Light Books are available from your local
bookstore, art supply store or visit our website at
www.fwpublications.com.

12 11 10 5 4 3 2

Distributed in Canada by Fraser Direct
100 Armstrong Avenue
Georgetown, ON, Canada L7G 5S4
Tel: (905) 877-4411

Distributed in the U.K. and Europe by David & Charles
Brunel House, Newton Abbot, Devon, TQ12 4PU, England
Tel: (+44) 1626 323200, Fax: (+44) 1626 323319
Email: postmaster@davidandcharles.co.uk

Distributed in Australia by Capricorn Link
P.O. Box 704, S. Windsor NSW, 2756 Australia
Tel: (02) 4577-3555

Library of Congress Cataloging-in-Publication Data

Drawing and painting animals : the essential guide / edited by
Jeffrey Blocksidge.
 p. cm.
Includes index.
ISBN 978-1-60061-110-0 (pbk. : alk. paper)
1. Animals in art. 2. Drawing--Technique. 3. Painting--Tech-
nique. I. Blocksidge, Jeffrey, 1981-
NC780.D72 2008
743.6--dc22 2008009840

Reader's Union edition:

ISBN-10: 1-60061-357-8
ISBN-13: 978-1-60061-357-9

12 11 10 5 4 3 2

Edited by Jeffrey Blocksidge
Interior designed by Cheryl Mathauer
Cover designed by Guy Kelly
Production coordinated by Matt Wagner

METRIC CONVERSION CHART

TO CONVERT	TO	MULTIPLY BY
inches	centimeters	2.54
centimeters	inches	0.4
feet	centimeters	30.5
centimeters	feet	0.03
yards	meters	0.9
meters	yards	1.1

contributors

ANNE DEMILLE FLOOD

Anne deMille Flood's lifelong fascination with drawing was sparked by the gift of a set of colored pencils in 1994. Since that time she has worked passionately with this versatile medium and has developed her love of colored pencil into a thriving pet portraiture business. Anne resides in Washington state with her family and shares her knowledge of pet portraiture in workshops throughout the Pacific Northwest. View more of Anne's work by visiting her web site at www.annedemilleflood. com.

LESLEY HARRISON

For over thirty years, Lesley Harrison has used pastel as the medium of her profession. In the process, she has dedicated a major portion of her life to pushing the limits of these pure pigment sticks. Lesley's studio is located in the Sierra Foothills of California between Lake Tahoe and Sacramento. Her current work and workshop schedules can be found on her web site at www.harrison-keller.com or her blog at www.lesley-harrison.net.

CATHY JOHNSON

Artist, writer and naturalist Cathy Johnson has been drawing and painting all her life. She is the author and illustrator of thirty-three books, including *Creating Textures in Watercolor*, *First Steps: Painting Watercolor*, *First Steps: Sketching & Drawing*, *Watercolor Tricks and Techniques* and *Watercolor Pencil Magic* (all from North Light Books).

DOUG LINDSTRAND

Doug Lindstrand is a freelance wildlife artist and photographer living in Anchorage, Alaska. He spent a number of years living in the wilds of Alaska to study animals and practice his art. Doug has self-published numerous books including *Wild Alaska* and *Mountain Royalty*. *Alaska Sketchbook*, *Bear*, *Drawing Mammals* and others were published by Fox Chapel Publishing.

SHERRY C. NELSON

Sherry C. Nelson's career in painting has stretched across nearly thirty-six years, and has been shaped by her love of the natural world and its creatures. First and foremost she is a teacher, and has shared her wildlife painting techniques with thousands of students in every single state and many countries around the world.

CLAUDIA NICE

Claudia is a native of the Pacific Northwest and a self-taught artist who developed her realistic art style by sketching from nature. She is a multimedia artist, but prefers pen, ink and watercolor when working in the field. When not involved with her art career, Claudia enjoys gardening, hiking and horseback riding in the wilderness behind her home on Mt. Hood. She passes on her love of art and nature by acting as an advisor to several youth groups.

JEANNE FILLER SCOTT

Jeanne's paintings have been featured on the covers and in articles of magazines such as *Equine Images*, *Wildlife Art News*, *InformArt* and *Chronicle of the Horse*. She is the author of the North Light books *Wildlife Painting Basics: Small Animals* (2002), *Painting Animal Friends* (2005), and the upcoming *Painting More Animal Friends*, which will be released in 2008. Her work has been included in the books *The Best of Wildlife Art* (North Light Books, 1997), *Keys to Painting Fur & Feathers* (North Light Books, 1999), *Painters Quick Reference: Cats and Dogs* (North Light Books, 2006) and *The Day of the Dinosaur* (Bison Books, 1977). See more of Jeanne's work on her website at www.jfsstudio.com.

BART RULON

Bart Rulon lives and works on Whidbey Island in Washington State's Puget Sound. He received a bachelor's degree from the University of Kentucky in a self made scientific illustration major. He graduated with honors and has been a full-time professional artist ever since, publishing five books with North Light. His original artwork, prints, photos and books are all available at www.bartrulon.com.

JOHN SEEREY-LESTER

World-renowned artist John Seerey-Lester was born in 1945 in Manchester, England, where he grew up with a sketchbook in hand. He has traveled to Canada, Alaska, China, Africa, Antarctica, South and Central America, India and Nepal in search of the magnificent wildlife he portrays on canvas. In 1991 Mill Pond Press published and released a book on his life and work, *Face to Face with Nature: The Art of John Seerey-Lester*.

LIAN QUAN ZHEN

Lian Zhen was born in China. He received a Bachelor of Art Degree from the Univeristy of California Berkeley and a Master of Architecture from the Massachusetts Institute of Technology. His first book: *Chinese Painting Techniques for Exquisite Watercolors* was published by North Light Books in October, 2000.

The following artwork originally appeared in previously published titles from North Light Books (the initial page numbers given refer to the pages in the original book; page numbers in parentheses refer to pages in this book).

Realistic Pet Portraits in Colored Pencil ©2004
Flood, Anne deMille
24, 18–19, 11–12, 13–14, 64–65, 68–71, 92–93, 116–117, 110–113, 156–157 (8, 42–43, 44–45, 46–47, 62–65, 98–99, 120–123, 154, 156–157)

Painting Animals That Touch the Heart ©2002
Harrison, Lesley
14–15, 16–17, 55, 66, 92–99, 106–109, 118–121, 166–169 (48–49, 50–51, 52, 90–97, 104–107, 118, 164–167)

No Experience Required: Drawing and Painting Animals ©2005
Johnson, Cathy
11, 13, 14–17, 34–37, 40–45, 53–55, 58–61, 71, 74–77 (10–15, 18–29, 32, 56–59, 86–89)

The Artist's Guide to Drawing Realistic Animals ©2006
Lindstrand, Doug
24–25, 40–41, 76–79, 98–99, 102–103, 118–119, 124–125, 128–129, 132–133 (16–17, 60–61, 138–149, 182–185)

Painting Garden Animals With Sherry C. Nelson ©2004
Nelson, Sherry C.
12–15, 26–27, 60–69, 110–119 (36–41, 108–117)

Painting Your Favorite Animals in Pen, Ink and Watercolor ©2006
Nice, Claudia
24–25, 56–57, 30–31, 34–35, 98–99, 104, 107–109, 118–121, 136–137, 140–141 (30–31, 54–55, 82–85, 100–103, 132–137, 158–159, 168–169)

Painting Animal Friends ©2005
Scott, Jeanne Filler
14, 22–27, 38–41, 86–89, 82–85, 108–111 (33, 66–71, 72–75, 124–127, 128–131, 178–181)

Artist's Photo Reference: Songbirds & Other Favorite Birds ©2004
Rulon, Bart
36–39, 119–123 (160–163, 186–189)

Painting Wildlife With John Seerey-Lester ©2003
Seerey-Lester, John
48–49 (34–35)

Chinese Watercolor Techniques: Painting Animals ©2005
Zhen, Lian Quan
70–73, 102–113 (76–81, 150–153, 170–177)

TABLE OF CONTENTS

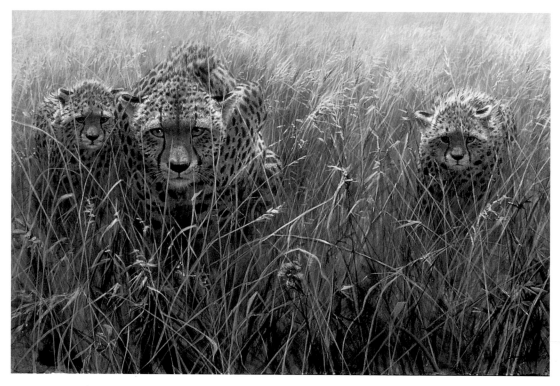

Chapter One 8
MATERIALS, MEDIUMS & **TECHNIQUES**

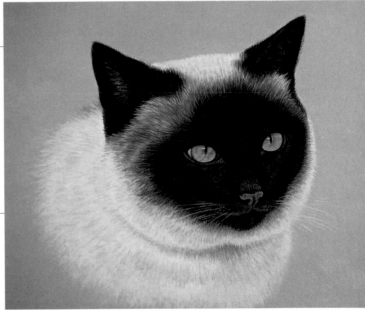

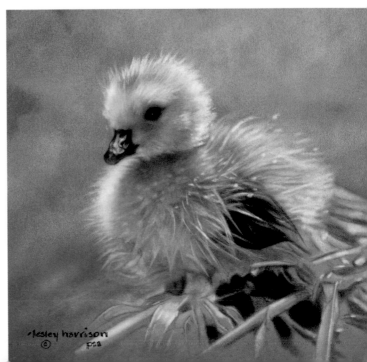

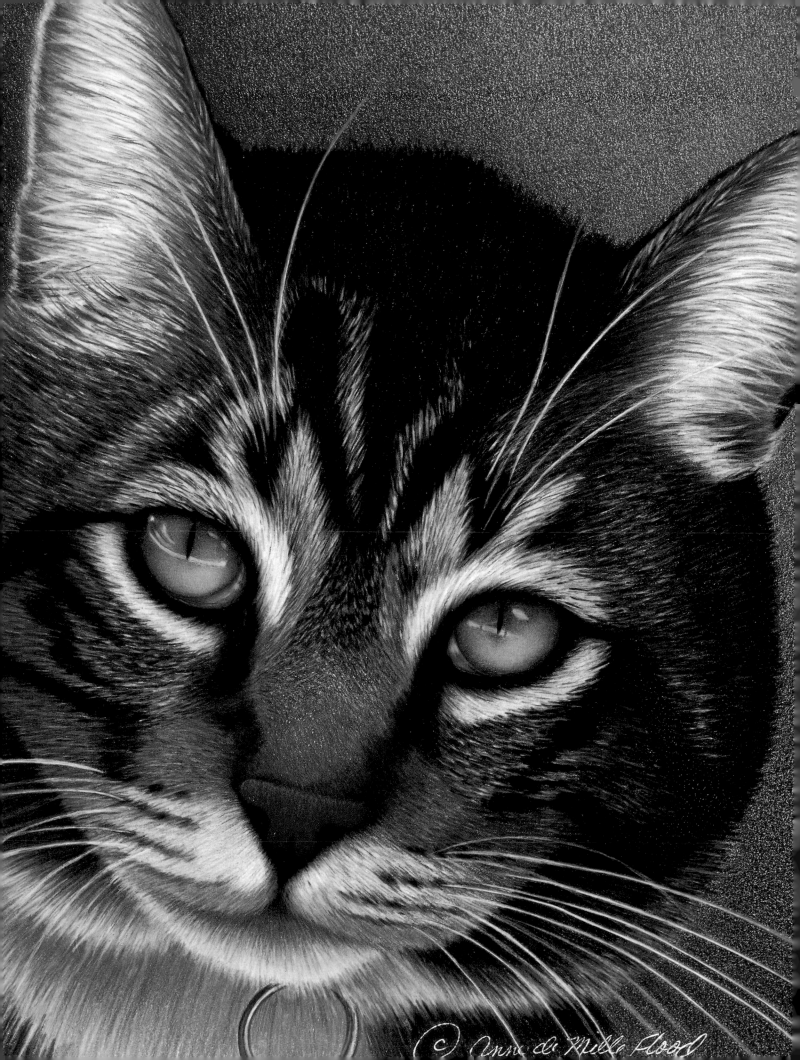

Chapter One | Materials, Mediums & Techniques

Knowing your materials is the first step in creating art of any kind. Try each medium and become familiar with what each has to offer. The options of how you execute the craft are limitless, but the basics of color, value and composition can be applied to every work. The point is to experiment, have fun and start drawing and painting animals in a way that works for you. Go forth and explore!

Mustafa
Anne deMille Flood
Colored Pencil on Paper
14" × 11" (36cm × 28cm)
Collection of Gulten Argamak

Basics
MATERIALS

What materials you'll need depends a great deal on what medium you plan to try first. For the absolute basics, a sketchbook with decent weight paper, at least 80-lb. (170gsm). This weight is heavy enough to prevent your paper from buckling too badly, and it will take the rough handling it might get in the field. Look for one with a medium "tooth", or texture. For now, you don't want a paper so slick that it won't take pencil well or so rough that your pen will skip and stutter. Don't try to get by with too cheap a sketchbook; fighting uncooperative paper is enough to put you off the whole idea!

You might try a spiral-bound sketchbook, or you may prefer a hardbound book, or one with glued sheets, so the spiral wire doesn't get in your way. Stick to smaller sizes as you try them out until you find the paper or papers you like best. For a modest cash outlay, you can purchase a nice spiral-bound watercolor paper sampler. This allows you to try everything from hot-pressed paper to lovely subtle tints.

A no. 2 pencil or an inexpensive fiber-tipped or gel pen will get you sketching. For depicting animals on paper, this is really all you need, but there are plenty of other materials to try.

You may find a book on animal anatomy helpful. Also helpful is Eadweard Muybridge's *Animals in Motion* (Dover, 1957), a reference of some four thousand individual sequential photographs, including horses, dogs, cats, camels, deer, cockatoos, hawks, goats and many others. Originally shot in the 19th century, these photos are still used by artists today.

TOOTH

Tooth is the degree of roughness on a paper's surface. The rougher papers (the ones with more tooth) are ideal for powdery mediums like charcoal or pastel. The smoother papers (ones with less tooth) work better for more fluid mediums.

Getting Started
If a medium intrigues you, start small. Get a sketchbook, a pencil and a pen, and maybe something for color, like colored pencils or watercolor paints.

VALUE

The following pages constitute a kind of miniature art course of the basics: value, composition and color. We'll begin with value.

Whatever your medium—drawing with a pencil, pen and ink, colored pencils, or painting with watercolor or acrylics—the basics of value still apply. In the artist's vocabulary, "value" doesn't mean a bargain or an ethical stance, but shades of color, from the darkest dark to lightest light. The simplest example is black (darkest value) and white (lightest value), with all the shades of gray that separate them; each hue has a darkest version of itself and a lightest version of itself.

It's usually best to limit the values in your work to, say, no more than five. You can create the illusion of depth and space quite simply with as few as three values: a dark, a light and a midtone.

Allow either dark or light to dominate your composition in order to keep things from looking too broken up. For example, make your largest area the lightest, make the next largest midtone and confine your darks to small, sharp accents. Or use the midtones for your largest area, the darks for the next largest and the lightest value for the tiny accent. Use this "rule" to create mood or atmosphere. If the darkest darks dominate, for instance, the effect will be moody and dramatic. If you allow the lights to dominate, you'll get a more cheerful picture.

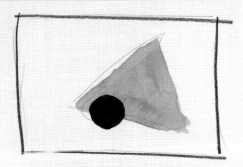

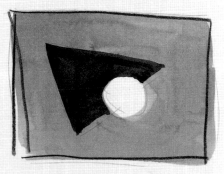

Allow One Value to Dominate
Notice the effect when one value dominates. It's much more interesting than if each value took up equal amounts of space.

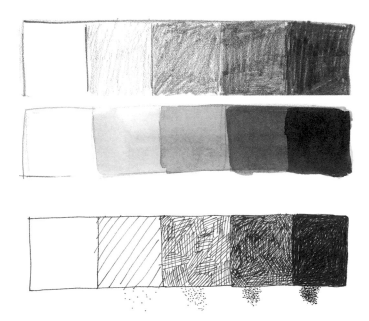

Value Charts
Make yourself a chart with perhaps five values, from the lightest to the darkest. Start with black, white and shades of gray. You can make a chart for each medium as a basic visual reminder.

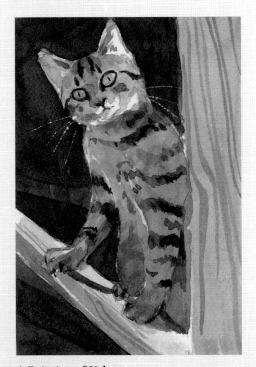

A Painting of Values
Notice how a very limited range of values can still create depth, volume and a sense of reality. Here, a cat stands out against deep shadows. Keep the strongest contrasts where you want the viewer's eye to go—in this case, to the cat's face.

Basics
COMPOSITION

Composition involves working with spatial concepts to create a pleasing layout. Some rules are classically simple. The first thing you need to do is decide whether you want to use a vertical (portrait) or horizontal (landscape) format. Sometimes a decision like that is simple, but not always. Consider the fact that horizontal compositions tend to be restful, and vertical compositions are more energizing. Does that make you reconsider your vertical sketch of cows lying in a field? Where you place your center of interest will determine its importance. Experiment with different arrangements and formats until you are pleased with the visual weight of your center of interest.

<div style="border:1px solid">

CENTER OF INTEREST

The center of interest is the most important visual element of a picture. In most realistic works of art, the center of interest is the subject of the painting.

</div>

<div style="border:1px solid">

USE VARIETY

Don't make everything the same size or spaced the same distance apart in your composition; that can be static and boring. Use variety in sizes or spacing to provide interest.

</div>

Divide the Composition Into Thirds
Divide your working area into thirds, top to bottom and from side to side, as shown. The center of interest will be most pleasing, in a traditional manner, if you place it at one of the intersections of those lines. This works well, whether you choose a horizontal or a vertical format.

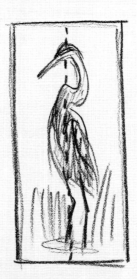

Simple Center of Interest
You may prefer simply to focus all attention front and center for a serene effect.

Off Balance
It's not always necessary or even desirable to stick with the classical mode of composition, of course. Explore an off-balance, unusual composition by placing your subject off to one side for a lively sense of motion.

COLOR

Color can really bring your work to life, so it's worth mastering the basics!

The basic color wheel is made up of the primary colors: red, yellow and blue. Primary colors can't be created by mixing any other colors (they *are* the basics), but with these three colors, you can create all the other colors of the rainbow.

Our color wheel (see below) includes a warm and a cool version of each primary color. When you mix colors, it's a good idea to match the temperature. For example, a cool red and cool blue will combine to make a much nicer purple than you'd get with a warm red and a cool blue. Likewise, a cool blue mixes better with a cool yellow to make a nice, clean green, and a warm red and warm yellow make the purest orange, as on our color wheel.

Of course, in painting animals, most often you won't be using the pure primary and secondary colors, at least not exclusively. But you can create very subtle paintings using a subdued version of this color theory. Naples Yellow or Yellow Ochre can stand in for the yellow, Burnt Sienna can be your red and Payne's Gray can act as the blue; these hues are gorgeous together, and are often found in nature in larger amounts than the more pure versions. Mix and match to create a realistic effect.

A Color Wheel
This color wheel shows a cool and warm version of each primary. Separating the primaries from each other are the secondary colors: green, orange and purple. Green is created by mixing yellow and blue, which is why it's placed between these two primaries. Likewise with orange (from red and yellow) and purple (from red and blue).

A Color Wheel for the Animal Kingdom
This variation on the primaries theme might look more believable in nature. Yellow Ochre, Burnt Sienna and Payne's Gray stand in for yellow, red and blue.

Go for the Complements
The complementary colors, that is! Colors opposite each other on the color wheel are known as complementary colors; green is the complement of red, purple is the complement of yellow and orange complements blue. You can use that knowledge to provide a vital, exciting vibration when you place complements next to each other in your painting. You can also mix complementary colors together to create a subtle gray. Let one color dominate the mixture, otherwise you'll get a plain gray—unless that's what you want!

Basics
LOOSENING **UP**

If you feel intimidated by the idea of "making art," try loosening up a little. Use a child's box of crayons, if you like! If "wasting" good paper bothers you, practice on newsprint or the backs of used computer paper. This is just to get you loose and flowing, anyway. Get your whole hand and arm into the act, making big, sweeping motions. Stand up to do it, if you like. Tape your paper down so it doesn't move around with your sweeping movements.

Little kids don't worry too much about creating masterpieces. They just have fun, play and create. We can do the same. Explore these different marks: lines, spirals, shapes, dots.

Pencil

Technical pen

Dip pen

Colored pencil

Watercolor pencil

Round watercolor brush

Flat brush (side and edge)

Lines With Different Mediums
Make a variety of lines using all the tools in your arsenal. Notice how different pencil lines are from those made with a brush. Try varying the pressure.

Learning the Movement
This is a good time to just make marks. Let yourself go. It's like dancing!

Spirals
Try spirals or coils, getting used to the feel of making these marks. Try making them uniformly, then with variations.

Dots
Make dots. Make tiny, uniform ones. Make them close together and more widely spaced. Make big dots and little dots. Look at how you can use them to suggest shading.

Dashes
Try dashes in a similar fashion and think about what they suggest to you. Insects over a field of grass, birds in the sky? Play with the length, direction or precision of these dashes, and let your imagination soar. Consider how you might use them in your drawings or paintings.

GETTING PAST **WHITE PAPER**

If blank paper bothers you (and you're not alone—it bothers a lot of people!), try preparing a bunch of sheets ahead of time without worrying about what will eventually go on them. Use them right away or set them aside; you may come up with something weeks or months later that's perfect for that particular no-longer-white paper.

The little squiggles and sketches here are only suggestions... do what you like!

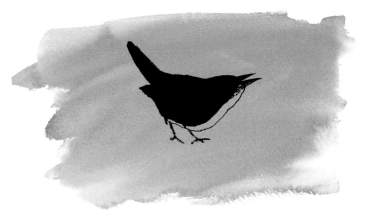

Change the Color of the Paper
An all-over, variegated green wash could form the background for a close-up of a bird in the grass or a landscape with cattle in the distance. The important thing is that you've started! It's no longer white paper.

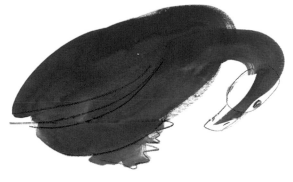

Bring Abstract Shapes to Life
If you want to play at a more abstract exercise, try something like a Rorschach test. Just splash a shape on that clean white paper, in watercolor or thinned-down acrylic, then let it dry. Go off and leave it alone. Later, it may suggest something to you: a prehistoric bird, a dragon, a butterfly or just an interesting background on which to draw something completely unrelated. This one evokes a red goose!

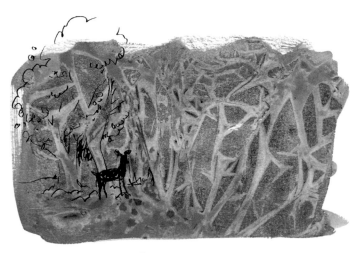

Work With Watercolor
Splash and spatter watercolor in a pleasing combination of colors, or lay a sheet of crumpled wax paper, plastic wrap or aluminum foil in a wet wash. Pull it away when the paint's partially dry, or let it dry completely for more emphatic designs (this may take overnight). Then draw or paint what you like on the paper. It's no longer intimidating because it's not staring at you with that pristine surface. This one looks as though it could be trees in an autumn forest, so I thought adding the deer would be a nice touch.

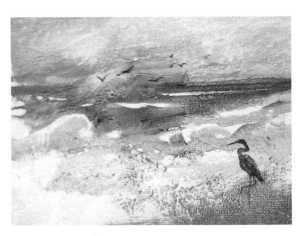

Play With Acrylic
Play with textures to get past that fear of white paper. Use acrylics to texture a background, then glaze it with colors. Again, let the result suggest what to do next. In this case, the paint looked like the line of foamy surf at the ocean's edge, so the proper colors and a fishing bird were added.

Pencil
WHITE CREATES LIGHT
DEMONSTRATION

BY DOUG LINDSTRAND

A drawing's white, unmarked areas are just as important as the actual pencil lines. In this drawing there will be a strong light coming from the left, which will make that side of the lion's face very bright. You will create lights and darks in two different ways: in one you will fill in all the areas with tone, and in the second you will add darks while leaving light areas blank. Try both methods to really get a feel for the difference white lights can make.

The color of the paper is the lightest tone you can get. Leaving blank areas is a great technique to use to designate the lightest lights.

MATERIALS

SURFACE
Drawing paper of choice

PENCIL
HB Graphite

OTHER
Charcoal
Tortillion
Tracing paper

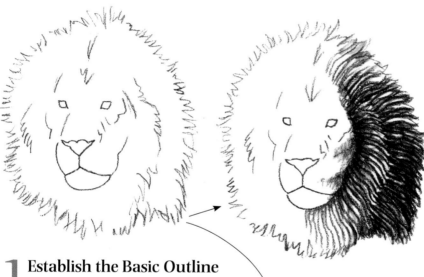

1 Establish the Basic Outline
Use tracing paper overlays to get an accurate outline of the lion's face. Make sure your outline is as accurate as possible—especially the position of the facial features.

2 Draw Pencil Lines and Leave the Lights
Draw the lion's mane with pencil lines. Use a tortillion to shade in parts of the mane and face, leaving white areas for highlights. Notice the increased depth you've created with the contrast of light and dark.

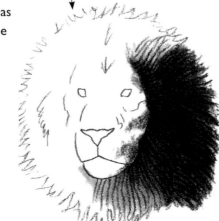
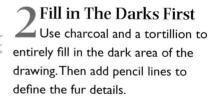

2 Fill in The Darks First
Use charcoal and a tortillion to entirely fill in the dark area of the drawing. Then add pencil lines to define the fur details.

DRAWING SECRET

Once you've completed your final outline, try waiting a day or two before transferring the image to your drawing paper. Keep the drawing in a place where you can glance at it occasionally. A fresh look may make a previously unnoticed flaw obvious to you.

PENCIL **PRACTICE**
DEMONSTRATION

BY DOUG LINDSTRAND

Practice drawing animals with different types of pencils and applying different degrees of pressure. Press hard for a dark color or press lightly for light areas. Only by understanding your drawing tools will you be able to use them effectively. A good exercise is to use different types of pencils on a single drawing. This will help you understand which pencil is best for which element.

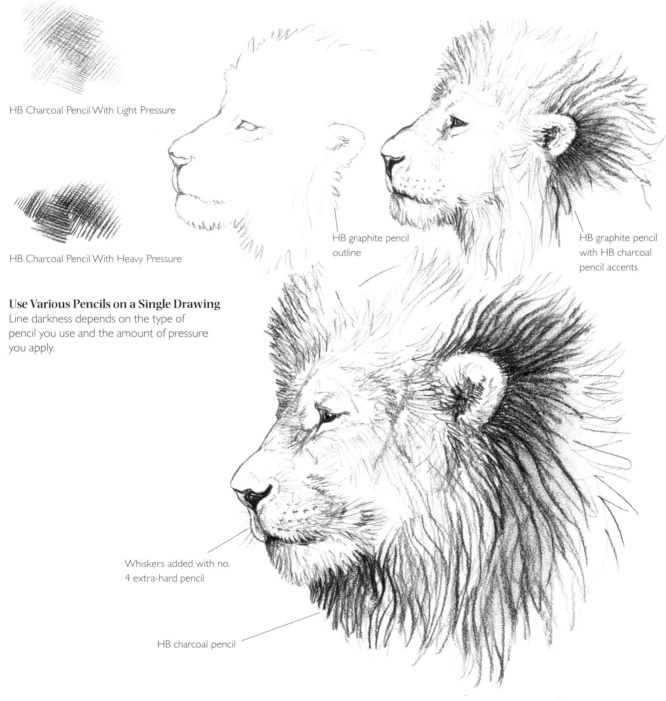

HB Charcoal Pencil With Light Pressure

HB Charcoal Pencil With Heavy Pressure

Use Various Pencils on a Single Drawing
Line darkness depends on the type of pencil you use and the amount of pressure you apply.

HB graphite pencil outline

HB graphite pencil with HB charcoal pencil accents

Whiskers added with no. 4 extra-hard pencil

HB charcoal pencil

MAKING A **PENCIL DRAWING**

DEMONSTRATION

BY CATHY JOHNSON

First, of course, decide on your subject. The cat had gotten the cabinet door open overnight and found himself a private place to sleep among the cups and glasses, it was just too funny—and endearing—not to record in a sketchbook.

MATERIALS

SURFACE

A smooth, heavy paper,
such as Strathmore vellum

PENCILS

4B pencil
HB pencil
Water-soluble pencils

OTHER

Kneaded eraser
Tracing paper (optional)
Workable fixative

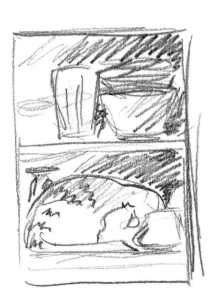

1 Decide Format and Make Sketches

Before you turn your original quick sketch into a more finished drawing, decide on a format: Would a vertical format be more effective for your subject, or a horizontal? The horizontal format works well since that's how the cat was oriented. Then decide what needs to be included and what doesn't. Here we can edit out the additional shelf above the animal. A more extreme horizontal could go well with this subject, too.

Sketch some possibilities. They can be tiny thumbnail sketches no bigger than your thumbnail, if you like. Don't let your composition get too static; break out of the box a little. Let the tail droop down below the shelf to break up the rectangular frame.

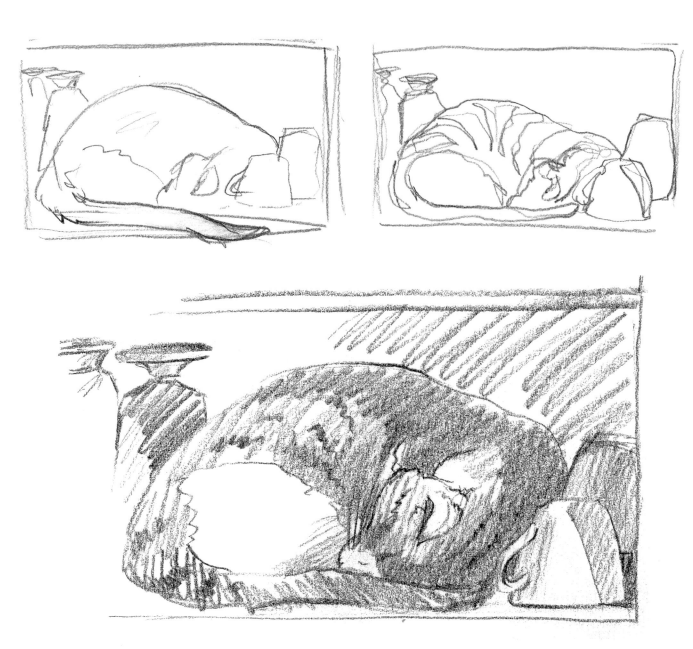

2 Explore the Possibilities

Now, consider which technique would be most effective for your subject, and make some more experimental sketches. Explore the possibilities with a clean, simple outline, a modified contour drawing with lively lines, or a tonal sketch like the original.

BE AWARE OF ALL SHAPES

When drawing an unusual pose, pay attention to the negative shapes (the shapes around the animal) as well as the positive ones. Doing so will help you draw unusual forms more accurately.

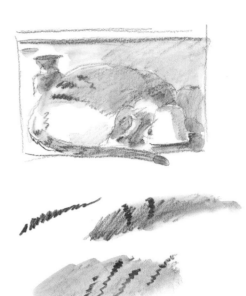

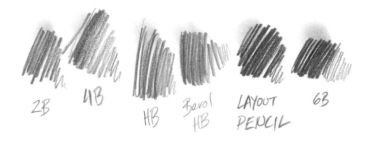

2B 4B HB Berol HB LAYOUT PENCIL 6B

3 Get Comfortable With Your Medium

Help yourself decide which pencils to choose by making a few samples. See what blends well—a quick rub with your forefinger will tell you.

Experiment with the new water-soluble pencils, too. Try a variety of techniques to familiarize yourself with this unusual medium. Wet the pencil first, then shade in your drawing, making sure there is a variety of values. Wet the paper all at once to make a light all-over tone. Once this is dry, dampen everything again, then draw some darker lines and markings with your water-soluble pencil.

See how this works with your basic composition. The silvery quality is nice, but let's stick with a simpler technique.

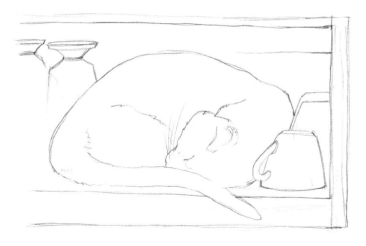

4 Transfer Your Sketch

Now that you've decided where you're going, transfer your sketch to the vellum drawing paper. Do this by eye, very lightly, with the HB pencil. Or, if you would feel more comfortable, do your initial drawing to size on tracing paper and transfer that lightly to your drawing paper.

It's possible to use a grid to transfer, but grid lines are difficult to erase with this medium.

AVOID SMEARING

Keep a clean sheet of paper under your drawing hand to prevent smearing. If you're right-handed, work from left to right; if you're left-handed, just the opposite.

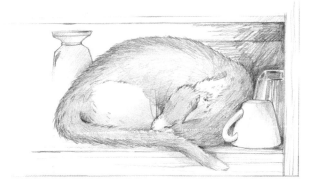

5 Start With the Light and Medium Areas

It's easier to darken an area that is too light than erase areas that are too dark. Work smoothly with the wedge of your pencil's point, allowing your strokes to follow the direction of hair growth in some places. No need to hurry! Blend the graphite with your finger here and there to suggest volume, as on the white fur of the chin and back leg.

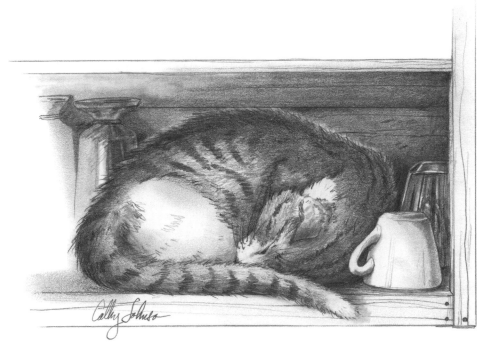

Bodine
Cathy Johnson
Graphite on Strathmore vellum
6" × 7½" (15cm × 19cm)

6 Finish With the Darkest Values

Finish with the darks and add details such as the cat's markings and eye. Use a sharp pencil to suggest individual dark guard hairs and markings; a 4B works well. You can lift areas that may be too dark or have smeared with a kneaded eraser, but be sure to turn it (knead it, hence the name) often so you don't redeposit graphite where you don't want to. Don't rub; just pick up excess graphite by pressing and lifting. Take your drawing to the point where you are pleased with it. You don't have to carry a drawing through to a more completed form if you are satisfied right now.

Graphite will smear (that's its major drawback), so if you want to keep a pencil drawing, finish it with a light spray of fixative such as Kamar Varnish by Krylon.

Pen and Ink
GETTING TO KNOW **PEN AND INK**

Ink is an amazingly versatile medium. It's also venerable; artists, calligraphers and scribes have used ink for thousands of years. Why not explore the possibilities—including the modern fiber-tipped and technical pens—for yourself?

PENS

Gather a variety of ink-drawing tools, including some with a built-in ink reservoir (such as some fiber-tipped, ballpoint or fountain pens), and an old-fashioned dip pen and ink. You may want to try a very fine crow quill pen, available at most art or craft supply stores, or something a bit larger. A brush pen can be a fun and expressive tool to try as well.

Once you've found a good selection of pens, put them through their paces to see what they can do and what effects you can achieve with them. Make repeated straight, parallel lines, called hatching, and then go back over them in another direction to make a darker area; that's called crosshatching. Make stippling dots and squiggles, just to see how the pen handles. Try it out on the animal of your choice.

**Brush Drawing
With Sepia Ink**

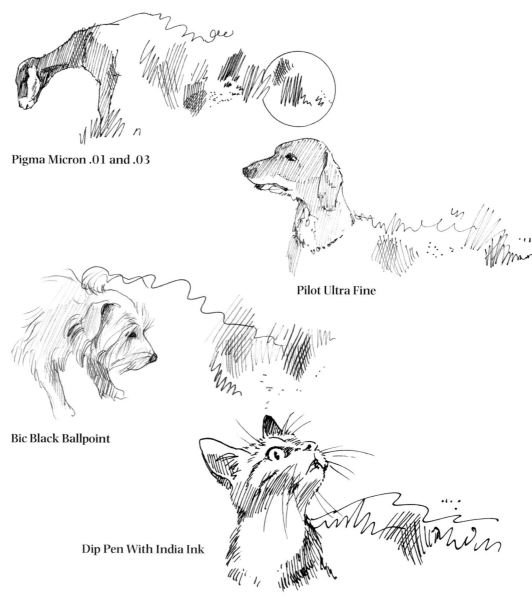

Pigma Micron .01 and .03

Pilot Ultra Fine

Bic Black Ballpoint

Dip Pen With India Ink

THE DIP PEN

The dip pen is one of the more traditional tools to use with ink. Using a dip pen is not difficult, it just requires finding a nib to match your needs and learning a few simple tricks.

Dip only the nib into the bottle, not the handle (or you'll get your fingers all inky!), and then tap the pen against the ink bottle to get rid of the excess ink. Test the pen before you touch it to your drawing. When you're all through, rinse the nib and dry it on a paper towel; it will last longer that way.

BRUSHES

It's not necessary to use a pen, of course; you can also apply ink with a brush. Again, don't dip too deeply into the ink bottle and always test the brush on a piece of paper first. Wash the ink out quickly, or it will ruin the brush—this is no place for a good sable brush!

INKS

Inks come in a variety of colors and consistencies. While black is the traditional—and still most popular—color, there's quite a range to try. Some inks are waterproof when thoroughly dry. Others will spread when they are re-wet. Both have their advantages, so test out both types.

Though waterproof ink is permanent when dry, you can thin it with water to create a halftone effect. I like to apply this with a brush.

Colored Ink
Starting from the left, there are four water-soluble calligraphy inks, two artist's acrylic inks and even a silver and gold! All these samples were applied with a brush.

Waterproof vs. Water-Soluble
The waterproof ink on the left works well with watercolor paints. The water-soluble ink on the right can be applied and then wetted later if you decide to adjust the tone.

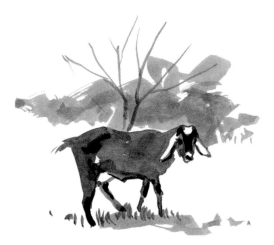

Halftone
Even waterproof ink can be thinned before it dries, for a halftone effect.

> **NIB**
>
> The nib is the tip of the pen, usually made of metal, though sometimes goose quill or bamboo. The shape and size of the nib determine the shape and size of the line. Most art stores carry a wide variety of nibs for lettering artists.

Watercolors
WATERCOLOR **BASICS**

What you use for watercolor depends a great deal on whether you like to work large or small, loose or tight, indoors or out, so this list will necessarily be fairly general. The basics are the basics

RECOMMENDED EQUIPMENT

Watercolor paper. Try a sample pack so you can experiment with rough, cold-pressed and hot-pressed paper. This should be at least 140-lb. (300gsm) so you don't have to stretch it to keep it from buckling.

Watercolor paints. Use a good brand, either pan or tube paints, but avoid student-grade paints. They're simply not worth it. Winsor & Newton, Daniel Smith, Grumbacher (professional grade) and Schmincke are among the best brands.

A large plastic or enamel palette. This is good for indoor use. A portable watercolor set works just fine for outdoors.

Round watercolor brushes. I recommend brushes with red sable or synthetic hairs in sizes no. 3, no. 5, no. 8 and no. 12.

Flat watercolor brushes. I again recommend sable or synthetic hairs. Choose a variety of sizes, but it's best to start with ½-inch (13mm), ¾-inch (19mm) and 1-inch (25mm).

A fan brush. Select a medium-sized brush with bristle or synthetic hairs.

Old toothbrush. This works for spattering paint.

Water container. This can be a Mason jar, Loew-Cornell Brush Tub or an old army canteen with a cup.

Rags or paper towels for wiping up spills, blotting washes and even painting. You can hold one in your free hand while you work so you can wipe your brush or the painting quickly.

Natural sponge for texturizing the paint.

Rough Paper

Cold Press

Hot Press

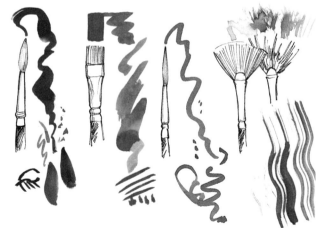

A Variety of Brushes

The round brush (far left) is capable of all kinds of strokes and squiggles and dots. Artists made do for centuries with rounds, and as versatile as they are, and as many sizes as they are made in, it's no wonder.

The next brush (second from left) is a flat, which once was used just for lettering or calligraphy. Artists now have found how truly versatile and useful they are! Like rounds, they come in a great variety of widths.

Riggers or liners (second from right) are capable of nice, long, relatively uniform lines. You'll find all kinds of uses for these.

Fan brushes (right) are often given a haircut by their watercolorist owners to make more interesting, less uniform marks. Synthetic hairs make finer lines; bristle brushes are more emphatic.

WATERCOLOR **WASHES**

To warm up or to familiarize your-
self with the medium, try these tradi-
tional watercolor washes: flat, graded
and variegated. Then branch out into
wet-in-wet and glazing, and you'll be
well on your way to being a watercol-
or virtuoso.

Flat Wash

To make a flat wash, use a large flat or
round brush and mix up a good-sized pool
of water and pigment. Draw your brush
across the top of your wash's area to make
a horizontal line. Keep your paper slightly
tilted to encourage a bead of paint to form
at the bottom of the stroke. Refill your
brush and make a new stroke, slightly over-
lapping the first and picking up that bead of
pigment. Continue on down the page as far
as you wish. Pick up the remaining bead of
pigment with a clean brush. If the brush isn't
clean or is too wet, paint will bloom back
into your smooth wash.

 This is one of the most difficult washes to
pull off perfectly. It's easier, oddly enough, on
rougher watercolor paper since the pigment
"averages out" as it settles into all those lit-
tle valleys.

Graded Wash

A graded wash is essentially the same thing
as a flat one, but it's achieved by adding suc-
cessively more water instead of reloading
your brush from the pigment puddle. Don't
forget to pick up the bead of wet paint on
the bottom edge, even on the final pass, to
prevent back runs.

Variegated Wash

The variegated wash is most useful. To cre-
ate it, roughly apply paint, varying both the
color and your strokes as you go. You'll find
a million places to use this one, and will
develop your own favorite way of apply-
ing it. Here, we've roughly mixed blue, yel-
low and red on the paper, allowing them to
blend.

Wet-in-Wet

Painting wet-in-wet will give you soft tran-
sitions and sometimes unexpected effects
that are very useful for shadows, suggest-
ing volume or just adding interest. Lay down
an area of color and immediately splash
another color right into or next to it, allow-
ing the two to touch and blend.

Glazing

Glazing is just the opposite of wet-in-wet.
Let your first wash dry thoroughly, then
paint another layer over it. You can add an
almost infinite number of glazes or only one.
Try not to lift or muddy the wash under-
neath. With glazing, you can create a third
color, make a color more subtle, add a misty
opaque or create a sunset glow.

BY CATHY JOHNSON

Watercolors
WATERCOLOR **PAINTING**
DEMONSTRATION

For this example, we'll paint a picturesque nineteenth-century woolen mill in northwestern Missouri called Watkins Mill. The mill has been open to the public for some years, and boasts an up-to-the-minute visitors' center, a brick schoolhouse and church, a lake and nearby camping. You can use a variety of techniques and resource photos to get the effect you're after.

MATERIALS

SURFACE

11" ×14" (28cm × 36cm) watercolor paper

BRUSHES

½-inch (13mm) flat
¾-inch (19mm) flat
1-inch (25mm) flat
Fan brush with bristle hairs
Nos. 5 and 8 rounds
Stencil brush
Synthetic brush for masking fluid

PIGMENTS

Alizarin Crimson
Brown Madder Alizarin
Burnt Sienna
Burnt Umber
Cadmium Yellow Medium
Cobalt Blue
Phthalo Blue
Raw Sienna
Sap Green
Ultramarine Blue

OTHER

Craft knife or single-edge razor
HB pencil
Masking fluid
Paper towels

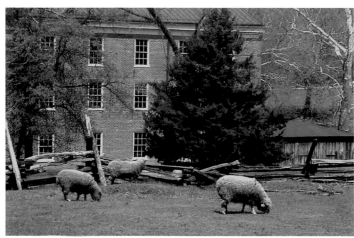

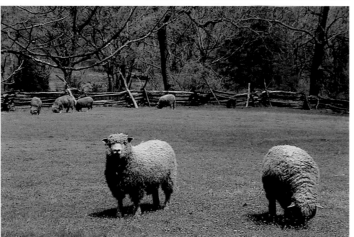

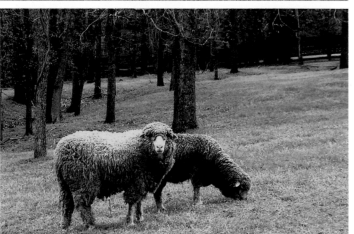

Resource Photos
Pick and choose from your photos to find what you want to include in the final painting. Here, sheep from three different reference photos seemed most interesting. A quick sketch lets you see how they'll work.

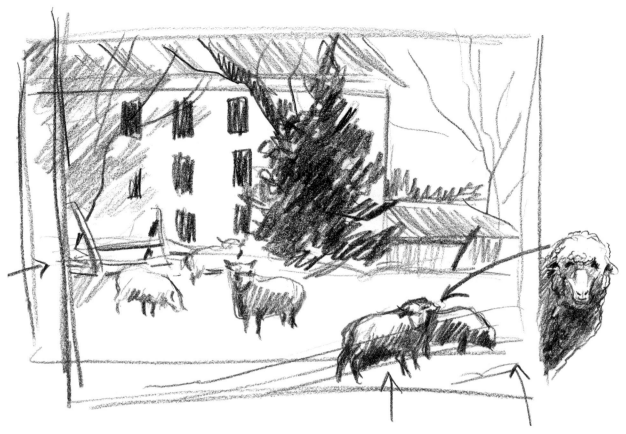

Sheep Sketch
Make a quick sketch of the sheep you plan to include and the positions you want them in. Remember, those closest to you will look largest and most detailed. Make notes on the sketch, if you like, or do a detail sketch in the border.

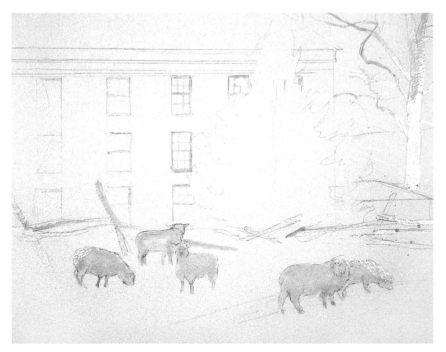

1 Transfer or Draw
Transfer or draw your composition on your watercolor paper with an HB pencil. Protect areas you want to keep white, for now, with masking fluid. Here, the mask covers the windows, the sycamore tree, the light-struck fence and the sheep.

2 Lay in the Large Shapes

Paint around large shapes, but go right over those protected with masking fluid. The background woods are a more obviously variegated wash, using Cadmium Yellow Medium, Raw Sienna and a variety of blues. The grass in the foreground is also variegated. Use Cadmium Yellow Medium with Phthalo Blue to get a stronger, fresher green. Let shadow areas describe the shape of the ground.

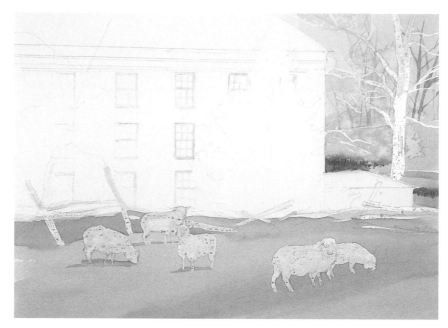

3 Apply First Washes

Put the first washes on the mill building itself with a mixture of Burnt Sienna, Brown Madder Alizarin and Ultramarine Blue. Quickly wash in the light green of the tree on the left, working wet-in-wet with Cadmium Yellow Medium and a bit of Phthalo Blue. Allow that to dry, then add the shadows under the eaves with Cobalt Blue.

When that is dry, do the first washes of the dark cedar tree with a bristle brush, barbered fan brush or a rescued brush. Use a rich mixture of Phthalo Blue, Sap Green and a touch of Alizarin Crimson.

Paint in the dark windows with Ultramarine Blue and Burnt Umber—painting right over the mask—and allow these washes to dry thoroughly.

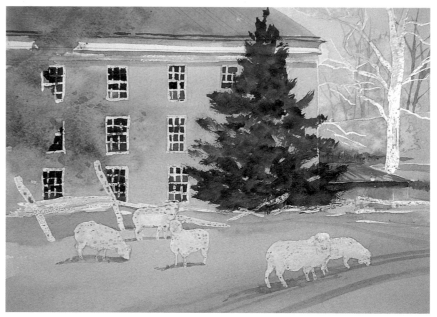

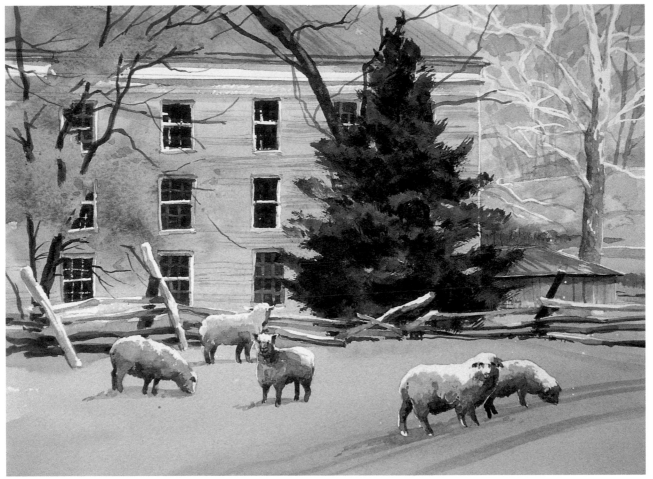

4 Remove Mask and Apply Final Washes

Carefully remove the mask from the tree, fence, windows and sheep. Once the mask is removed, paint over the overly wide, too-coarse mullions with another rich layer of Ultramarine Blue and Burnt Umber, just covering the mullions but leaving the window frames. Allow that to dry completely, then scratch in the lines again with your craft knife. Add shadows with Cobalt Blue.

Paint in small variegated washes on the tree trunk on the right and model the shape of the tree. Add the other trees and limbs on that side, and paint the dark limbs on the tree at left that is just getting its young spring leaves. Mix a bit of the same yellowish green with less water so it's darker. Cover the rest of the painting with scrap paper, then use the stencil brush to spatter in a suggestion of tiny young leaves. Continue to model the cedar tree, adding darker shadows and the rest of the limbs, along with a suggestion of the trunk.

Use Ultramarine Blue and Burnt Sienna for the split-rail fence. Paint the shadows on the sheep with a lighter, warmer mix of those two colors, with a bit of Raw Sienna. Leave the upper edges of the sheep white paper, and shade to darker washes underneath, being careful to model their shapes as you go. Remember that the closer animals will be a bit more detailed.

Finish up other details as needed, working over the whole composition until you are satisfied. Suggest a few blades of grass with tiny strokes.

Watkins Mill, April
Cathy Johnson
Watercolor on paper
11" × 15" (28cm × 38cm)

Pen, Ink & Watercolor
HAIR **TEXTURE**

To create the watercolor hair coat use crisscross lines applied with a no. 2 round detail. The point was stroked on in layers. Each layer was allowed to dry before the next was applied.

1 Base wash of Burnt Sienna and Yellow Ochre.

2 Hair strokes in Burnt Sienna plus Yellow Ochre.

3 Hair strokes in Burnt Sienna.

4 A shadow area is created by adding hair strokes of Burnt Sienna plus green.

Stippling
Stippling is a series of dots produced by touching the pen nib to the paper surface while the pen is held in a vertical position. Use stippling to depict short, velvety hair.

 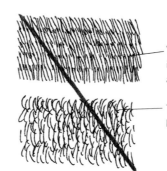

— When stroking crisscross lines avoid working across the animal in rows. It will result in a furrowed pattern.

— This hair looks fried because the ends of the lines are curved.

Crisscross Lines
Crisscross lines are randomly crossing hair-like strokes that are semi-straight and flow in one direction. Use crisscross lines for short hair. A .25 mm pen nib works well.

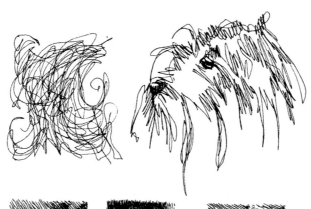

Scribble Lines
Scribble Lines are continuous looping lines that are drawn quickly and loosely. Use scribble lines for curly or thick tangled hair. They also make good "quick sketches" where lines are restated to make corrections.

Curving Lines
Long, wavy lines are perfect for defining horse tails, manes and shaggy dogs.

Varied Strokes
Varying the number of strokes in an area creates stripes, spots and dappled patterns.

CREATING HAIR **TEXTURE**
DEMONSTRATION

BY CLAUDINE NICE

MATERIALS

SURFACE

Watercolor paper

BRUSHES

Small flat or stroke brush

PENS

.25mm pen with sepia ink

PIGMENTS

Burnt Sienna

Burnt Umber

OTHER

Paper towel

Pencil

There are two main ways of combining pen, ink and watercolor to create a hair texture. In the sepia sketch below, the pen work was done first and a watercolor wash was brushed over it to tint it. In this method, the emphasis is given to the ink work. In the second method, shown step by-step, the watercolor goes on first, then the ink.

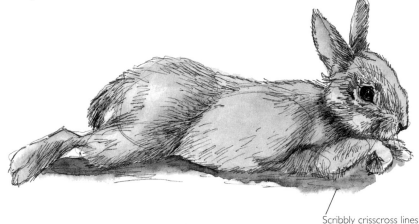

Scribbly crisscross lines

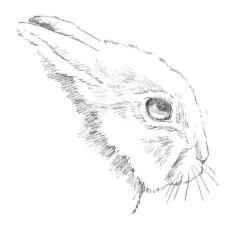

Drybrush Texture

1 Make Your Drawing

Make your drawing in pencil showing shadows and hair direction. The actual sketch should be very light so it will blend into the washes.

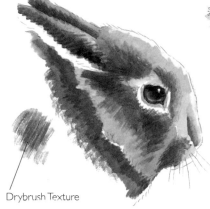

2 Apply Washes

Brush a light wash of Burnt Sienna mixed with Burnt Umber over a damp surface to provide a base color. Leave white areas upainted. Let it dry.

Drybrush the same hue over the first wash in the shadow areas. Use a small, flat or stroke brush, blot it well on a paper towel and stroke in the direction of the hair. Don't over blend the edges. Let it dry. Shadows can be darkened by drybrushing on additional layers.

3 Make Your Drawing

Use a .25mm pen and sepia ink to add crisscross hair strokes. Pay attention to hair direction and length. The crisscross lines should be no longer than the hairs they represent.

Acrylic
ACRYLIC **BASICS**

MATERIALS

Consider a set of smaller tubes of acrylics to see how you like them if you've never used this medium before. Liquitex, Daniel Smith, Golden and others make tube colors as well as a more liquid form in jars. If you want to use the impasto technique, you'll want the tube paint. Thinner applications and watercolor effects are somewhat easier to achieve with jar colors.

If you opt not to buy a preselected set, purchase a tube or jar of the primaries—red, yellow and blue—plus white, black and a few earth colors. Many artists prefer having both a warm and a cool of each primary for the widest range of mixing possibilities.

RECOMMENDED EQUIPMENT

Acrylic paints, tube or jar. Jar paints are more liquid and require less mixing with water or medium, but the tube paints will let you use a bold impasto technique. Avoid craft paints, though, since they are less pigment-dense.

Matte or gloss medium. These are for mixing and thinning your paints. You can also use water, if you wish. You can use the matte or gloss medium as a varnish at the end.

Gel medium. Adding this to your regular paints thickens the paint for an impasto effect. You can also buy a variety of textured acrylic additives. These can be fun, but they're not necessary; all you need right now is paint.

Round synthetic brushes. Try no. 3, no. 5, no. 8 and no. 12. Acrylic is more difficult to clean from brushes than watercolor, so stick with the less expensive synthetic brushes.

Flat synthetic brushes. Try the ½-inch (13mm) and 1-inch (25mm).

Painting surface. You have a variety of choices for your painting's surface. Acrylic works on stretched canvas, canvas board, canvas-textured paper and even heavy watercolor paper. You can also use acrylics on stone, wood or Masonite. Acrylics are versatile as well as tough and flexible.

Water container. You may also need containers for other mediums, if you use them.

Palette. Dried acrylics will come off a china or enamel palette with relative ease. There are also special palettes that keep your paints moist, but a palette with a cover will keep the paint moist longer, too.

A spray bottle of water. Spritzing your palette (or your painting) with water will keep paint from drying.

The usual paper towels or rags for quick pickups, cleaning your palette or adjusting the painting.

Mixing Colors
A warm and a cool version of each primary color will make it easier to mix clean secondary colors—orange, violet and green—not to mention the tertiary colors and all the mixtures between. You can gray a primary color with its complement (the hue directly across the color wheel) or mix them with each other to produce a nice range of gray-to-brown neutrals, as shown in the center.

WORDS TO KNOW

Impasto: In this technique, paint is applied so thickly that brushstrokes are clearly visible. The raised paint adds exciting texture to the painting.

TYPES OF BRUSHSTROKES

Learning to handle your brush is crucial in depicting the texture of fur, clouds, grass and hooves. There are several types of strokes you should be familiar with when painting the natural world.

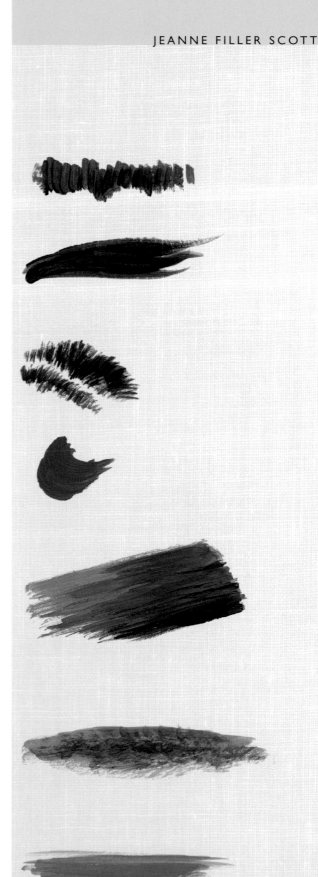

Dabbing Vertical Strokes

These strokes are done quickly, in a vertical motion, with either a round or a flat brush. They are good for painting the texture of grass in a field

Smooth Flowing Strokes

These strokes are good for long hair, such as a horse's mane or a long-haired cat's tail. Use a round brush with enough water so the paint flows, and make the strokes flowing and slightly wavy.

Small Parallel Strokes

Use this kind of stroke to paint detail, such as short animal fur, using the tip of your round brush. Be sure to paint in the direction the hair grows on the animal.

Dabbing Semicircular Strokes

These are done fairly quickly, in a semicircular movement, with a flat brush such as a shader. These strokes are good for skies, portrait backgrounds or other large areas that need to look fairly smooth, but not vertical or horizontal, such as a wall or floor.

Glazing

A glaze or wash is used to modify an existing color by painting over it with a different color thinned with water, so that the original color shows through. This creates a new color that you couldn't have achieved any other way. Dip your brush in water, then swish it around in a small amount of the glazing color. Blot briefly on a paper towel so you have a controllable amount of the glaze on your brush, then paint the color smoothly over the original color. In this example, a glaze of Burnt Sienna was painted over a portion of the log to show how the glaze warms up the colors.

Drybrush or Scumbling

This is when you modify a color you've already painted by painting over it with another color in an opaque fashion, so that the first color shows through. Using a moist, not wet, brush, dip the brush into the paint, then rub it lightly on a paper towel, so that there is just enough paint to create a broken, uneven effect when you paint over the original color. Repeat as necessary.

Smooth Horizontal or Vertical Strokes

These strokes are good for man-made objects and water reflections. Using enough water so the paint flows, but is not runny, move your round brush evenly across the surface of the panel.

Acrylic
FIELD **STUDIES**

When using acrylics in the field, you can use Strathmore paper, canvas panels or primed Masonite. Paper obviously is easier to carry, particularly on an extended field trip. Cut the paper to 11" × 17" (28cm × 43cm) and carry it between two pieces of Masonite to keep it flat. Then attach the paper to a piece of Masonite with rubber bands for a hard surface to work on. When you return, put the completed studies in a binder. For shorter excursions, carry several Masonite panels. Take a jar of gesso primer into the field with you so you can redo an area that isn't working easily and quickly.

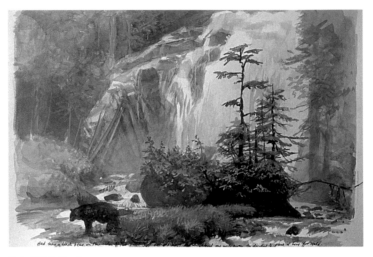

Establish Scale
Adding a bear to this study of Chatterbox Falls in the Gulf Islands, British Columbia, Canada, establishes the scale of the scene. After painting the waterfall and the background and letting it dry, push it back by applying a series of washes of gesso and water. Then paint in the trees, foreground and bear. The bear helps establish the scale of the trees.

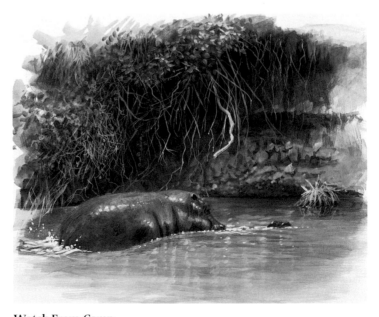

Watch From Camp
This study in East Africa on the Mara River was done with a ⅜-inch (10mm) flat.

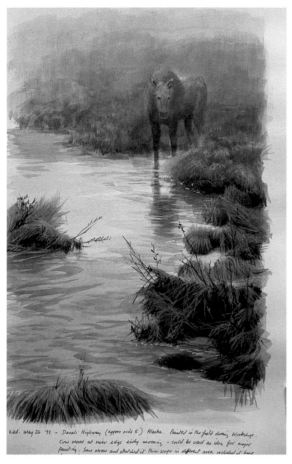

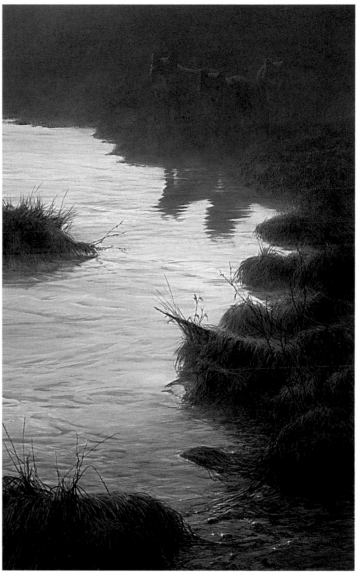

Start With Field Sketch
This field painting of a cow moose, done in Alaska, was later adapted for a different animal. The setting—the light on the water and the grasses—is what made the scene impressive. The acrylic paint is used almost like watercolor, very softly and subtly, working from light to dark. Acrylic painting is like painting in a mist. As you paint darker washes, the mist lifts to reveal a clear image.

Adapt Scene
The setting of the painting at left was adapted for this painting of wolves. A quick sketch of wolves done on a different field study, also in Alaska, was combined with the darkened moose setting for a completely different feel.

Phantoms of the Tundra
John Seerey-Lester
Oil on Masonite
36" × 24" (91cm × 61cm)

Acrylic
WET-ON-WET
ACRYLIC BACKGROUNDS
DEMONSTRATION

BY SHERRY C. NELSON

Begin by sanding the edges of the Masonite panel; no need to sand the painting surface. If the back is fuzzy, sand that a little too, so the particles don't get into your paint. I do the backs with an electric sander, outside.

MATERIALS

SURFACE

Masonite panel

PIGMENTS

Gamal Green

Rainforest Green

Seminole Green

Silver Pine

OTHER

Acrylic Retarder

Electric Sander

Krylon Matte Finish #1311

Paper towels or newspaper

Sandpaper

Small sponge paint roller

1 Apply Basecoat

Wet-on-wet acrylic backgrounds most often begin with a basecoat of one of the colors. Drizzle on Silver Pine quite generously. You'll need enough to wet the roller as well as to coat the surface liberally.

How do you know when too much is too much? If the paint remains bubbly after you've coated the entire surface, you've put on a little too much. If it's sticky, and disappears right away into the surface, you've used too little.

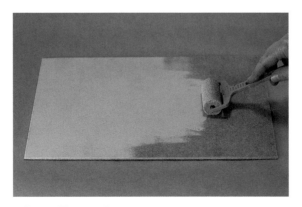

2 Roll Evenly

Use the sponge roller in one direction until the surface is covered. Then go across in the other direction for a smoother finish. Lighten the pressure on the roller when you change directions. If you've put on too much paint, just change directions another time. The paint will gradually quit being bubbly.

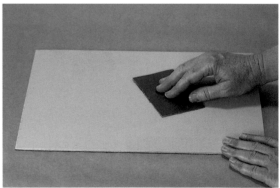

3 Sand

After the first coat dries (it will no longer feel cool to the touch), sand it well. Sand the edges again and the painting surface too, to remove any dust particles that may have gotten into the paint. Press lightly with all four fingers on the sandpaper and move it around on the surface as if you were polishing it.

4 Reapply Basecoat

Now reapply the Silver Pine, using just a little less than before. Then drizzle a little puddle, perhaps half a tablespoon, of acrylic retarder onto the surface in the middle of the paint. Now, using the sponge roller, recoat the surface more quickly this time, since all other colors must be applied while the surface is still wet.

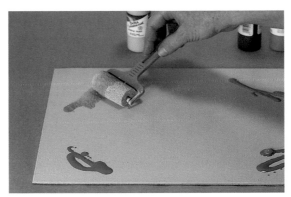

5 Add Shading Color

Now comes the first additions of shading color. Apply two drizzles of Seminole Green on the bottom of the surface, and two matching amounts of Rainforest Green on the upper two corners of the surface. As you get ready to blend, push the roller lengthwise into the Rainforest Green, not across the stripe.

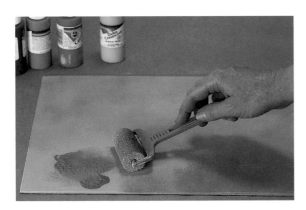

6 Blend

When blending, move the roller around a little, blending the edges of the new color into the background surface. If you feel you can't control the color easily, roll some off onto a paper towel or onto the newspaper. Blend the Rainforest Green into the upper part of the surface, leaving the colors just a little splotchy. Remember, you want that "out-of-focus" effect here. Now roll in the Seminole Green on the bottom of the surface.

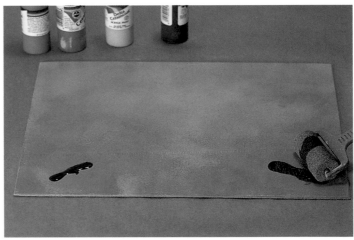

7 Add Dark Color for Depth

Here you see the Seminole Green blended into the background. The drizzles of dark color placed within it in the lower corners of the surface are Gamal Green, a shading color to strengthen the greens and give them more depth. Again, roll into the stripe of color lengthwise, not across it.

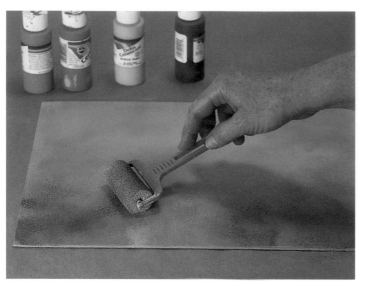

8 Blend Again

The Gamal Green is almost blended now. Try to keep it within the Seminole Green area, since it is the shading color. The darker colors are hardest to control; if needed you can always roll off excess before blending on the line where the greens meet the blue-green background.

Were you able to get the last of the blending done before the basecoat colors dried? If so, that means you had just the right amount of acrylic retarder. If not, use a bit more next time. It is important to finish before the paint begins to dry so that the acrylic has time to "settle" onto the surface, to flatten out. If your backgrounds are too bumpy and they dry too quickly, you can simply use more paint and more retarder—and, of course, work faster!

9 Sand

With retarder, you'll need to wait overnight before sanding. Then sand well until the surface is satin smooth. Resand the edges, too.

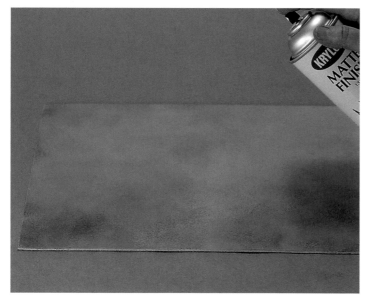

10 Finish

Take the surface out-of-doors, preferably on a windless, warm, sunny day and spray one light, even coat of Krylon Matte Finish #1311. Hold the can about a foot from the surface and begin spraying at the top. Working from side to side, let the spray go off the edge before starting back across in order to prevent build-up. Hold the surface to the light so you can see the spray fall, and move on as you see it beginning to coat the surface. You'll soon learn how much is too little (the oil paints won't blend easily) or too much (the oils slide around too readily). Let the surface dry outside for fifteen minutes before bringing indoors.

TRANSFERRING THE **DESIGN**

BY SHERRY C. NELSON

MATERIALS

SURFACE
Previously prepared background

OTHER
Artist's graphite sheet
Ballpoint pen
Tape
Tracing Paper

Many of the projects in this book provide a line drawing to make it easier for you to begin painting. Because accuracy is so essential to making your animal paintings look realistic, transfer the design from a photocopy of the line drawing, not a traced copy.

If you are unable to make a photocopy of the design, you will have to trace it. Make your tracing as exact a copy as possible; every variation from the line drawing will impact the final appearance of your painting.

Use artist's graphite, sold in large sheets at art supply stores, for transferring the line drawing to the surface. It's important to use graphite that is thinner-soluble, so you can come back later and clean off the excess graphite.

1 Test Transfer Placement

Lay a piece of dark or light graphite, whichever is specified for the project, on top of the prepared background. Lay the line drawing on top of the graphite and position it as you desire. Tape one edge of the line drawing, not the graphite paper, to the painting surface.

Now lay a piece of tracing paper over the design. Make a small mark somewhere on the design and lift the graphite to check that it leaves a mark on the painting surface and not on the back of your line drawing. Now you are ready to make the transfer.

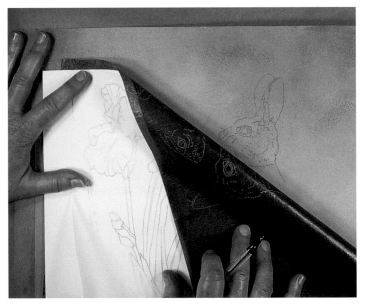

2 Transfer Using a Pen

Use a ballpoint pen; do not use a pencil, which tends to make wider and less accurate lines as the point wears down. Carefully transfer all detail included in the line drawing. Even transfer spots and other pattern areas so they will show through the basecoat later. The tracing paper helps you determine if you have skipped any areas, and it will protect your line drawing for another use. Check the painting surface after you've drawn a few areas. Is the transfer too light or too dark? Adjust the pressure to get it just right.

Acrylic
FUR **FACTS**

Unnatural Looking **More Realistic**

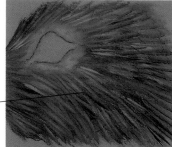 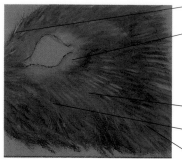

short on forehead

dense around eyes

When hair lengths are the same throughout, the animal looks "fake."

Hair varies in length in different parts of the body.

softer

too consistent

firmer

longer on neck and face

 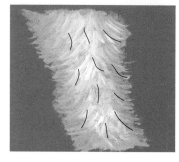

Hairs do not always follow the shape of the body.

In this example the hairs flare out to the side, and may even be perpendicular to the line of the leg.

 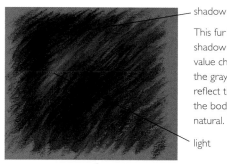

shadow

The hairs may not all be the same color, but the value pattern is the same throughout.

This fur has areas of shadow and light, natural value changes within the gray fur, which reflect the contours of the body. Much more natural.

light

In this sample the hairs are all equally light and lie uniformly over the dark base.

Instead, fur should be painted in layers beginning with the undercoat of dark, then the overcoat of lighter values, and finally the finest and lightest guard hairs.

Hairs here are too repetitive, too uniform, too consistently curved.

Here you can feel a more natural flow and movement to the hairs. Lots of variation.

PAINTING COAT TYPES **STEP** BY **STEP**

	STEP 1	STEP 2	STEP 3

Solid color fur

Apply dark value.

Add lighter values; connect values with blending.

Highlight with lightest values. Add longest guard hairs.

Agouti or "ticked"

Dark pattern of undercoat varies in value.

Light pattern of overcoat varies in value too.

Guard hairs—just a few.

Combination of agouti and solid color

Colors for undercoat separate at first.

Agouti and solid colors connected with short strokes where they meet.

Overcoat of light on agouti, plus a few guard hairs.

Long, loose hairs

Undercoat.

First light value.

Final hair strokes.

Short, straight hair

Undercoat in several colors.

Blend between colors; strengthen dark.

Blend between values; add light guard hairs.

Colored Pencil
COLORED PENCIL **BASICS**

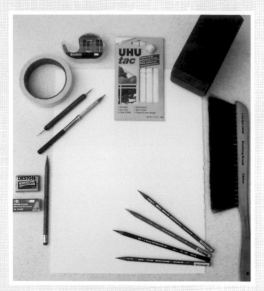

The Essentials
The materials pictured in this photo are my personal preferences. However, there are suitable substitutes available at any good art supply store. Be sure you have some version of the items pictured above, as I believe these are the fundamentals for getting started with colored pencils.

MATERIALS

In addition to a good workplace and an inspiring reference photo, here are some materials and supplies that are necessary for success as a colored pencil artist.

PAPER

Rising Stonehenge is a very good paper which is usually available through art supply catalogs and stores (don't expect to find it in a craft store). The Stonehenge brand works well if you apply a lot of color. It is substantial enough to accept many layers. It has a slight texture, which can be used to create some of the effects in your pieces. You can use the white of the paper to create highlights. You will find it is worth taking the time to seek out a good supplier. If you choose not to use Stonehenge, look for a paper that is pure white, at least two-ply and that has some tooth or texture.

GRAPHITE PENCIL

Keep a no. 2 graphite pencil handy for tracing line drawings and making notes in the margins of your paper. Unlike wax-based pencil lines, graphite lines can be easily removed with a gentle eraser. Don't press too hard when tracing your image or you may create impressed lines.

DRAFTING BRUSH

This is a vital tool to have when working in colored pencil. It is essential to keep your work area and paper clean, so brush often while you work. If you cannot locate a drafting brush, a clean, broad paintbrush will work well; just be sure the bristles are soft and dense enough to brush away all the debris. If the bristles are too rigid or stiff, they could scratch the paper surface.

PENCIL SHARPENER

There are several suitable brands of inexpensive electric pencil sharpeners that are readily available at any office supply store. Battery-powered sharpeners work well if you are at a workshop or away from a power source. Most electric and battery-powered sharpeners are not intended for use with wax-based pencils, but they last long enough to make it worth replacing the sharpener periodically. Clean your pencil sharpener by inserting a graphite pencil occasionally.

PENCILS

Sanford Prismacolor is the brand of pencils used in the colored pencil demonstrations in this book. The waxy, smooth feel when they are applied to paper, and the range of over 120 colors is more than adequate for most needs. That doesn't mean that there aren't other quality brands. There are many good possibilities but the Prismacolor pencils are easily available and affordable. Look for the sets at discount retailers, large office supply stores or even craft stores. Sets are usually the best value, so shop around and purchase the largest set you can afford.

Once you have purchased a set and begun to use it, you may quickly find it necessary to replace frequently used, individual colors. Seek out an art supply store that carries open stock pencils so you can easily replace them as you need. With the growth of Internet art supply sources, more and more online retailers offer a good selection of the Prismacolor brand at competitive prices.

PENCIL EXTENDER

Eventually the pencils will be too short to hold in your hand effectively. Don't throw them away—use a pencil extender. Have a few of them on hand as they will enable you to use the pencil until it is quite a short stub. You will lose control if you attempt to work with too short a pencil, so this tool is a necessity.

ERASERS

A kneaded eraser is another item that is a must when working in colored pencil. Like the pencils, they are widely available and inexpensive. Kneaded erasers are elastic, can be stretched or molded into a ball and work wonders for cleaning the paper as you work. Keep a plain white eraser on your table for erasing graphite lines when necessary.

TAPE

Keep both clear tape and masking tape close at hand at all times and use them in various ways. Use masking tape to anchor your drawing to the table and to lift color when needed. Touching the masking tape gently to an area and slowly lifting allows the removal of color in that specific spot. Repeating this technique as many times as necessary removes quite a bit of color.

Masking tape comes in a variety of widths, making it useful for lifting large areas. Invisible tape is see-through and suitable for lifting small amounts of color. In both cases, be sure to touch the paper gently and lift slowly to avoid tearing.

LIFTING COMPOUNDS

Another ideal method for lifting color is removable adhesive putty. This is widely available at craft or office supply stores; it is inexpensive to purchase and comes under a variety of names. Removable putty is simply a tacky, gum-like material that can be molded into a ball, and when pressed onto the paper, lifts a sub-

stantial amount of color. Repeating the motion gradually lifts off multiple layers of color.

STYLUS

A stylus, or embossing tool, is usually available in the stationery section of your art or craft center. A stylus is ideal for embossing a signature or impressing elements in the portrait, such as whiskers or delicate highlights. By pressing hard into the paper with the stylus, you can create an indentation that will remain white when color is applied. Work carefully around impressed lines, making sure your pencil skips over the indentation as you apply color.

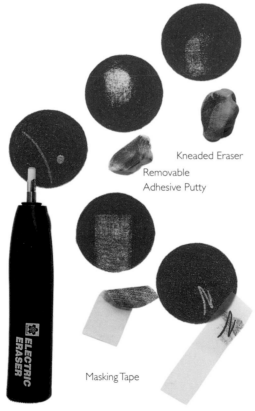

Kneaded Eraser

Removable Adhesive Putty

Masking Tape

Electric Eraser

Invisible Tape

Comparing Color-Lifting Methods
Removing color is sometimes necessary, but care must be employed so the surface of the paper is not torn or damaged in the removal process. This photo compares the results of using a kneaded eraser, masking tape, invisible tape and removable adhesive putty when lifting color. An electric eraser is also excellent for removing small and very specific areas of color.

USE PUTTY TO SAVE HIGHLIGHTS

When lifting color, be aware that you will most likely not be able to take away enough color to get back to pure white paper. If you are concerned that you will inadvertently cover up a highlight and want to be sure to keep that area pure white, use a dab of removable putty to mark where the highlight will be and work around it. When you have finished applying color, just take off the putty and voilà, a nice, clean highlight!

Colored Pencil
POINT, PRESSURE & **SHADING**

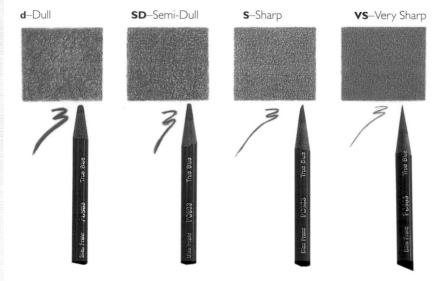

d–Dull **SD**–Semi-Dull **S**–Sharp **VS**–Very Sharp

What's the Point?

In the colored pencil demonstrations in this book, you will see letters referring to the sharp-
ness of point needed, as shown in the illustration above. All four of the boxes were applied
with medium pressure using True Blue with differing sharpness of pencil. Utilize the sharp-
ness of the point to achieve different effects in your work. For example, the box on the far
left illustrates the rough color application you can achieve with a dull point. Create smooth,
even layers by using a needle-sharp point, as shown in the box on the far right.

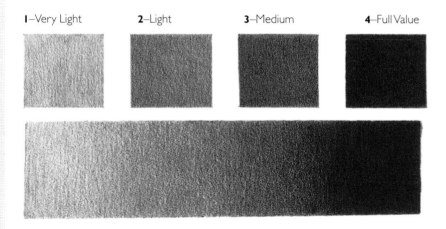

1–Very Light **2**–Light **3**–Medium **4**–Full Value

How Hard to Press

Here you can see how a color changes according to how hard you press. To achieve a whis-
per of color, hold the pencil loosely, barely touching the paper (see the box on the far left).
Medium pressure (the third box) is best described as pressing about as hard as you write
your name. To achieve color as deep as the box on the far right, press as hard as you can—
this application is called applying color full value. Look for numbers 1–4 in the demonstra-
tion charts to tell you how much pressure to use for each step.

Shading—From a Whisper to a Shout

Adjust your pressure to create soft shading and rich darks. Shading gives an object shape
and form. Practice creating shapes by shading with a single color until you feel comfortable
with the process. Shading can be used to create a tonal foundation on which you can build
color.

STROKE

In a colored pencil piece, stroke is just as important as all the other techniques. A stroke is best defined as the method you use to apply color and pertains to the direction and pattern of color application. The richness of the color buildup and the layering of the strokes bring depth and realism to your work. The following list of strokes are effective in rendering animal characteristics, but they are not the last word when applying color to your piece. If you find a way to apply color that feels comfortable to you, by all means use it!

Learn the Language
These strokes are the foundation for all the illustrations in this book.
Practice them before you continue.

TURN THE PAPER AS YOU WORK

If you are having difficulty using a certain stroke, or it feels uncomfortable, try turning the paper as you work. This is especially useful if you are trying to get the stroke pattern to move in a specific direction. You will find it helpful to turn your reference photo to match your artwork.

Vertical Line–VL
Vertical strokes placed side by side can be layered to achieve coverage. The length of stroke varies depending on the size of area that needs to be covered.

Circular–C
Move the pencil in an overlapping, circular pattern. The smaller and tighter the circles, the smoother the coverage.

Stipple–ST
Dab the pencil point on the paper to create short, choppy strokes. The closer the stipples, the more coverage, but the pattern should be obvious. Avoid pounding the pencil, which creates impressed dimples.

Loose Scribble–LS
Open, loose, back-and-forth strokes, that can change direction. This stroke creates a furlike appearance when layered. Strokes can also overlap, making for more complete coverage.

Linear–L
Medium to long strokes that follow the shape of the object they are portraying.

Crosshatch–X
Diagonal strokes, crisscrossing each other. Layer them to achieve quick, even coverage for a background.

Colored Pencil
COLORED PENCIL **TERMS**

Now that you have explored some of the basic techniques that will help you along the way, let's discuss a few more colored pencil terms.

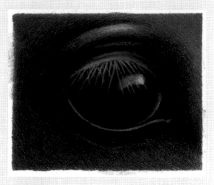

Burnish–B

See how reflections and eyelashes were created on this equine eye. Lighter colors are burnished on top of several dark layers. Black Grape, Indigo Blue and Black combine to create the foundation of the eyeball, then the shape and feature of the eye is enhanced by applying White and Deco Blue on top.

(Even though burnishing isn't a stroke, to simplify, it has been included with the *strokes* in the step-by-step graphs in the colored pencil demonstrations in this book.)

WASH

A wash is an even layer of color applied to an area to create a basecoat. It will often have succeeding layers of color applied to it. Washes can be applied with a light touch or full value as shown below. They can be the foundation of a shape or just used to fill in an area that needs no more attention.

BURNISHING

Burnishing is a technique in which several layers of darker-value colors are first heavily applied, then a lighter-value color is pressed onto this basecoat.

Create a solid base on which to add a lighter color by pressing hard enough to create a smooth, waxy surface without any paper surface showing through. Burnishing is an excellent technique for producing fine details or effects such as reflections, shine and moistness.

A Wash Can Be Delicate

First, apply Cream using a light touch and a circular stroke, followed by a wash of Deco Yellow and Chartreuse. This creates a delicate foundation that might be used as the base for a luminous eye.

A Wash Can Be Bold

Begin all three blocks with Peacock Green, then add a layer of Tuscan Red to the second and third blocks. Finally, add a layer of Indigo Blue to the third block. This example is bold and dark and can be used as a background. It is easy to see how much a wash can differ. These examples demonstrate the smoothness and consistency of layering.

LAYERING

So far you have discovered techniques that allow you to build color through the use of pressure and stroke, and how to adjust texture using the sharpness of your pencil point. Now you will learn how layering achieves richness by adding multiple colors on top of one another. Layering is just as important for creating depth in your work as are other techniques. It differs somewhat from pressure and point because you must choose color combinations to help you achieve the results you are striving for.

There are many colors available in any colored pencil palette and the color-blending possibilities are endless.

Always apply at least three layers of color to give depth to your work. Take the time to experiment with the different colors and you will discover many out-of-the-ordinary, attention-grabbing combinations, which may become your favorites.

When layering with colored pencils, keep in mind that the colors are translucent, which means the underlying colors show through. The beauty of layering is in the wonderful mix of colors and how they combine when placed one on top of the other. The waxiness of the pencils also allows you to actually mix the colors with your pencil point, creating an impressionist-like effect.

MODELING

Modeling refers to the process of creating shapes by layering and shading. Layering and modeling combine to help create shape or model an object.

HIGHLIGHT

Whenever the term *highlight* is used it will refer to an area of paper left free of color in order to give the effect that light is hitting that area directly. Highlights are crucial when creating the effect of light bathing the subject or touches of light striking it in certain spots. Highlights are very effective in making dramatic statements and giving excitement to your piece. You can maximize the highlight by always working on clean, pure white paper.

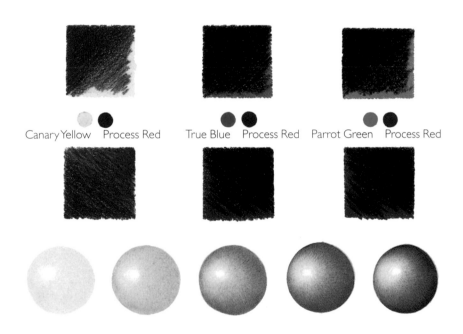

Canary Yellow Process Red True Blue Process Red Parrot Green Process Red

Translucent Layers Transform Colors

Colors change depending on how they are combined. The underlying wash shows through in all the samples at left, demonstrating how semitransparent colors can be altered through layering. In this book, we will build color using only dry, wax-based pencils. Since the pigment is never liquefied, the layers remain translucent. If you have a problem with overlayering, or if you are unhappy with a combination, try adding another color—it will be transformed!

Layering, Modeling and Highlight Come Together

In this demonstration the shape of the sphere gradually appears as layering and modeling techniques are used. The highlight is left free of color throughout the process, eventually becoming the strongest point of the light source. The edges of the ball darken as they move into shadow. The first step is a wash of Cream, then each step adds a layer of color: Jasmine, Goldenrod, Terra Cotta and finally Tuscan Red and Dark Umber. Create the delicate buildup of color with the combination of a very sharp pencil point and a linear stroke.

REMEMBER YOUR COMBINATIONS

Leave a border around your image so you can make notes, or keep some small swatches of your paper near your drawing table. This will allow you to note the color number, name and a sample of the combination you have discovered. Keep the swatches in a folder or transfer them to a chart so you can refer to them later. The more sophisticated and complex your colors become, the more rich and exciting your piece will be.

Pastel
PASTEL **BASICS**

It is a great time to try pastels for your first experience or go back to pastels if you have been away from them for a while. There are now more options for a pastel artist than ever before, thanks to a resurgence of interest in this wonderful medium.

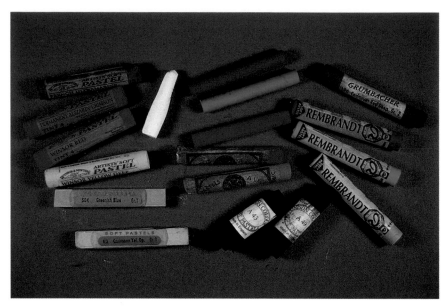

Soft Pastels
This is a grouping of the pastels you can use to start and build paintings. The white pastel is homemade.

Hard Pastels and Pencils
This is a grouping of the pastels you can use for detailed finish work.

EXPRESSIVE MEDIUM

Even a little eighteen-stick starter set of Grumbacher pastels will allow you to express realness.

WHAT ARE PASTELS?

Pastels are the most permanent of all art mediums because there are no liquid binders that might cause them to darken, fade, yellow, crack or blister with time. There are pastel paintings that were created in the sixteenth century, and their colors are still as bright and vivid as the day they were painted.

The name "pastel" comes from the French word *pastiche* that describes how pure, powdered pigment is ground into a paste with a small amount of gum binder and then rolled into sticks. With a small amount of research you can even learn to make your own pastels.

SOFT PASTELS

Soft pastels can be used alone or in combination with many other mediums. They can also be used on many different surfaces as long as enough tooth (see page 10) exists or is created to help them adhere permanently to the surface. Remember, a pastel stick becomes powdered pigment again as soon as you rub it on something. The binder is simply there to give us a means of shaping it into a stick so we can use it.

Girault pastels have strong browns and earth tones, their greens are good, and they have some really nice blues. These are a nice medium-soft grade that goes onto velour paper nicely. To paint animals you need sets strong in browns and grays.

Sennelier from France makes a lustrous set of pastels that are generally quite soft and quite expensive. Most of them are generally a bit too soft for velour paper.

Grumbacher and **Rembrandt** are harder than some of the others but are nice to have. They have a good range of grays.

Unison is a newer brand of pastels that is very popular with pastel artists. They are soft with some wonderful blue-greens that are hard to come by.

Daler-Rowney and **Winsor & Newton** make whole sets of soft pastels, too. There is a new company called **Great American Art Works**, and a company in Australia produces some nice sets called **Art Spectrum.**

HARD PASTELS

If you love detail then you'll want to use a lot of hard pastels for the finish work in your paintings. Hard pastels come in sticks, or encased in wood as pastel pencils.

Prismacolor's NuPastel is a very good brand. They have a range of almost one-hundred different colors and can be sharpened for detail without breaking.

Conté also has a set of smaller, hard pastels and **Derwent** makes a wonderful set of pastels. These are both great pastels to work with for very fine details.

Pastel
PASTEL **PAPER**

We're going to talk here about three different types of paper, but there are many different options, and you are encouraged to experiment.

VELOUR PAPER
Velour paper that can be bought at most art supply stores and through mail-order catalogs. It is quite delicate to work on, have framed and shipped. But the softness and reality that it brings to living subjects is beautiful. With Velour paper you can achieve more layers of pastel and finer detail.

Velour paper is wonderful, but every wonderful thing has a downside. The difficult thing about this paper is that you really can't erase on it. That simply means that you do all your sketches and planning on another piece of paper that is more forgiving and then transfer it to the velour. You can use carbon paper or artist's transfer paper.

SANDPAPER
Another paper you can use is a fine-grade sandpaper, which can be bought in most art supply stores and through mail-order catalogs. Sandpaper is fun to work on because it "grabs" the particles of pastel and hangs on to them!

PASTEL CARD
Another paper to try is pastel card. It's a little less grainy than sandpaper yet still has a lot of tooth. It doesn't "eat" as much pastel as sandpaper and is fun and quick to work on, but it will not allow you to achieve the same amount of detail as you can on velour paper.

CAN YOU "FIX" PASTEL PAINTINGS?

Spraying fixative on your pastel dulls the color and detail. If you do your paintings on velour paper, the pastel sinks down into the nap of the paper and won't fall off like it can on other papers.

However, always be careful not to drop your paintings. Dropping a painting causes the pastel to fall from the paper's nap, and will damage your painting.

Varied Effects
Hard and soft pastels look quite different depending on the paper on which they are applied. The sample at the top shows pastel applied on sandpaper. The sample below shows pastel applied on velour paper. (The thinner lines are made with hard pastels; the wider lines are made with soft pastels.)

OTHER **TOOLS**

SHARPENERS

To sharpen your hard pastels, use sand-paper blocks, which you can buy at art supply stores, or mount a piece of sand-paper from a hardware store on a piece of wood. This way, you have four sharp edges. You can sharpen your pastel pencils to a point for your fine lines and detail.

RAZOR BLADES

It's easier on your pastel pencils and your time to sharpen them with a razor blade. You will jam up your pencil sharpener if you try to sharpen pastel pencils because they are too soft and break off inside the sharpener. I got tired of dismantling my electric pencil sharpener to fix the loose pastel gumming it up.

BLOWER BRUSH

The blower brush is used to blow loose pastel off of different parts of your painting, usually in its initial stages. Always blow the dust away from you as you work.

BLACK CONSTRUCTION PAPER

When working with pastels, it is important to protect your work as you go. To avoid smudging, place a piece of black construction paper over the areas of your painting that are already started. (Black paper will not cause a glare from your lights and will be easier on your eyes.)

MASKING TAPE

I use masking tape to position protective paper in different places over and around the painting I'm working on.

Necessities
Sandpaper blocks, blower brush, razor blades, masking tape and black paper.

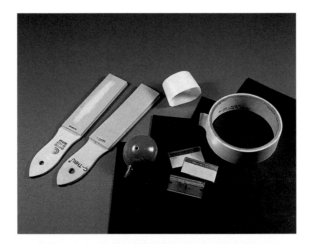

Painting in Process
Use black paper to protect your art as you work.

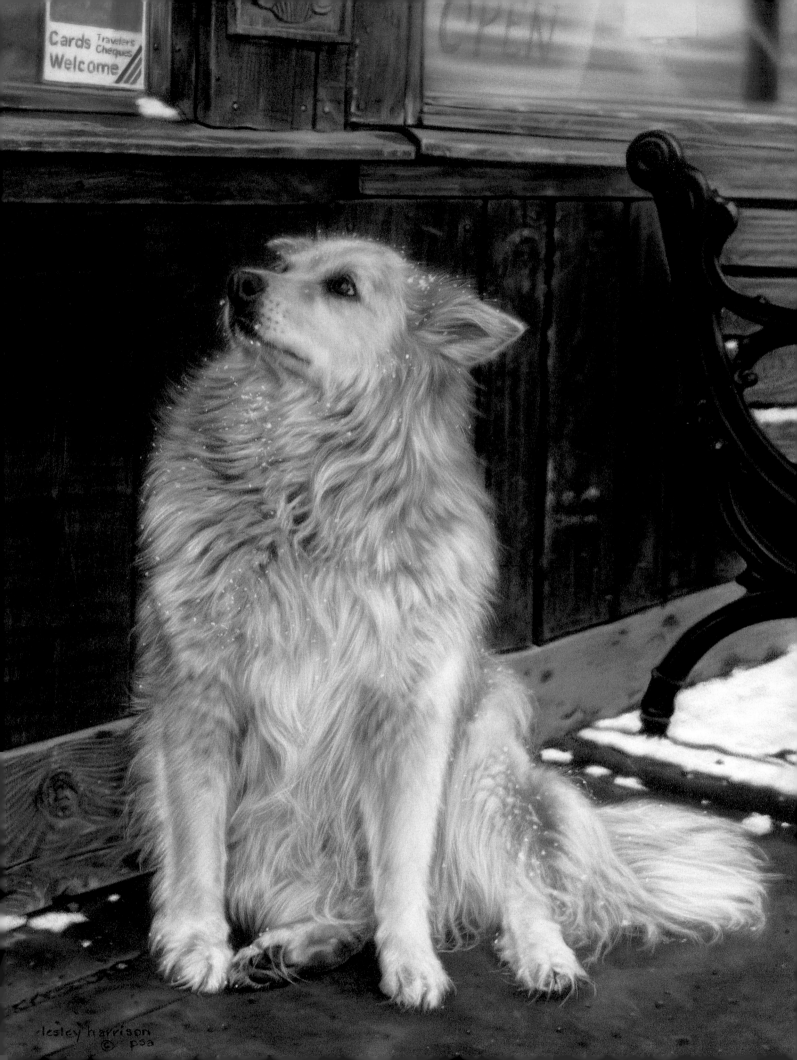

Chapter TWO | Dogs and Cats

There are very few households that don't have at least one dog or cat. We grow up learning about animal love, loyalty and companionship from the family dog or cat. There would be so much lacking in our lives without their unquestioning love and devotion, emotions that we often wish we could receive from the humans in our lives. Their loyalty is unconditional and can be an oasis when we need relief from the pressures of everyday life.

Because we are around them all the time, dogs and cats are natural for us to paint and it is great fun to learn to portray them in different ways and poses. Most of us have a perfect model sleeping on the couch right now or waiting for us to take them for a walk.

No Dogs Allowed
Lesley Harrison
Pastel on velour paper
20" × 16" (51cm × 41cm)
Private collection

Drawing
PAWS AND **CLAWS**

The cat's front foot consists of four toes and a dew claw resting in the position of the thumb. All five digits have retractable claws. The hind foot has four toes but no dew claw.

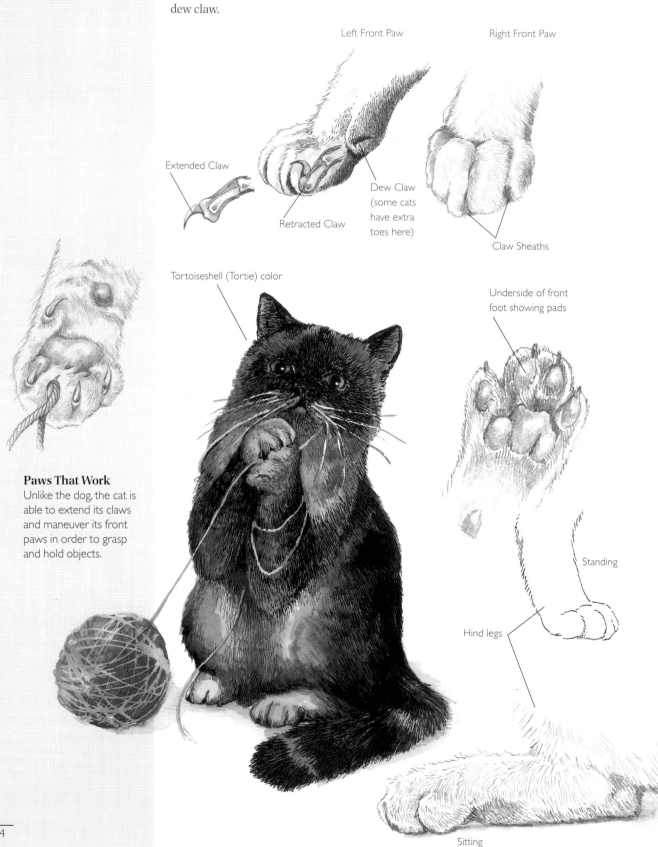

Left Front Paw

Right Front Paw

Extended Claw

Dew Claw
(some cats have extra toes here)

Retracted Claw

Claw Sheaths

Tortoiseshell (Tortie) color

Underside of front foot showing pads

Paws That Work
Unlike the dog, the cat is able to extend its claws and maneuver its front paws in order to grasp and hold objects.

Standing

Hind legs

Sitting

HAIR DIRECTION

The hair on the cat's face flares outward from around the eyes and the sides of the nose, and flows towards the ear tips, paws and tail. The hair on the bridge of the nose is very short. It stands upright like velvet or grows down toward the nose tip. The little squiggles and sketches here are only suggestions ... do what you like!

Short Hair on the Bridge of the Nose
This area of very short hair forms an inverted V where it meets the hair growing away from the eyes.

Ways to a Fair Likeness
Short crisscross lines were used to duplicate the hair. The whiskers and ear hairs were masked out before painting using a Masquepen that easily delivers masking fluid in thick or thin, curving or straight lines.

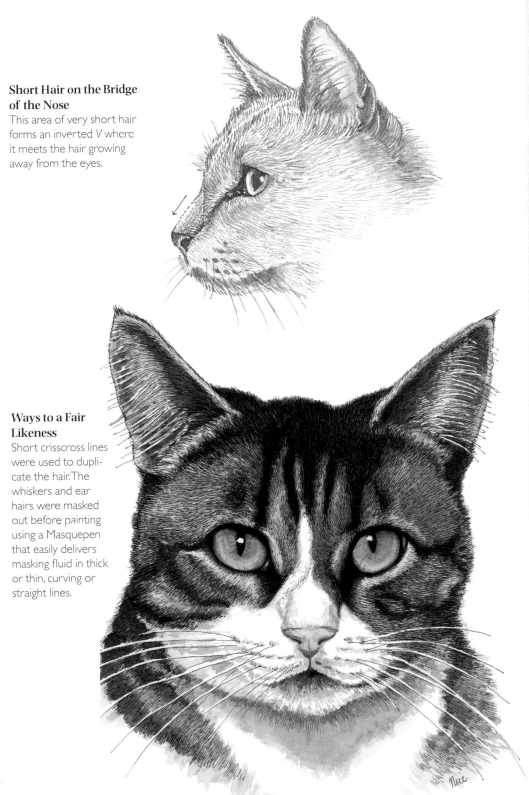

Drawing
PEN AND INK DRAWING
DEMONSTRATION

BY CATHY JOHNSON

Start where you are most comfortable, work from either left to right or right to left when working with ink. Play with your pen to see what kinds of strokes work best for fur; try repeated strokes or zigzags in combination. Some people use the pointillist technique called stippling, making thousands of tiny dots to build up form, detail and volume. That requires a great deal of time and patience so this demonstration uses a more linear technique that works well for beginners and old hands alike.

MATERIALS

SURFACE
Vellum 2-ply paper

PENS
Micron Pigma .01, .03 and .05

OTHER
No. 2 pencil

Thumbnail Sketch
Do a tiny preliminary sketch to decide where you want to place the darkest darks and lightest lights. It's easier to do this in pencil than pen and ink. Keep it quite small, no larger than 2" × 2" (5cm × 5cm). It's a good tool for planning.

1 Create Pencil Sketch
Pick your subject and make a rough pencil sketch of your composition. You can use a less expensive paper for the sketch, if you want, or do it right on the paper you plan to use as the final ink drawing. This planning stage can be as rough or as complete as you like; since you'll draw over and then erase the pencil guidelines, you may choose to make them very simple.

It's possible simply to start drawing in ink right on your art paper, with no pencil guidelines at all. If you're confident enough, go for it!

TRANSFERRING A DRAWING

There are a number of ways of transferring a sketch. You can use a light box or simply hold the two layers up to a window. Taping the two sheets of paper together ensures that they won't slip out of register.

2 Finalize Sketch and Begin Drawing

Unless you want to jump right in with the ink, now is the time to place the bones of your image with pencil. Make any necessary corrections before you add ink. It's a lot easier to erase a light pencil line than it is to fix ink!

When you begin inking, build up your textures, forms and values first. Use expressive lines, hatching or crosshatching where needed. Switch to a larger pen, such as a .03 Pigma Micron, here and there to add a bit of variety, but use it sparingly. See it used on the left side of the forms to emphasize shadows.

Add interest by spacing your lines closely for the darkest areas, and crosshatching the midtones. Remember, a wide variety of values adds interest, but allow one value to dominate. Use these tricks to suggest volume as well as value.

Let some of your strokes follow the the direction of hair, particularly if the animal has stripes or spots you want to suggest.

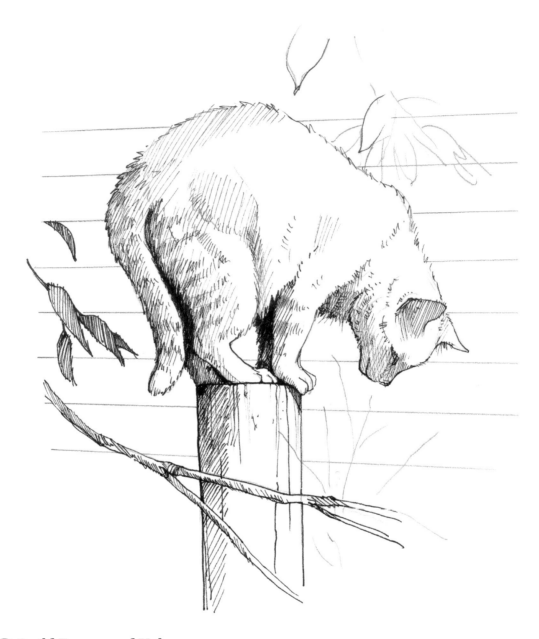

3 Build Forms and Values

Keep building forms and values, adding as many details as you like. Give yourself some loose guidelines here for leaves, weeds and siding.

DEPTH IN YOUR DRAWING

Overlapping forms can give your drawing depth. Here, the foreground limb appears to be in front of the fence post, the dark leaves and siding behind the cat.

Stroke Swatch

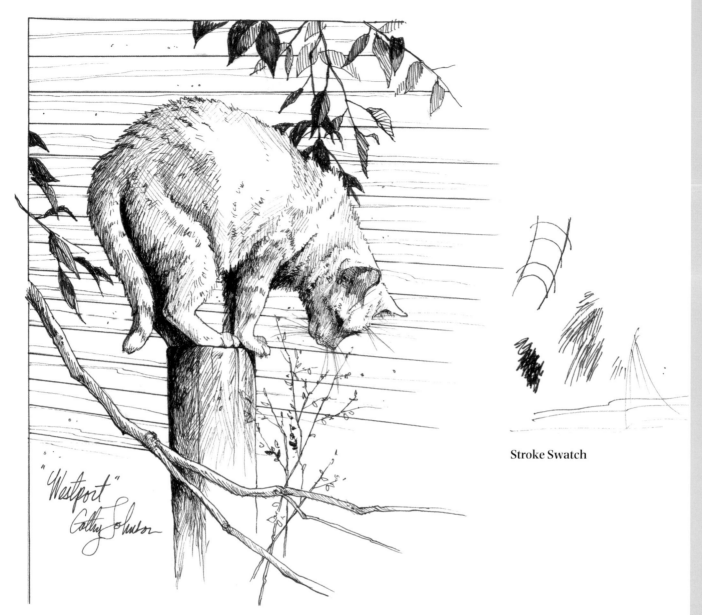

Westport Preparing to Leap
Cathy Johnson
Pen and ink on vellum
8" × 5½" (20cm × 14cm)

Stroke Swatch

PROTECT THE PAPER FROM SKIN OILS

If you're working on a fairly detailed ink drawing that will take a while to complete, place a sheet of clean paper under your drawing hand to keep the oils from your skin (or hand lotion) from sullying the paper. Ink may not take evenly on paper that has absorbed some oil.

4 Finalize Details

Notice how the shadowy stripes on the cat's tail, foreleg and back follow the roundness of the body. These have been simplified in the sketch. Use zigzag or repeated parallel strokes to suggest the characteristics of this fur.

The darkest darks can be added more easily with a thicker pen, such as the Pigma Micron .03 or .05. Switching to a different type of pen, or a brush and ink, would be faster, but it would change the quality and color of the drawing slightly. This is fine for photo reproduction, but not so good for a drawing you might want to frame. Closely repeat lines or simply scribble on the left side of the fence post.

If you have a slightly dried-out .01 pen, you can use it for finer, more delicate details such as the whiskers and grain line in the wood siding.

Drawing
TIGER HEAD AND FACE
DEMONSTRATION

BY DOUG LINDSTRAND

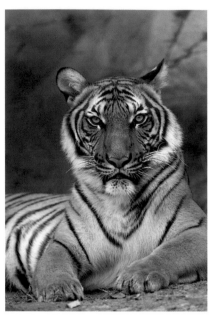

Indochinese Tiger

The face is the most interesting part of an animal, so it's important to draw it as accurately as possible. Cat faces have a very circular shape. Using intersecting guidelines will help you place the facial features accurately. Once you've established the basic shapes and spacing, you can add the details.

MATERIALS

SURFACE
Drawing paper of choice

PENCILS
HB Charcoal
HB Graphite

OTHER
Kneaded Eraser
Sharpener

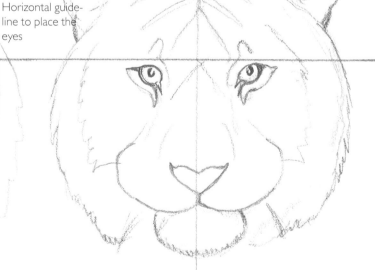

Vertical guideline to place the nose and mouth

Horizontal guideline to place the eyes

1 Draw the Basic Shapes
Draw a circle for the head, then draw intersecting guidelines to help you place the ears, muzzle, nose and mouth.

2 Begin to Define the Features
Position the eyes, ears, nose and mouth on the circles you established. At this point you should also begin to map out the placement of some of the stripes and the direction of the fur.

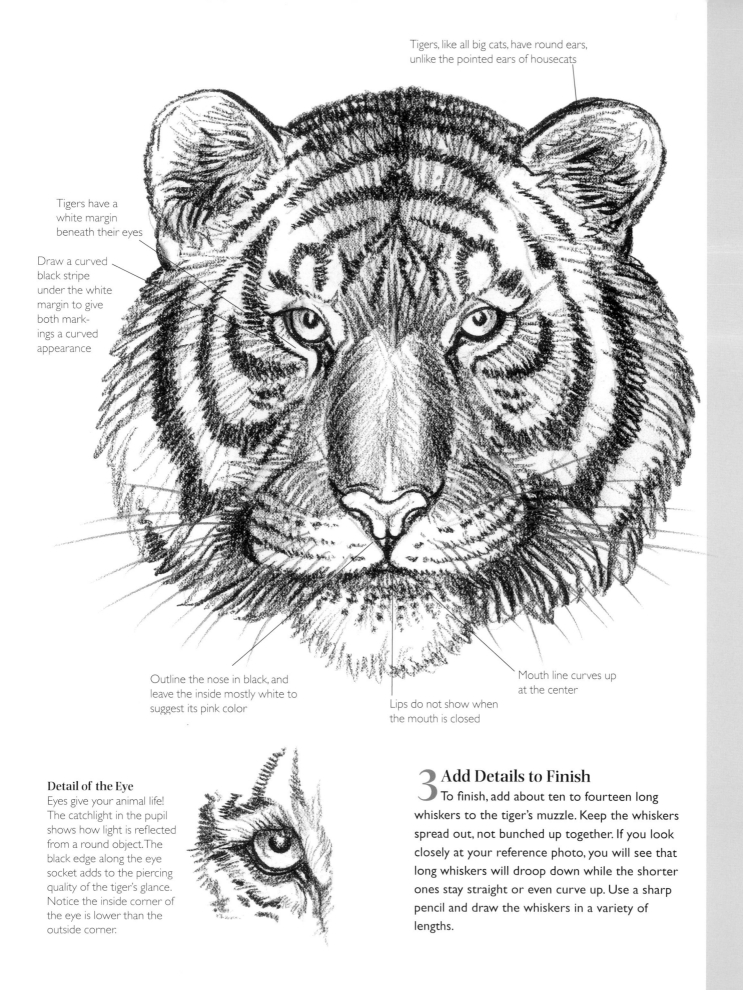

Tigers, like all big cats, have round ears, unlike the pointed ears of housecats

Tigers have a white margin beneath their eyes

Draw a curved black stripe under the white margin to give both markings a curved appearance

Outline the nose in black, and leave the inside mostly white to suggest its pink color

Lips do not show when the mouth is closed

Mouth line curves up at the center

Detail of the Eye
Eyes give your animal life! The catchlight in the pupil shows how light is reflected from a round object. The black edge along the eye socket adds to the piercing quality of the tiger's glance. Notice the inside corner of the eye is lower than the outside corner.

3 Add Details to Finish
To finish, add about ten to fourteen long whiskers to the tiger's muzzle. Keep the whiskers spread out, not bunched up together. If you look closely at your reference photo, you will see that long whiskers will droop down while the shorter ones stay straight or even curve up. Use a sharp pencil and draw the whiskers in a variety of lengths.

Colored Pencil
TABBY **CAT**
DEMONSTRATION

BY ANNE deMILLE FLOOD

The fur of this tabby is both complex and multifaceted. You'll be challenged to create the complex pattern with many layers of color. As you build color, be sure that your strokes are loose and open, creating the choppy pattern that is typical of tabby fur. Make the dark markings in the face dramatic and distinct by using full-value colors. The forceful gaze of the eyes is a delightful opportunity for you to create intensity through the use of finely applied layers, highlights and delicate modeling of the eye.

The background is out of focus and darkened near the top of the picture, giving you the chance to nicely frame the sunlit ears, and the grass in the foreground is a pleasant setting for this dramatic kitty.

MATERIALS

SURFACE

One piece Rising Stonehenge paper

PRISMACOLOR PENCILS

Apple Green
Black
Black Grape
Blue Slate
Blush Pink
Chartreuse
Cream
Dark Green
Dark Umber
Deco Blue
French Grey 10%
French Grey 30%
Goldenrod
Greyed Lavender
Henna
Indigo Blue
Jade Green
Jasmine
Light Umber
Peach
Peacock Green
Sepia
Slate Grey
Tuscan Red
White

OTHER

Drafting Brush
Kneaded eraser
No. 2 pencil
Stylus or embossing tool
White Stabilo pencil

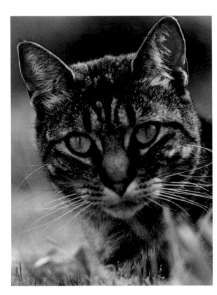

Tabby Cat Reference Photo

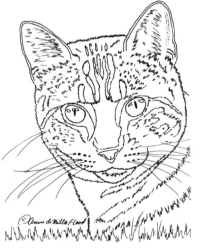

Tabby Cat Line Drawing

Before you begin, enlarge the line drawing to the size that you would like the finished piece to be. Then transfer the line drawing by gently tracing the image onto the Stonehenge paper with a no. 2 pencil. Impress the whiskers and your signature with an embossing tool. Erase the graphite whisker lines, then blot the entire line drawing with a kneaded eraser. Sweep the paper with a drafting brush and you are ready to begin applying color.

POINT		PRESSURE		STROKE	
D–Dull	**SD**–Semi-dull	**I**–Very Light	**2**–Light	**V**–Vertical Line	**X**–Crosshatch
S–Sharp	**VS**–Very Sharp	**3**–Medium	**4**–Full Value	**C**–Circular	**B**–Burnish
				ST–Stipple	**LS**–Loose Scribble
				L–Linear	

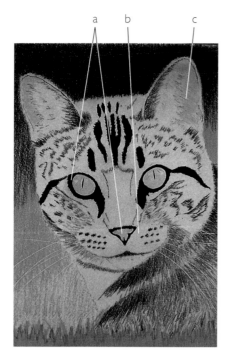
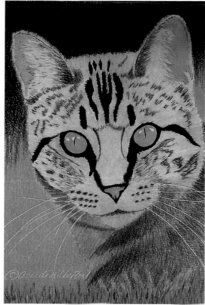
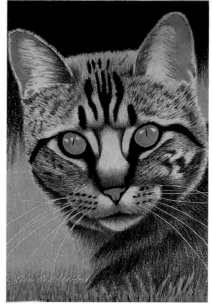

1 Frame the Eyes and Establish Markings

	Point	Pressure	Stroke
Chartreuse	S	3-4	V

Cover the entire background with Chartreuse using varying pressure.

	Point	Pressure	Stroke
Indigo Blue	S	4	V

Apply Indigo Blue to the upper part of the background framing the ears.

	Point	Pressure	Stroke
Chartreuse	SD	4	L

Begin establishing the grass pattern.

	Point	Pressure	Stroke
Cream	VS	3	C

Gently and evenly wash the entire iris with Cream. Leave the highlights free of color.

	Point	Pressure	Stroke
Black Grape	S	4	L

Outline the eyes and fill in the pupil. Thicken the outline as shown (a) and extend into the tear zone.

	Point	Pressure	Stroke
Black	S	3-4	LS

Establish the markings in the fur, mimicking the stroke direction of the reference photo. Differentiate between the darkest and the midvalue markings by using pressure.

	Point	Pressure	Stroke
Black Grape	S	4	L

Outline the edges of the nose and fill in the nostrils.

	Point	Pressure	Stroke
Cream	S	3	V

Cover the end of the nose (b) with Cream.

	Point	Pressure	Stroke
Cream	S	3	L

Begin establishing the fleshy part of the ears (c) with Cream. Do not work into the area where there is fur.

2 Layering to Build Color

Tuscan Red	SD	4	V

Layer Tuscan Red over Indigo Blue at the top of the picture. Make it dark where it frames the ears.

Jasmine	SD	4	V

Layer Jasmine over Chartreuse in the midtone area of the background.

Dark Umber	SD	3-4	L

Begin establishing a pattern in the grass with Dark Umber (just the dark shapes).

Jasmine	VS	3	C

Wash the iris with Jasmine.

Dark Umber	S	4	L

Fill in the pupil, tear zone and the rim around the eye with Dark Umber.

French Grey 10%	S	3	LS

Apply to the entire head of the cat.

French Grey 30%	S	3	LS

Apply to the chest and body. Begin establishing the pattern of the fur by using a directional scribble stroke.

Cream	S	3	V

Layer Cream on the end of the nose.

Jasmine	S	3	L

Continue to build the fleshy area inside the ears with Jasmine.

French Grey 10%	S	3	L

Use French Grey 10% to establish the fur pattern inside the ears.

3 Developing the Patterns

Do nothing to the background for this step.

Light Umber	SD	3-4	L

Continue to build the grass pattern with Light Umber.

Jade Green	VS	3	C

Wash the entire iris of both eyes with Jade Green. This is your last layer of foundation, so make it smooth and even.

Light Umber	S	3-4	LS

Look carefully at the reference photo; begin building the fur pattern on the head and body. Be sure your stroke mimics the direction of the fur as shown in the photo. It should be loose and open where necessary and more dense where the fur is in shadow.

Peach, Blush Pink	S	3	V

Wash the end of the nose with Peach and Blush Pink.

Peach, Blush Pink	S	3	L

Layer Peach and Blush Pink inside the fleshy area of the ears.

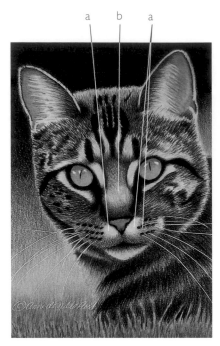

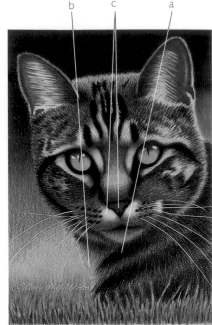

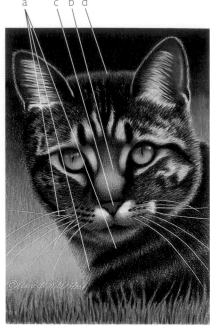

4 The Pattern Takes Shape

Peacock Green S 3-4 V
Wash the entire background with Peacock Green. Use heavy pressure near the top surrounding the ears.

Goldenrod SD 3-4 L
Continue building the pattern in the grass with Goldenrod.

Goldenrod VS 2-3 C
Begin modeling the shape of the eyes. Be sure to accentuate the shadow area under the upper eyelid.

Sepia S 3-4 LS
Continue to build the pattern throughout the head and body with Sepia.

Goldenrod S 3 V
Wash the end of the nose with Goldenrod.

Sepia S 3-4 V
Build up the sides and top (a) of the nose with Sepia.

Sepia S 3-4 ST
Stipple the bridge of the nose—between the eyes (b).

Goldenrod S 3 L
Layer Goldenrod over the fleshy area inside of the ears.

Sepia S 3 L
Continue to build the fur pattern inside the ears.

5 The Eyes Take Shape

Chartreuse S 4 V
Press hard with Chartreuse and blend the midtone and dark area of the background together.

Dark Umber S 3-4 L
Continue to add details to the grass by defining the dark shapes between the blades of grass with Dark Umber.

Dark Umber, Tuscan Red VS 3 C
Continue modeling the shape of the eye with Dark Umber and Tuscan Red; designate shadows and form the shape of the eye. Don't lose the highlight!

Black S 4 L
Apply Black to the pupil and the rim surrounding the eyes.

Light Umber, French Grey 30% S 3-4 LS
Work Light Umber and French Grey 30% into midtone areas of the fur; darken areas that are in shadow, such as the chin (a) and chest (b).

Henna S 3 V
Cover the end of the nose with Henna.

Dark Umber S 3 V
Work Dark Umber into the nostrils and around the sides of the nose. Apply to the top (c) of the nose.

Henna S 3 L
Add Henna to the fleshy area inside of the ears.

6 Bringing It All Together

Apple Green S 4 L
Use Apple Green to finish the grass pattern.

Dark Green VS 3-4 C
Keep modeling the shape of the eyes and strengthening the shadow areas with Dark Green.

Deco Blue S 3 L
Use Deco Blue to add some color to the highlights.

Black S 3-4 LS
Use Black to finish the fur pattern over the entire cat. Apply fine Black hairs overlapping the background. Be sure to get those facial patterns dark and dramatic.

Slate Grey S 3-4 LS
Use Slate Grey to add to the shadow areas of the fur such as under the chin, on the chest and the side of the face (a).

Black S 4 L
Use Black to finish off darkening the areas of the nose such as the nostrils and sides of the nose.

Black S 4 ST
Stipple between the eyes (b).

French Grey 30% S 3 C
Apply French Grey 30% to the bridge of the nose (c); the circular stroke will give it a soft appearance.

White, Slate Grey SD 4 B
Burnish with both colors along the top edge of the head where it meets the background (d).

Tuscan Red, Dark Umber S 3-4 L
Apply Tuscan Red and Dark Umber to darken the fleshy area inside the ears.

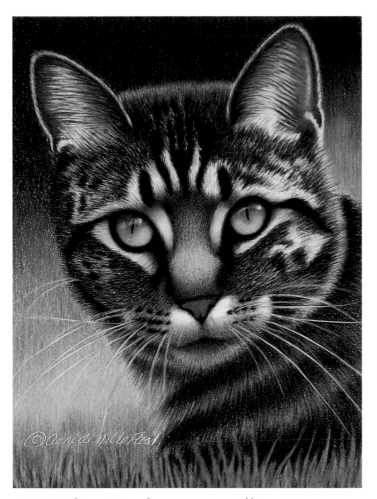

7 Finishing Touches

The grass and the background are now complete.

White VS 4 B
Delicately burnish the Deco Blue highlights on the eyes with White. Be sure a small amount of white paper is still showing.

White S 4 B
Add details to the fur by burnishing white hairs on the dark pattern where necessary.

Blue Slate S 4 B
Add some color to the lighter areas of the fur that are in shadow with Slate Blue.

White Stabilo S 4 B
pencil
Use the White Stabilo pencil to add some additional whiskers by burnishing long whiskers onto the picture where desired.

Greyed Lavender, VS 4 B
Deco Blue
Create reflections in the impressed line whiskers by adding some Deco Blue and Greyed Lavender to the indentations.

Nikki
Anne deMille Flood
Colored Pencil on Paper
14" × 11" (36cm × 28cm)
Collection of Kathy Knierien

Acrylic
DOMESTIC **SHORTHAIR**
DEMONSTRATION

BY JEANNE FILLER SCOTT

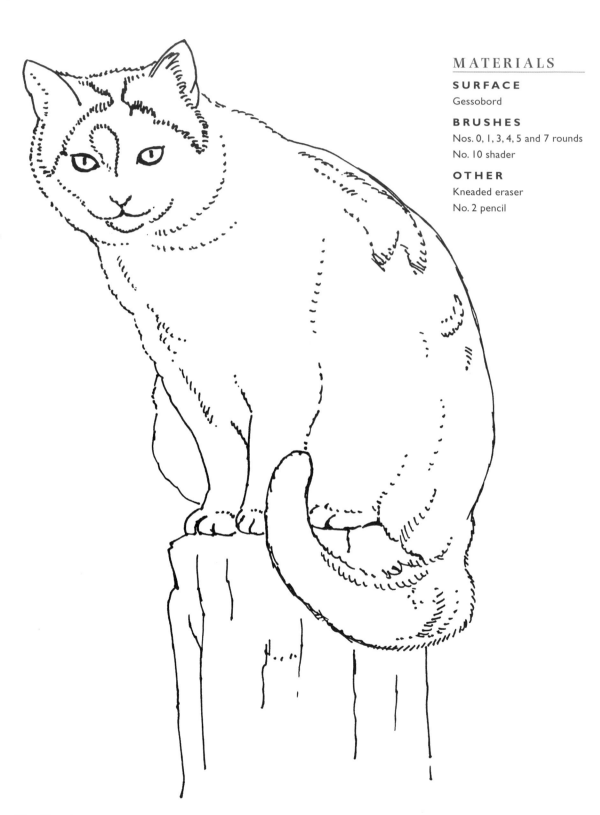

MATERIALS

SURFACE
Gessobord

BRUSHES
Nos. 0, 1, 3, 4, 5 and 7 rounds
No. 10 shader

OTHER
Kneaded eraser
No. 2 pencil

Line Drawing

Pigments

Payne's Gray

Burnt Umber

Ultramarine Blue

Burnt Sienna

Cadmium Orange

Permanent Hooker's Green

Titanium White

Raw Sienna

Scarlet Red

Yellow Oxide

Cadmium Yellow Light

Mixtures

black

bluish shadow

ginger color

warm shadow

pink

yellowish eye color

detail for black

shadow between the front legs

grayish color

detail black part of the tail

nose and muzzle

dark green

weathered gray

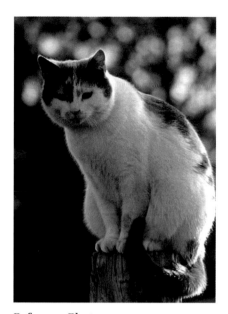

Reference Photo
Hazel showed up fifteen years ago, apparently homeless. It seems a previous owner had decided to make her an outdoor cat so she must have gone shopping for a new home.

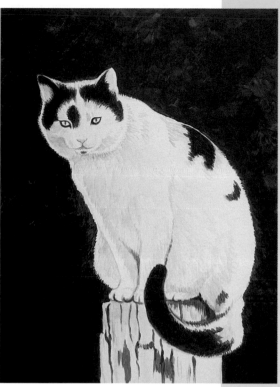

1 Establish the Form and the Dark Values

Lightly draw the cat and fence post in pencil. Use a kneaded eraser to lighten any lines that come out too dark. With a no. 5 round and Payne's Gray thinned with water, establish the main lights and darks. For broad areas, use a no. 7 round.

For the black coat color, mix Burnt Umber and Ultramarine Blue. With a no. 3 round, paint the black parts of the cat's coat. Use a no. I round for the outline of the eyes. As the paint dries, add more layers until the dark areas are dense.

FOR THE BACKGROUND

Mix a dark green with Permanent Hooker's Green, Burnt Umber, Cadmium Orange and Ultramarine Blue. Paint with a no. 10 shader, using a no. 4 round to paint around the cat's outline.

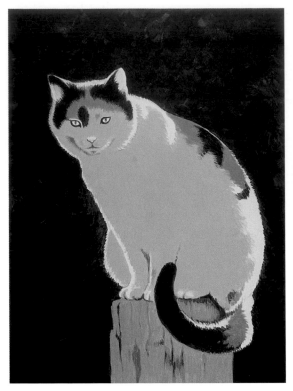

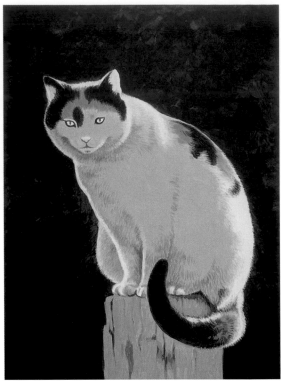

2 Paint the Middle Value Colors

Mix a bluish shadow color for the cat's coat with Titanium White, Ultramarine Blue and Burnt Sienna. First, define the nose and muzzle using a no. 3 round and a mixture created with a small portion of the bluish shadow color and Cadmium Orange, Burnt Sienna and Burnt Umber. Then, paint the shadowed areas with the bluish shadow color and a no. 7 round, using brushstrokes that follow the hair pattern. For smaller areas, such as the cat's face, use a no. 3 round. When dry, add another coat for good coverage.

Mix a ginger color for the coat with Titanium White, Raw Sienna and Cadmium Orange. Paint with a no. 3 round.

3 Paint the Outline and Begin Detailing the Coat

Paint the white highlighted outline of the cat with Titanium White and a no. 3 round, following the contours with your brush. Use a separate no. 3 round with the neighboring color to blend where the white meets the other color.

For the warm shadow color in the cat's coat, mix Titanium White, Ultramarine Blue, Burnt Umber and Burnt Sienna. Paint with a no. 3 round, using parallel strokes that follow the hair pattern. Blend the edges with a separate no. 3 round and the bluish shadow color.

BE PATIENT WITH WHITE

You don't want the white to become overly diluted, so wait to squeeze a small blob of Titanium White onto your palette until immediately prior to use. This will give you a thicker white that will handle and cover better.

FOR THE FENCE POST

Mix together Titanium White, Ultramarine Blue, Burnt Sienna and Burnt Umber. Paint the fence post with vertical strokes.

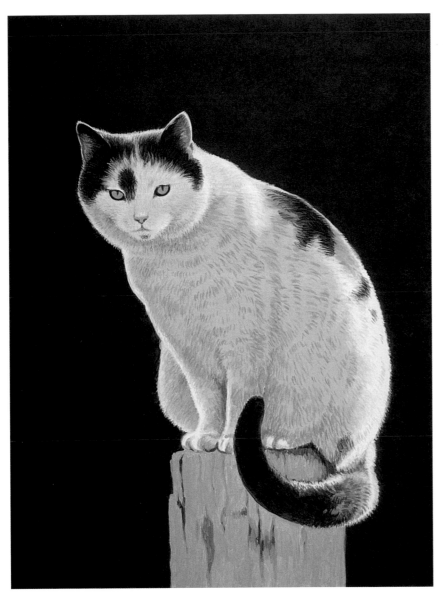

4 Add Detail to the Cat

Mix a pink color for the nose and inside the ears with Titanium White, Scarlet Red, Cadmium Orange and Burnt Umber. Paint with a no. 1 round. Paint the highlighted outline of the ears and top of the head with Titanium White and a no. 1 round. Use separate no. 1 rounds to blend the white with the adjacent black and ginger.

Mix a yellowish eye color with Titanium White, Yellow Oxide, Ultramarine Blue and a touch of Cadmium Orange. Paint with a no. 1 round. Reestablish the pupils and adjust the eye shape as needed with a no. 1 round and the black.

With a no. 1 round and Titanium White, add fur detail to the face. For detail in the black fur areas, use a no. 1 round to mix some of bluish shadow color with the black on your palette. Paint strokes sparingly over the black fur. Reestablish any places that become too light with the black and a no. 1 round.

Tone down and soften the warm shadow fur detail using a no. 1 round and the bluish shadow color.

PAINTING WHISKERS

To achieve control of your brush when painting the whiskers, first dip it in the paint, then press down so the brush is flat (not pointed). Rest your hand on the dry surface of the painting, then paint the whiskers.

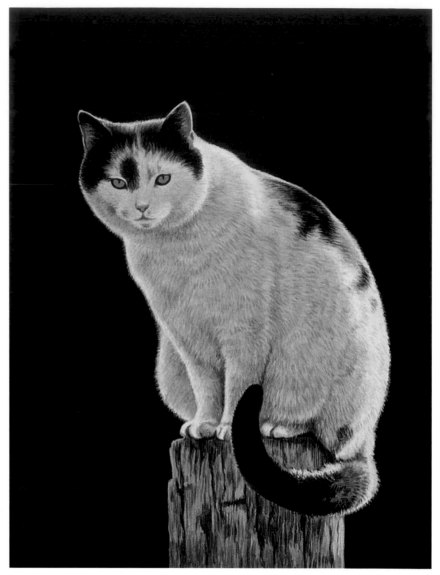

5 Add Detail to the Fur and Fence Post

Use a no. 1 round and Titanium White to add fur detail to the tail, the shadowed areas of the coat and around the cat's outline. Correct the outer contours as needed with a separate no. 1 round and the dark green background color. Tone down any white brushstrokes that are too prominent with a no. 3 round and some of the bluish shadow color.

Darken the shadow between the front legs and under the feet with a no. 1 round and some of the black mixed with some of the bluish shadow color.

Add detail to the fence post by painting roughly vertical cracks with a no. 3 round and the black. Add lighter tones with a no. 3 round and some of the bluish shadow color, using the same vertical strokes. Use a semi-dry-brush technique with a no. 3 round to tone down. Add detail with a grayish color made from the black and bluish shadow colors.

At this point, paint another layer of the dark green over the background for even coverage.

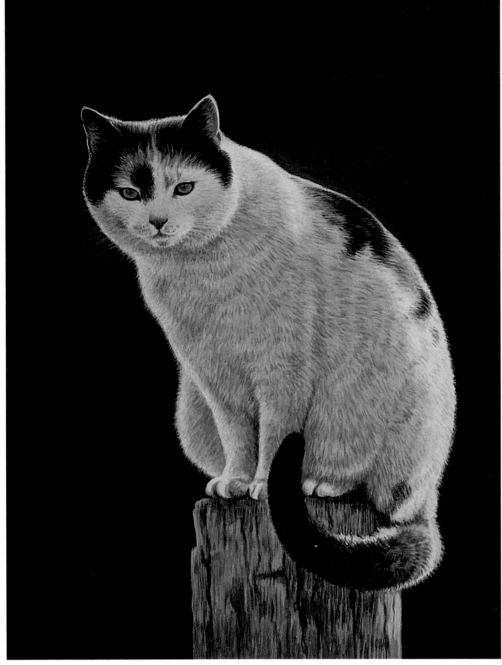

Hazel
Jeanne Filler Scott
Acrylic on Gessobord
12" × 9" (30cm × 23cm)

6 Add Finishing Details

Paint detail in the black part of the tail with a no. 1 round and a bit of the bluish shadow color mixed with Burnt Umber. Blend with a separate no. 1 round and the black, using the same brush and color to "fuzz" the edges of the tail.

Use a no. 1 round and a small amount of Burnt Umber thinned with water to paint a circular wash around the pupils in the eyes, blending the edges to avoid a sharp line. Paint horizontal, slightly curved arcs for highlights in the eyes with a no. 1 round and the bluish shadow color. Reestablish the pupils as needed.

Paint a thin wash of Burnt Umber with a no. 3 round over the cat's nose and the ginger-colored fur on the head.

Paint the whiskers with a no. 0 round. Use the bluish shadow color for the whiskers on the right side of the face (overlapping the background) and for above the eyes. Use Titanium White for the whiskers on the opposite side of the face. Paint with curving, light-pressured strokes.

If any whiskers come out too thick or stand out too much, use a separate no. 0 round to correct them with the color beneath the whiskers.

Acrylic
SIAMESE
DEMONSTRATION

BY JEANNE FILLER SCOTT

Line Drawing

SURFACE
Gessobord

BRUSHES
Nos. 3 and 5 rounds

OTHER
Kneaded Eraser
Pencil

Pigments	Mixtures
Burnt Umber	dark brown
Ultramarine Blue	buff
Raw Sienna	blue eyes
Titanium White	gray

 shadow line on the cat's neck

slightly more shadowed part

 highlight for dark brown fur

 fur detail around eyes

 dusty bluish color

white part of the eye

bluish highlight

 whiskers

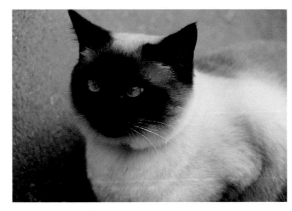

Reference Photo
Siamese cats are beautiful with their dark masks and sapphire blue eyes. This cat's name is Sassy.

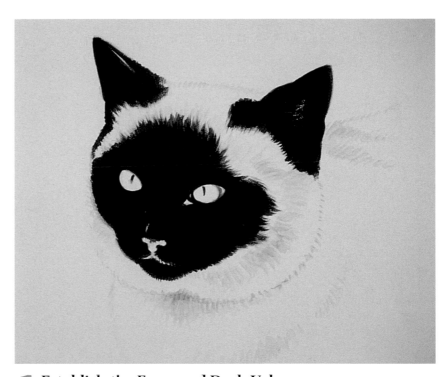

1 Establish the Form and Dark Values

With your pencil, lightly sketch the cat onto the panel, using a kneaded eraser to lighten lines or make corrections. With Burnt Umber thinned with water and a no. 3 round, paint the eyes and nose, then use a no. 5 round for the broader areas.

Mix a dark brown for the cat's face and ears with Burnt Umber and Ultramarine Blue. Paint with a no. 5 round, switching to a no. 3 round around the eyes and nose. Use brushstrokes that follow the hair pattern. As the first layer of paint dries, add another coat for a good, dark coverage.

2 Paint the Middle Values

Mix the buff color for the cat's coat with Titanium White and Raw Sienna. Paint strokes that follow the hair growth pattern with a no. 5 round.

For the blue eyes, mix Ultramarine Blue and Titanium White. Paint with a no. 3 round. Use a separate no. 3 round and the dark brown from 1 to reinforce the eyes' shape as needed.

Mix a gray for the nose and muzzle with Titanium White, Ultramarine Blue and a small amount of Burnt Umber. Paint with a no. 3 round.

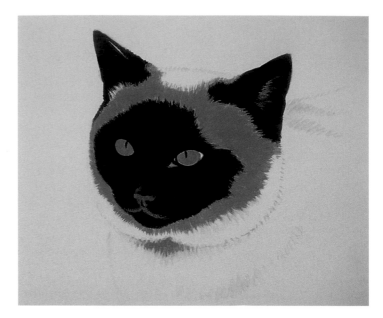

3 Begin Adding Detail

Begin to add detail to the cat's fur with a no. 5 round and the dark brown from 1. Mix the dark brown with enough water to make it flow smoothly.

Mix some of the gray from 2 with some Titanium White. Use this color and a no. 5 round to paint a shadow line on the cat's neck with parallel strokes.

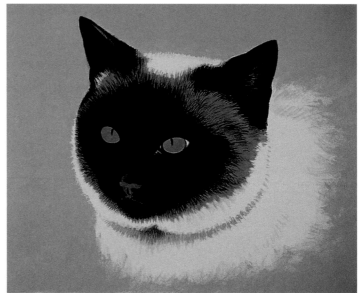

4 Paint the Light Values and Add Detail

Mix a cream color for the fur with Titanium White and a small amount of Raw Sienna. For the slightly more shadowed part, mix Titanium White with small amounts of Raw Sienna and Ultramarine Blue. Follow the pattern of the fur with parallel brushstrokes and a no. 5 round. Switch to a no. 3 round for smaller details. With a separate no. 3 round and the buff from 2, blend where the two colors meet. Use a no. 5 round to paint the light colored fur against the background.

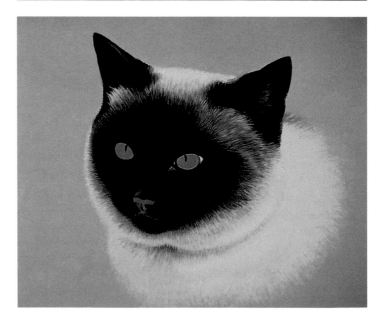

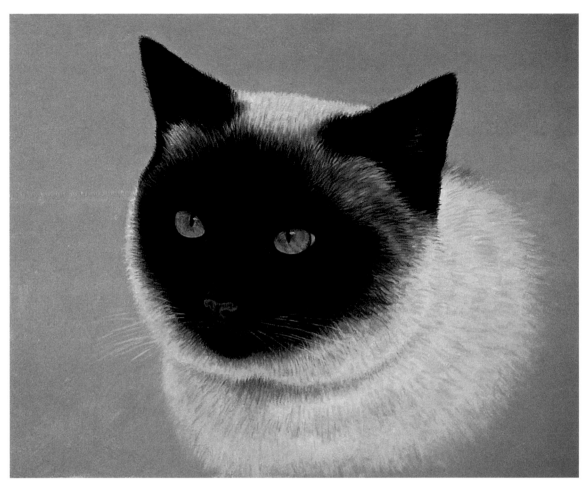

5 Add the Finishing Details

To highlight the dark brown fur, mix Burnt Umber, Ultramarine Blue and a small amount of Titanium White. Paint with a no. 3 round, using parallel strokes that follow the fur pattern. Also use this color to detail the cat's irises; paint small, parallel strokes that follow the curvature of the eye with a no. 3 round. Soften these lines with a no. 3 round and the blue eye color. Add detail to the nose with the same color and brush.

Take a portion of the buff color and mix it with a little Burnt Umber, then detail the fur around the eyes, on the muzzle and on the ears with a no. 3 round. Use a separate no. 3 round to lightly drybrush the dark brown along the edges, blending to create a soft look. Use the same brush and color to soften the edges of the cat's mask where it meets the buff.

For the shadows on the lighter fur, create a dusty bluish color. Mix Titanium White with touches of Raw Sienna and Ultramarine Blue. Paint with a no. 5 round. Mix a bit of Titanium White with a touch of Ultramarine Blue to paint highlights in the eyes. Mix this bluish highlight color with a touch of Burnt Umber to paint the white part of the left eye. Paint with a no. 3 round, blending the edges with a separate no. 3 round and the neighboring color.

To soften the ears against the background, use a no. 3 round and the dark brown to paint small, thin strokes around the edges of the ears. Use just enough water so the paint flows. Mix a color for the whiskers with a portion of the cream and a touch of Ultramarine Blue. With a no. 3 round and just enough water for the paint to flow, lightly paint slightly curved strokes.

Sassy
Jeanne Filler Scott
Acrylic on Gessobord
8" × 10" (20cm × 25cm)

PRACTICE MORE DELICATE BRUSHSTROKES

To get the feel of the kind of delicate brushstrokes you'll need for the whiskers, first practice a few strokes on a piece of scrap board. This will help to give you the skill and confidence to paint the whiskers.

Watercolor
CHINESE CAT
DEMONSTRATION

BY LIAN QUAN ZHEN

From this detail-style demonstration you will learn to paint animal hair. Unlike spontaneous style—where you paint fast and apply a minimum number of strokes—in detail style you paint slowly and apply many layers of colors. The mature Shuan paper is made for taking layers of colors without letting the colors become muddy. Even if you paint up to nine layers of color, the painting still looks spectacular.

MATERIALS

SURFACE
16" × 12" (41cm × 30cm)
mature Shuan paper

BRUSHES
Small hard fur
Medium and large soft fur

CHINESE PAINTS
Carmine
Indigo
Ink
White
Yellow

OTHER
Drafting tape
Ink Pen
Paper towels
Pencil
Tracing paper

1 Trace Composition

Use a pencil to sketch the composition on a 16" × 12" (41cm × 30cm) piece of tracing paper. Then use an ink pen to outline the objects, making them darker. The darker outlines allow you to see the composition through the mature Shuan paper, when you create the first outline in the next step.

2 Transfer the Composition

Lay the mature Shuan paper on top of the tracing paper and secure them with drafting tape on one edge. Wet the small brush a little and dilute the ink to create a midtone. Before applying strokes, dab the small brush on a paper towel to blot excess water and ink. Carefully outline the images starting from the cat's head. For the eyes, paws and rocks use darker ink.

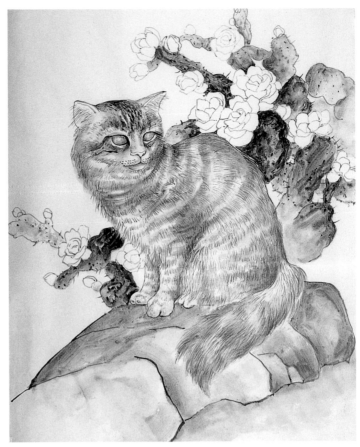

3 Tone the Cat

Use two brushes to tone the objects with ink: the medium brush for blending and the small brush for applying ink. First lightly wet the area you want to tone; If you get water bubbles, you have used too much water. Apply ink to the wet area. This process is like toning in a pencil sketch.

4 Capture the Cat's Spirit

Add more details to the head with a larger variety of ink tones than to the other parts of the animal because the head is important in capturing the cat's spirit.

Toning Methods for Detail-Style Paintings

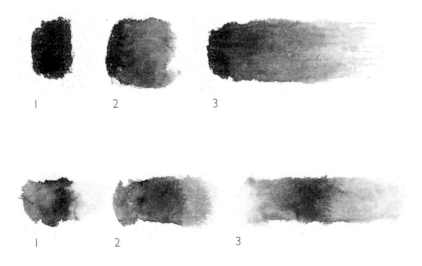

Method 1: Wet-On-Dry

1. Use one brush to apply ink.
2. Dip another brush in a little water. Touch the middle of the stroke and blend it toward the right. Do not start from the left edge of the stroke or you get even blending without the gradient effect
3. Continue using the wetted brush to blend the ink toward the right side more to get the gradient from dark ink to white.

Method 2: Wet-In-Wet

1. Wet the toning area. Pick up ink with another brush and dab it in the wetted area.
2. With the brush you used for wetting the paper, start pushing the ink from the edges of the center out to both sides.
3. Drag the ink farther from the right edge of the stroke toward the right; from the left side edge of the stroke toward the left to create the gradient effect. Do not drag the ink from the center or you get even ink tone without the gradient effect.

5 Form the Cacti
Wet the cacti with a medium brush until you start to get bubbles; then add dark ink. It blends into the water creating a nice texture. When the ink is about 70 percent dry, paint the needles with the small brush and dark ink. The dark ink of the needles slightly blends into the lighter ink of the cacti suggesting that they are attached.

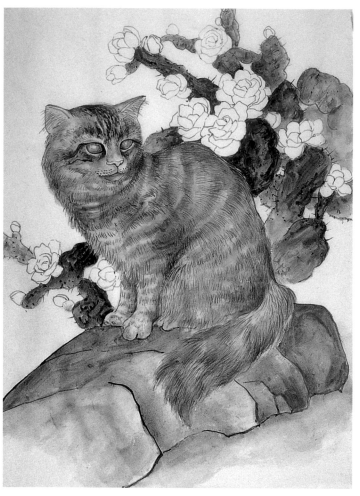

6 Lay in the First Layer of Color
After the ink dries use the medium brush to apply Yellow on the cactus bodies, Carmine on the cat and Indigo on the rocks. It is important not to apply a thick layer of color at the beginning because detail-style paintings need multiple layers of color—sometimes up to nine layers—to achieve their beautiful effect. This is much different from watercolor, as well as spontaneous style in Chinese painting.

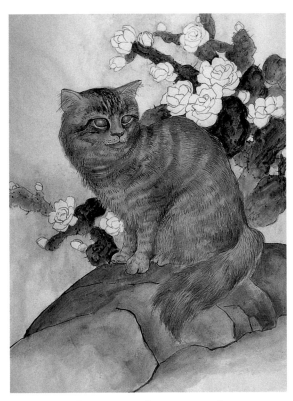

7 Add the Second Layer Colors

After the first layer colors dry, apply a second layer of colors. Paint a thin layer of Yellow where the cat meets the rocks. Apply a thin layer of Indigo on the cacti and around the flowers. Painting the background around the flowers causes them to stand out.

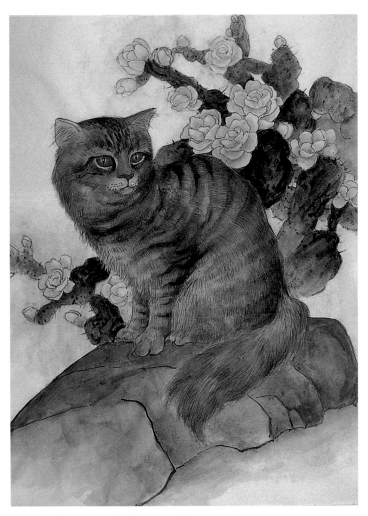

8 Add More Color and Tones

Let the second layer of colors dry, then apply a third layer. Paint Carmine on the body of the cat. Paint its eyes with Yellow and Carmine, adding dark ink to the pupils, leaving white spots as highlights. Add Carmine to its nose.

Next, add one thin layer of Carmine on the rock with the large brush. Paint a thin layer of Yellow for the flower. Use the small and medium brushes to tone the petals with Carmine at the beginning and Yellow from the middle to the tip. Tone a few petals each time to gracefully blend the colors.

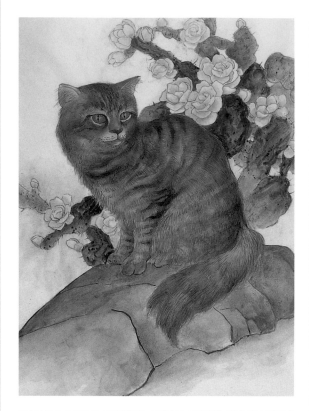

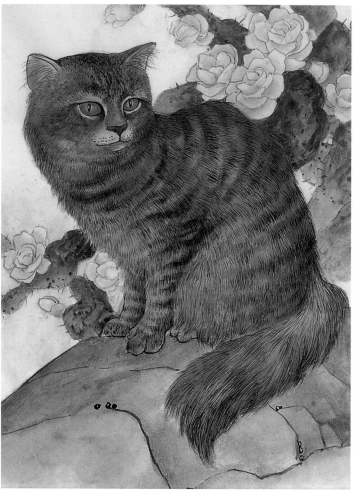

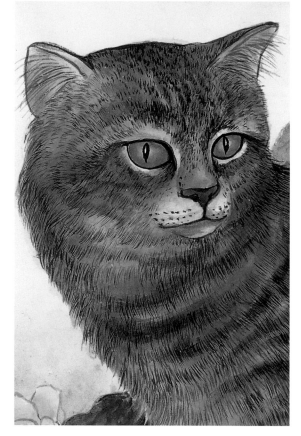

9 Add More Color and Detail

Apply the last layer of Carmine on the cat to finish his color. When the Carmine is dry, use the small brush to detail the individual hairs. For dark-colored areas such as the stripes, use dark ink. On the light areas, such as the spaces between the stripes, use Carmine mixed with a little ink. Paint more details for the head.

10 Highlight the Hair

Load the tip of the small brush with White. Paint one stroke for each whisker and hair on the head and body. Mix the White with a little Carmine to paint the pinkish colored hair. Let dry.

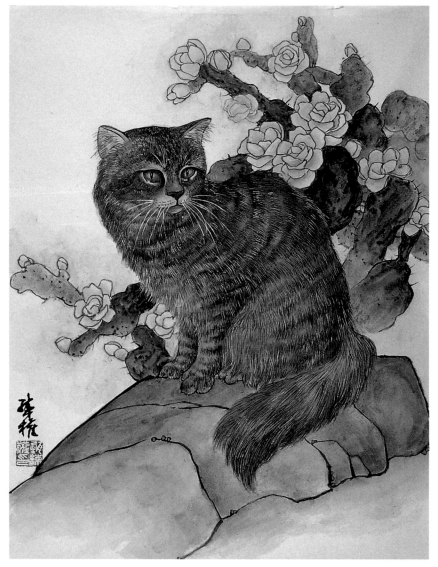

11 Add the Final Outline

You are creating this outline because the original outline is covered by multiple layers of color. The second outline is darker than the first one. Use a dark value of Carmine (mix Carmine with ink) for outlining the cat and dark value of Indigo (mix Indigo with ink) for the cacti.

Cat
Lian Quan Zhen
Chinese ink and colors on
mature Shuan paper
16" × 12" (41cm × 30cm)

Drawing
BASIC DOG **SHAPE**

Even though these two hounds vary greatly in looks, especially in the length of their legs, they share the same basic structure.

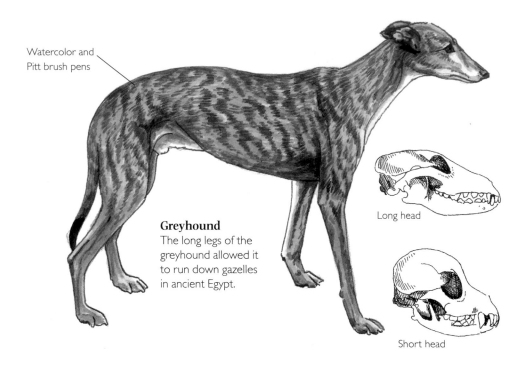

Watercolor and Pitt brush pens

Greyhound
The long legs of the greyhound allowed it to run down gazelles in ancient Egypt.

Long head

Short head

Dachshund
The short legs of the dachshund made it useful for hunting badgers in their dens.

Contour and parallel lines work well to depict hair seen at a distance.

Simple shapes to form a short head.

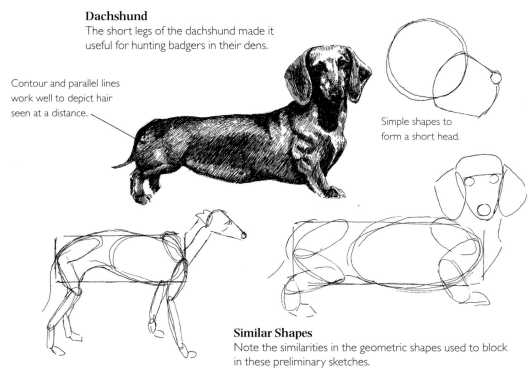

Similar Shapes
Note the similarities in the geometric shapes used to block in these preliminary sketches.

Below are three typical canine poses. The easiest one to draw is the standing position, where the dog is broadside to the viewer, because there are few fore-shortened areas. However, other poses are sometimes more interesting.

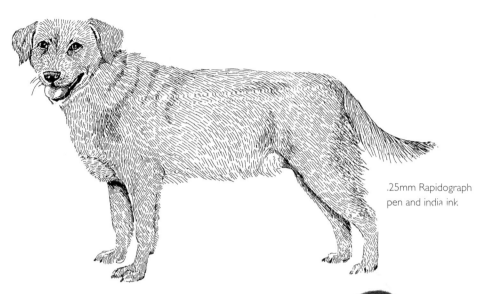

.25mm Rapidograph pen and india ink

Hair Direction—Contour Lines and Brushstrokes
Most of the time hair strokes are drawn only as long as the hairs would actually appear to the viewer at the distance they are being seen. When the subject is too far away to see individual hairs, the coat is suggested with contour lines or brushstrokes that flow in the direction of the hair. The hairs on the ink drawing above have been exaggerated to show the hair growth pattern.

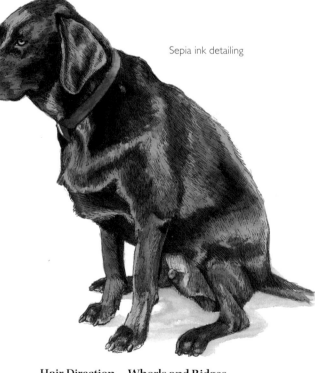

Sepia ink detailing

Watercolor sketch

Hair Direction—Whorls and Ridges
The hair on a dog encircles the nose, growing outward in all directions towards the chest, back legs and tail. There are areas near the eyes, on the chest, on the rump and on the belly where the hair collides, forming whorls and ridges on short-haired dogs.

Drawing
THE **EARS**

Besides providing acute hearing, the ears are a main source of body language communication.

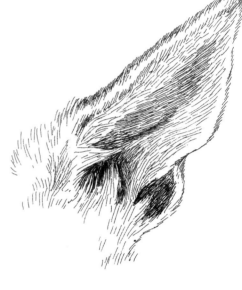

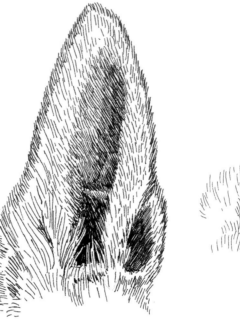

Happy Ears
A happy, excited or attentive dog will perk his upright ears forward in a fully raised position.

Careful Ears
When playing, howling, running, showing submission or uncertainty, the dog will lower his ears to keep them out of the way.

FLAT EARS

When the ears are flattened tight to the head the dog is feeling fear or apprehension.

Use watercolor glazes of Burnt Umber mixed with Dioxazine Purple to create the brown coat in this painting. It was applied with nos. 2 and 4 round detail brushes.

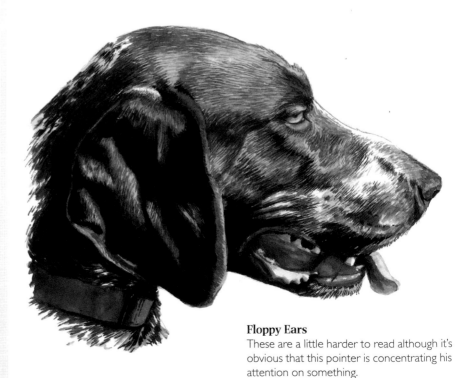

Floppy Ears
These are a little harder to read although it's obvious that this pointer is concentrating his attention on something.

PAWS

Animal feet are one the most interesting parts to depict. Allow yourself to become familiar with their shape and you'll eventually stop hiding them in the grass.

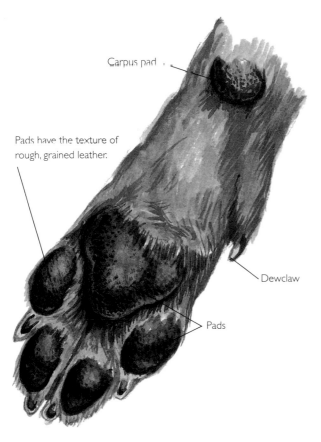

Carpus pad

Pads have the texture of rough, grained leather.

Dewclaw

Pads

Left Front Foot

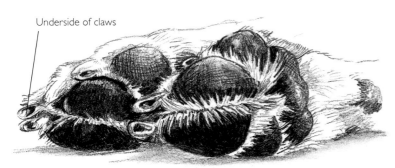

Underside of claws

Front Foot Reclining

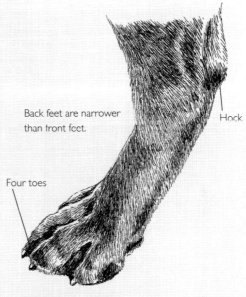

Back feet are narrower than front feet.

Hock

Four toes

Left Hind Lower Leg

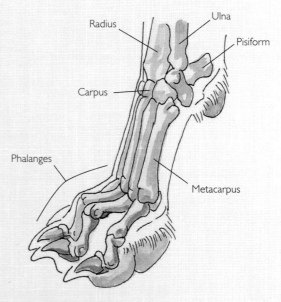

Radius

Ulna

Pisiform

Carpus

Phalanges

Metacarpus

Left Front Foot

Acrylic
MOUNTAIN CUR
DEMONSTRATION

BY CATHY JOHNSON

Acrylics offer some wonderfully versatile painting opportunities. Acrylic is a thicker medium than watercolor and it has a wider range of opaque and transparent pigments. Also, it isn't necessary to plan every detail or painstakingly draw your sketch onto the canvas; you can adjust as you go along.

Textures, mood, atmosphere—all contribute to the final painting. For this painting, pay attention to suggested details as well as carefully delineated ones.

MATERIALS

SURFACE
Canvas-textured paper

BRUSHES
¾-inch (19mm) flat brush
No. 2 round
No. 5 round

PIGMENTS
Burnt Sienna
Hooker's Green
Ivory Black
Naples Yellow Hue
Payne's Gray
Phthalo Blue
Raw Sienna
Sap Green
Titanium White
Ultramarine Blue

OTHER
Gloss medium (optional)
Masking tape

Reference Photo
You can mix and match your subject from a variety of resources—photos, sketches, direct observation—and change things as needed. In this detail, you can see that the beautiful Sarah's eye caught the light of the flash. Work around it. Also, you have to add her nose, but that won't be difficult.

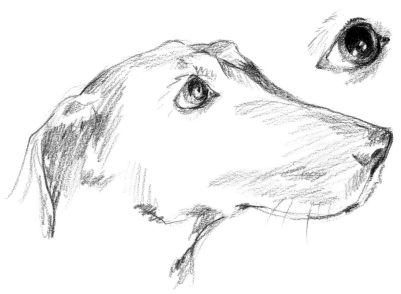

1 Sketch Your Composition

Sketch your subject first to make sure of your composition and the accuracy of your observation. Pay attention to the relationship between eyes, cheek and nose. If needed, zero in on a detail you want to explore, such as that no-longer-green eye. (Omit the yellow cat's tail below Sarah's mouth, too.)

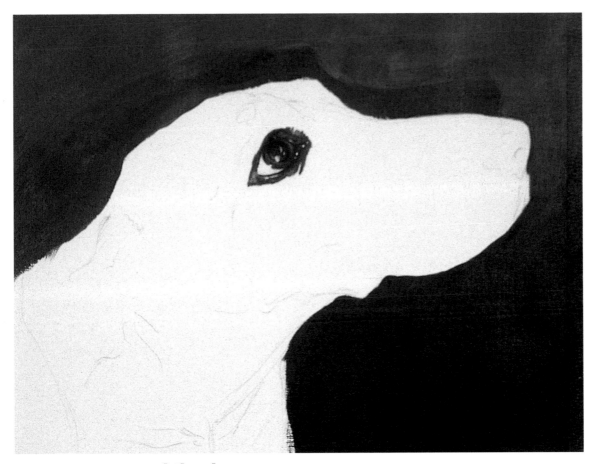

2 Create Your Final Sketch

Tape your canvas-textured paper to a rigid support. When you're sure what you want to do, sketch the subject onto your canvas-textured paper.

Your ¾-inch (19mm) flat will work well for this, but you can use a larger brush for laying in the background if you prefer. You can be loose and free here.

Because the eye is what will capture the viewer's attention in the finished piece, try getting the main details down first. Watch the shape and position of the pupil, given the angle of the head.

MIX ON THE CANVAS

You can mix colors on your palette, of course, but you can also mix on the painting itself. You'll get fresh, interesting mixes that way. These mixes aren't always perfectly blended, so you'll have touches of unmixed color here and there. Colors mixed on the canvas are often more lively than the carefully mixed homogenous colors.

3 Block In Areas of Color and Texture

For now, you should just block in areas with color and some initial texture. You can adjust these beginning areas and add a greater degree of detail later.

Mix Burnt Sienna, Raw Sienna and a touch of Ultramarine Blue to paint the first layer of the dog's glossy coat. Add Titanium White to the mix where the highlights will appear later. Don't worry about getting them perfect at this stage—you'll be able to make adjustments as you go.

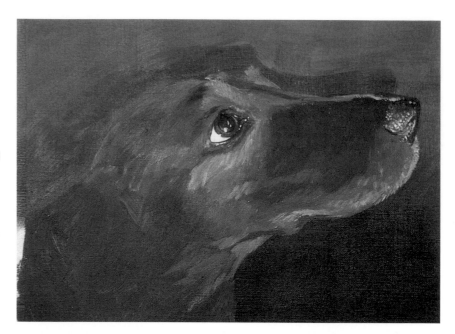

4 Suggest Individual Hairs

Continue working on the shiny coat using varying mixtures of Titanium White, Ultramarine Blue, Burnt Sienna and Payne's Gray. Your smallest brush will allow you to capture the lovely brindled colors of Sarah's coat. Use quick, short strokes with your smallest brush to suggest individual hairs, or use a drybrush technique. Remember to vary the colors, using the lightest ones where the light strikes that shiny coat.

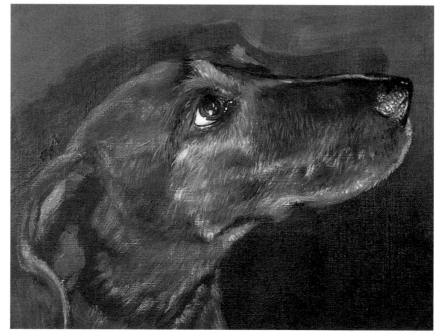

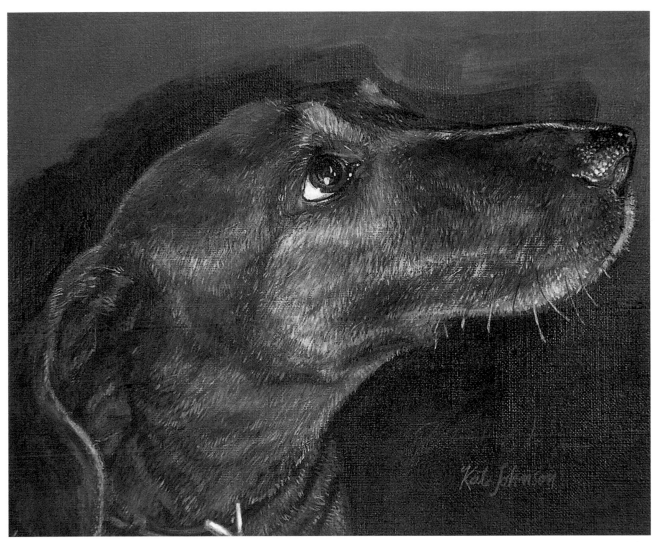

5 Finish

Let your work sit for a while; it's always good for a painting to gestate. If one area fights with another, consider ways to modify it, simplify it, push it back or add a bit more detail. When you're sure you're finished, allow the painting to dry thoroughly and carefully remove the tape.

The Look of Love—Sarah
Cathy Johnson
Acrylic on canvas-textured paper
9" × 12" (23cm × 30cm)
Collection of Joseph Ruckman

BY LESLEY HARRISON

Pastel
DOG AND CAT **PORTRAIT**
DEMONSTRATION

Moments like this (see photo below) are unusual and precious. This photo was on a Christmas card; it was not staged. This dog, Wally, and the cat, Bundy, really love each other and do these things on their own. Their owner was kind enough to give permission to paint from her photograph. To avoid any misunderstandings, make sure to ask the photographer or pet owner to sign a release that shows you have permission to use the photo as reference.

Reference Photo

MATERIALS

SURFACE
Beige velour paper

SOFT PASTELS
Black
Dark gray
Deep golden red
Golden brown
Medium gray
Reddish brown
White

HARD PASTELS
Black
Brownish gray
Light blue
Light cream
Pale gray
Pale yellow-green
White
Pink
Pinkish red

1 Establish the Sketch
Planning and doing sketches beforehand on other paper and then transferring a final sketch to your velour surface is essential for a good painting, especially on velour paper where erasing and reworking is difficult. Lightly sketch in the outline of the dog and cat with your black hard pastel.

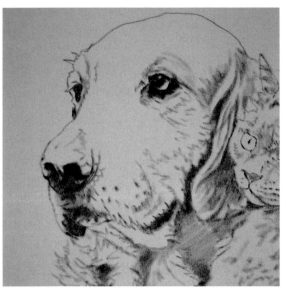

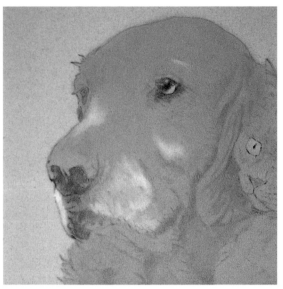

2 Darken Your Sketch

Your faint sketch showed placement and detail; now add more detail with a black hard pastel. It's easy to do at this stage and it warms you up for the job ahead. Start adding darker areas to get a sense of the balance of the painting.

3 Lay In the Medium Tones

Use the side of a medium gray soft pastel to cover the whole area of the dog except the eyes. Then put a golden brown soft pastel on top of that. Don't use too much pastel at this stage; you don't want to lose the detail lines or use up all the paper. Use a white soft pastel for the whites on his face, for placement only at this stage.

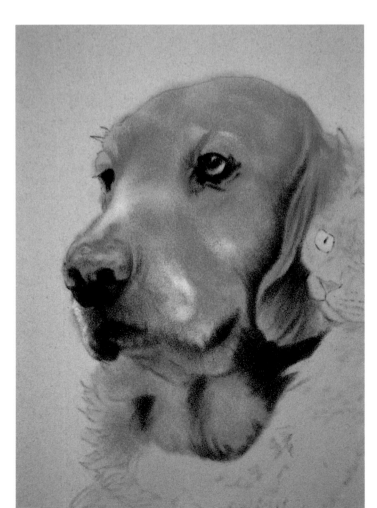

4 Tone the Darker Areas

Use a reddish brown soft pastel to start toning the fur on Wally's face and neck. With a dark gray soft pastel and then a black hard pastel, start putting in the grays and blacks on and around his nose, ears, mouth and eyes. He's starting to look like a very sweet dog, which is what you want. When painting other people's animals, it's important that the painting looks like the animal, not how you think it should look.

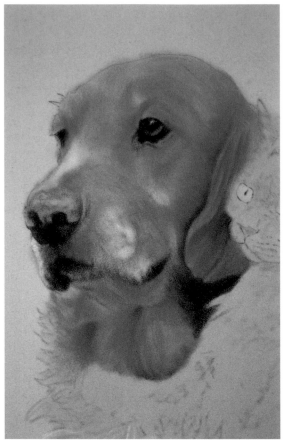

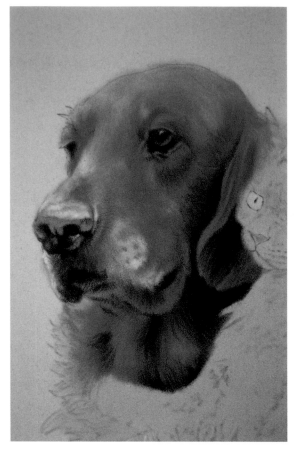

5 Develop Local Color

Find a deep golden red soft pastel and go over the darker areas of his fur yet again. This should be the perfect color for his sweet eye, too, so color in the iris of his eye while you have this color out.

6 Add Detail and Further Develop the Color

Find a delicate pink hard pastel to use on his nose. You don't want the nose to stand out, just to look realistic.

Now use a brownish gray hard pastel to start defining the planes and contours of his face more. This will be your last step before adding lights to make the painting come alive.

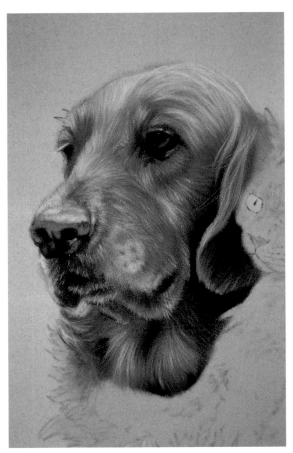

7 Start Adding Lights

Use a sharpened light cream hard pastel to start stroking in the hair in the direction it grows. The good news is that hair directions are much the same on all dogs. Stroke in shorter hair in some places, like the muzzle and lips, and longer hair on other parts of the body.

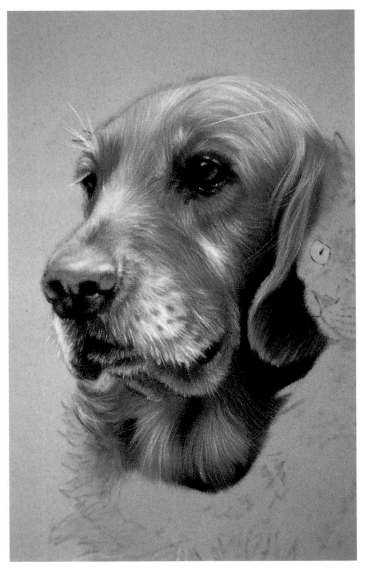

8 Add More Lights

Sharpen your white hard pastel and start adding white muzzle hair. This will make him look kind and old, sort of like humans when their hair starts turning gray, then white. Add some white to the nose, the top of the head and brow, and a highlight in the eye. I also put a tinge of blue there to soften the effect; this can read as a reflection from the sky and is not as shocking as bright white by itself. You want the dog to seem gentle, serene and aged.

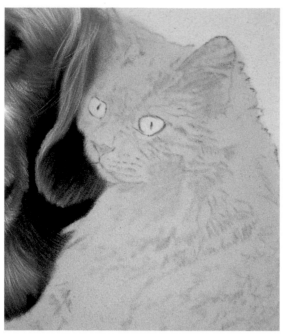

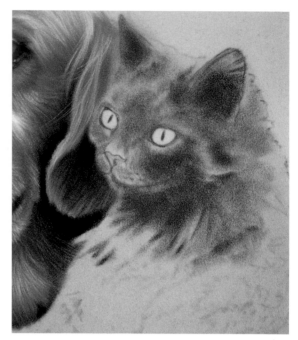

9 Apply the Basecoat on the Cat

If you didn't cover Bundy the cat in medium gray soft pastel when you were working on Wally, do it now. He definitely is a candidate for a gray undertone, since he's gray anyway. Leave his eyes the color of the paper for now—you'll add gorgeous yellow-green eyes later.

10 Deepen the Grays

Find the darker areas of the cat's face and fill them in with a dark gray soft pastel. Remember, you're building a foundation for later so he will have form and dimension.

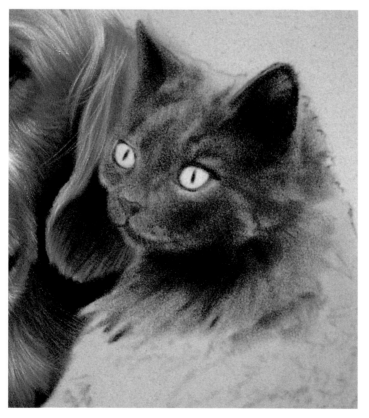

11 Add Black

Using a black soft pastel, go back over some of those dark grays and take them a step darker. You'll want black in the ears, under the neck—anywhere the light has the hardest time getting to.

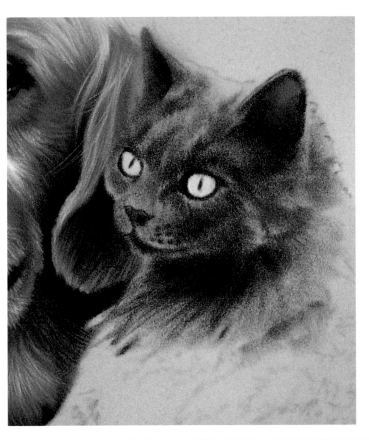

12 Add Details

Sharpen your black hard pastel and start defining some of the details. Use the sharp pastel edges to go around the cat's eyes, nose and ears. While you're on the ears, find a nice pinkish red hard pastel to add a little color.

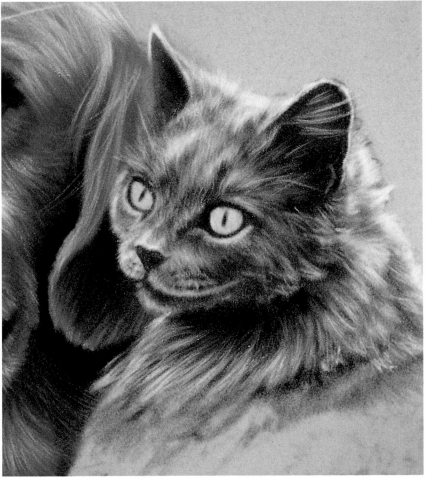

13 Add Lights

Use a sharpened pale gray hard pastel to stroke in the hairs around the cat's face. Add a few long wispy hairs in his ears, shorter hairs on his face and long-flowing hairs on his neck. Cats have a funny hair pattern on their face, so make sure you get it all going the direction it should.

14 Now For the Treats

Time to add yellow-green to the eyes. Don't cats have the most gorgeously colored eyes? Bundy sure does. Find a pale yellow-green hard pastel and gently stroke in some color. Use a very sharp black hard pastel or pencil to put the slit line in as the pupil. When there is a lot of light, cats only have a small up and down slit. Then add a bit of light highlight with a sharp light blue hard pastel so he matches Bundy. They're side by side so what we do for one animal, as far as light source and colors, should be done for the other.

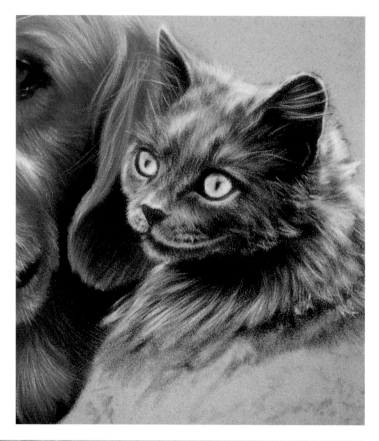

15 Add the Final Lights

Make Bundy look really spiffy by adding white highlights wherever needed on his fur and in his eyes. Don't forget his whiskers! Add them in with a very sharp pastel. It's a real thrill to have the whole painting framed and look at it and say "Oh no! I forgot the whiskers!" Even more fun is to have someone point it out after it's hanging in a gallery.

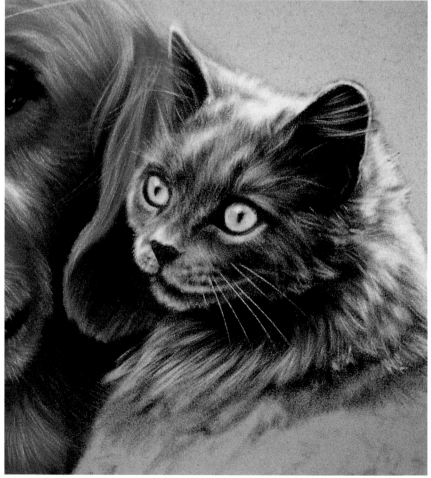

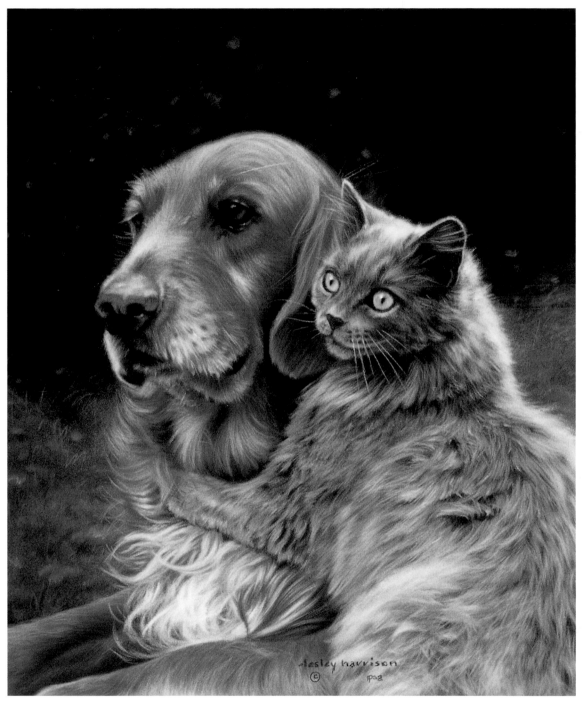

16 Add the Background

So, what do you think? These guys are fun and they're pretty cute. Now see if you can finish them on your own using the same colors. Keep fur direction and length in mind as you work on the rest of the animals' bodies. Bundy has his arm around Wally, in case you haven't noticed.

Add in a soft, vague background using greens and pinks to represent a lawn or field with bushes or trees in the distance.

Wally and Bundy
Lesley Harrison
Pastel on velour paper
14" × 11" (36cm × 28cm)
Private collection

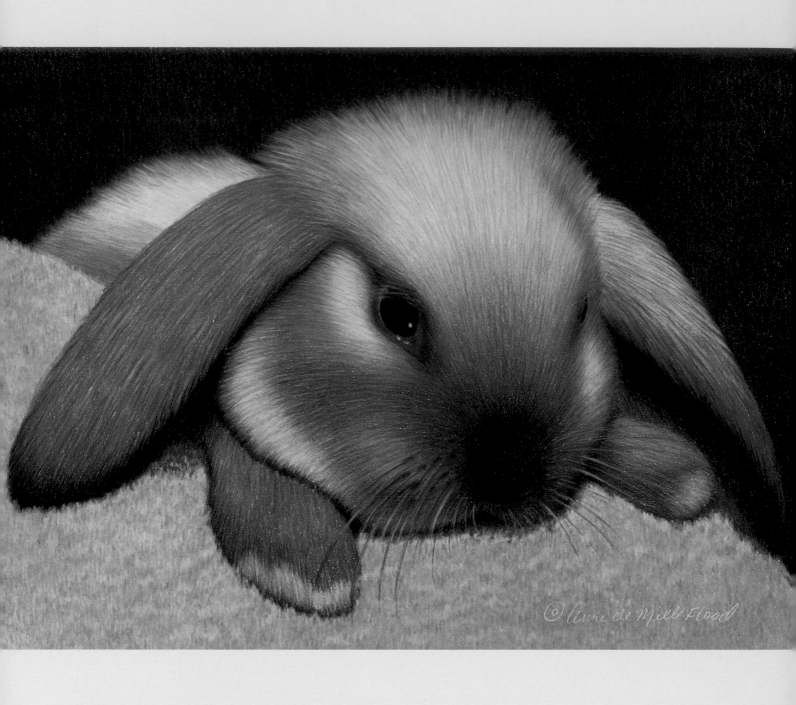

©Anne de Mill Flood

Chapter THREE | **Rabbits**

These adorable creatures often fit into the palm of a hand, and they are just so darn cute!

This chapter will give you some tips on working with rabbits and how to give your portrait a tangible appearance that is so inviting that the viewer will just want to reach out and touch it!

Soft Touch
Anne deMille Flood
11" × 14" (28cm × 36cm)
Collection of the Artist

Drawing
RABBIT FORMS **AND FUR**

The skull of a rabbit is elliptical in shape. Therefore an oval works well to represent the head when blocking in a preliminary drawing. A larger oval or circle if the rabbit is sitting on its haunches can suggest the basic body shape. Note that the top line of the rabbit from the shoulders back is rounded.

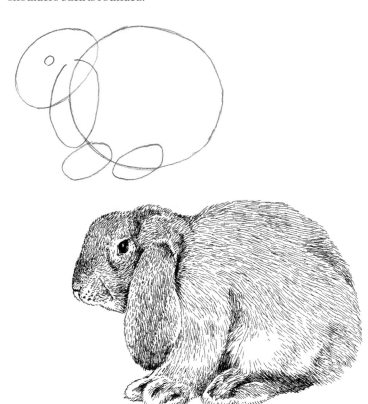

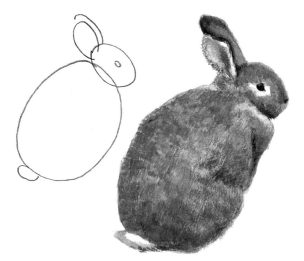

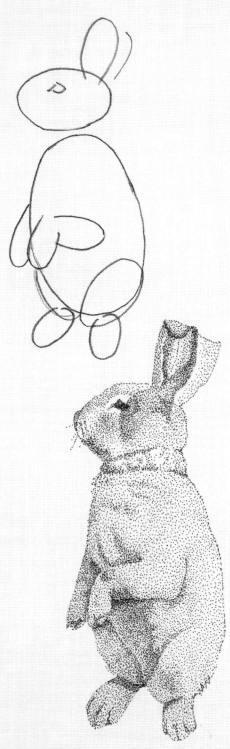

Lop-Eared Rabbit
This pen drawing highlights the fur's texture through simple and light lines moving with the contour of the rabbit's body.

Fur Texture
The brush stippling brings a simple drawing to life. Rabbits aren't complicated forms, the key is to capture that chunk of fur realistically.

Rex Rabbits
Rex rabbits have a velvety coat resulting from the guard hairs being shorter than the undercoat. Stippling represents it well.

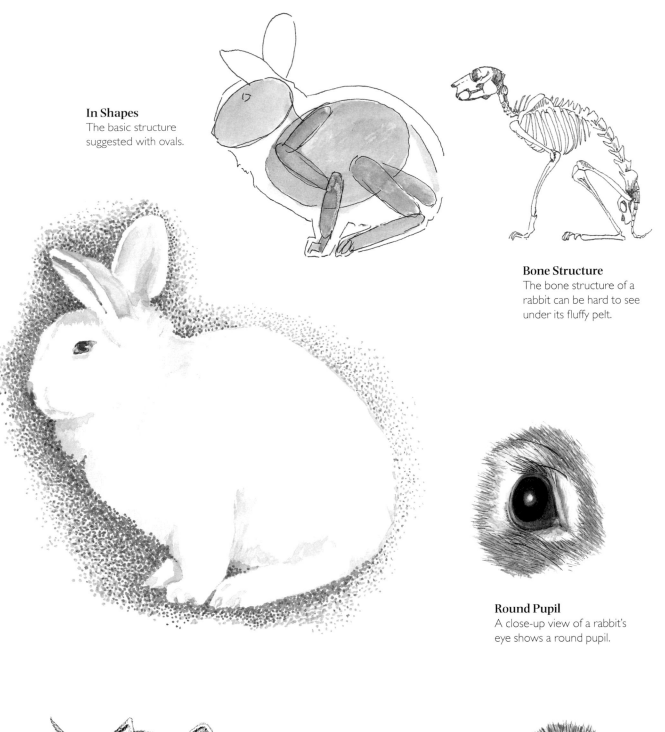

In Shapes
The basic structure suggested with ovals.

Bone Structure
The bone structure of a rabbit can be hard to see under its fluffy pelt.

Round Pupil
A close-up view of a rabbit's eye shows a round pupil.

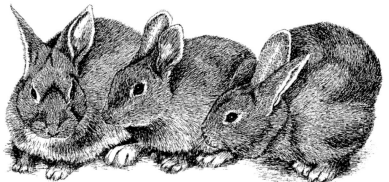

Cottontail Rabbits
So cute!

The Nose and Muzzle
The pen strokes accentuate the fur's texture.

Watercolor
SPONGE **TEXTURING**
DEMONSTRATION

BY CLAUDIA NICE

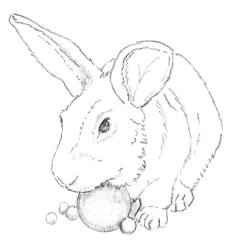

MATERIALS

SURFACE
Watercolor paper

BRUSHES
Various sizes, as needed

PIGMENTS
Burnt sienna
Yellow ochre

OTHER
No. 2 pencil
Small sea sponge

1 Start With Your Sketch
Sketch a rabbit onto watercolor paper. Make it large enough to maneuver a sponge in.

Texturing Tool
Use a small moist sea sponge to stump on the fluffy texture of a rabbit's coat.

The ball and marbles were added to the painting for a bit more color and interest. They call attention to the eye which is of a similar shape and value and help the viewer focus on the head. The toys also add a sense of playfulness to the composition.

2 Sponge on Color
Dip the sponge in a pale wash of color and tap it over the dry surface of the rabbit. Leave white areas unstamped. Let it dry.

3 Add Darker Tone
Sponge a darker tone into the shadow areas.

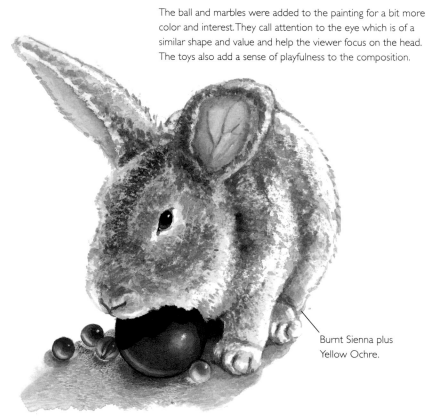

Burnt Sienna plus Yellow Ochre.

4 Glaze the Fur
Glaze the colored fur areas of the rabbit with a pale wash of the first color stamped on.

5 Brush Stippling to Fill
Use brush stippling to fill in areas that were difficult to sponge.

6 Smooth Areas
The smooth areas of the rabbit are painted in using a small round brush. This includes the inner ears and eyes.

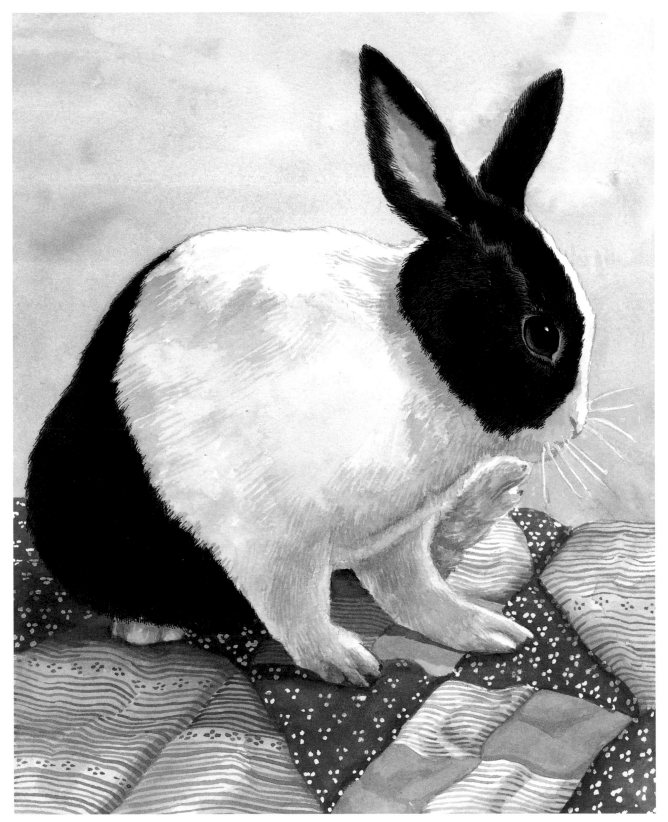

Watercolor Plus Ink
This painting is mostly watercolor with ink crisscross strokes in the black spotted areas. The colored, patterned quilt adds a little zip to a subject that is mostly colorless.

A Dutch Rabbit On Grandma's Quilt
Claudia Nice
Watercolor on paper
10" × 8" (25cm × 20cm)

Pastel
BABY **BUNNY**
DEMONSTRATION

BY LESLEY HARRISON

The bunny that you're going to paint for this demonstration is very young and very cute. You should enjoy this because bunnies are quite easy and fun to do.

MATERIALS

SURFACE
Blue or gray velour paper

SOFT PASTELS
Dark golden brown
Golden brown
Gray

HARD PASTELS
Black
Dark gray
Light gray
Dark orange
White

1 Complete the Sketch
This demonstration uses a blue piece of velour but if you have a choice, use gray.

Sketch in the bunny with a sharpened black hard pastel. This is a simple sketch because bunnies are mostly round and furry.

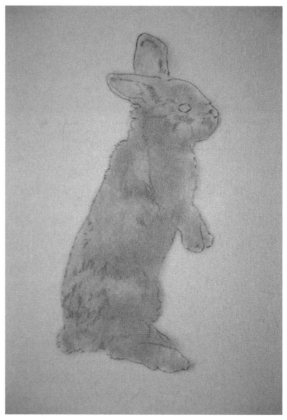

2 Cover Him in Gray
Here's where you fix the fact that you didn't have gray paper to start with. Use a gray soft pastel and cover his whole body, except the eyes, in gray. Voila! A gray bunny.

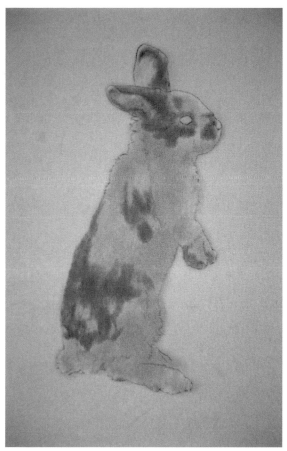

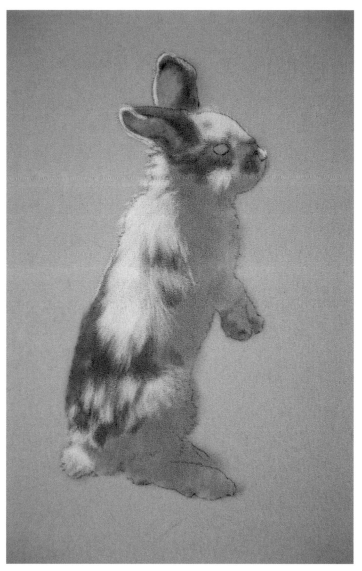

3 Add the Spots
With a golden brown soft pastel, color in wherever his spots will be. He's mostly a white rabbit with some pretty brown spots on his ears, around the eye, muzzle, paws and back. Stroke in the direction the hair is growing, even this early in the painting.

4 Add the Main Coat
Most of his body is white, so stroke in some white hard pastel directionally. Leave the shadowed areas of gray just as they are; you'll go in later and work that a bit more. Add white on his ears, forehead, tip of his nose, cheek, back, cute little tail and a little on his legs. The whitest white is where the sun is hitting him.

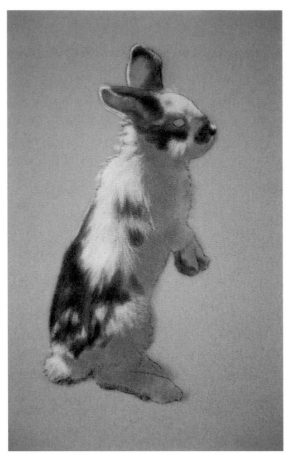

5 Deepen the Spots

To make his spots richer looking, add some dark golden brown soft pastel to them. It will give him more dimension when you're finished.

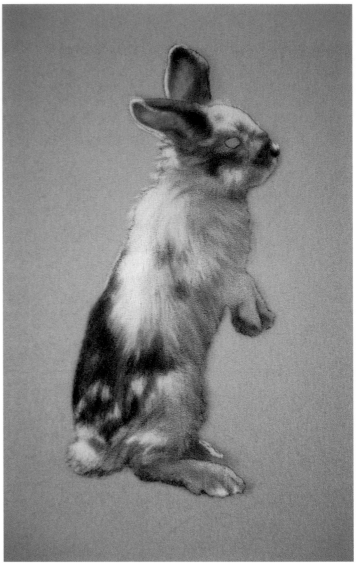

6 Work on the Shadowed Areas

Now, using a lighter gray and a darker gray than what we covered him with originally, go into the area in the shadow and use the light gray hard pastel for lighter hairs and the dark gray hard pastel to balance it all out. You want this to look shadowed but to have highlights with detail and dimension. Define his fur in the shadowed area, which means it will be a muted version of what you did on the rest of his body.

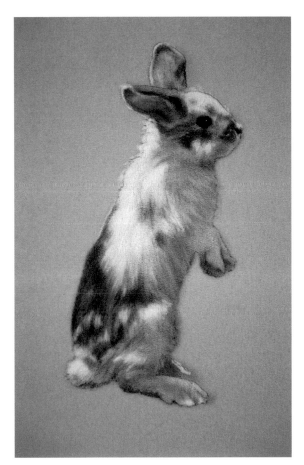

7 Work on the Eye and Ear

The light is shining through the ear nearest you, so you need to show it. The light makes the ear semitransparent and you actually see the veins in his ear. Use a dark orange hard pastel very judiciously for this. Veins are thin.

Using black, add the eye with a small white reflected spot on top of it.

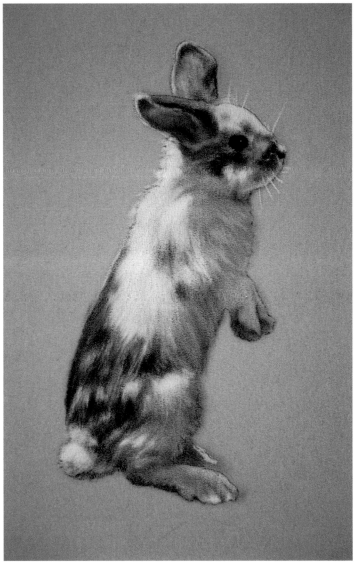

8 Add Final Touches

The finishing touches are the whiskers and light white on top of the brown spots to make them look more real. Sharpen your white hard pastel and use it for both.

Now all you have to do is figure out what kind of a background you'd like around him. Perhaps you can place him in a field of flowers and maybe he's checking one out, since he is just a baby and not very tall at all.

BY SHERRY C. NELSON

Oil and Acryic
LOP-EARED RABBIT **AND PANSIES**
DEMONSTRATION

Some critters beg to be cuddled. With their darling, droopy ears, big eyes and fur as soft as a down pillow, lop babies steal your heart for sure. They have sweet, affectionate natures, are very fastidious animals and can even be house-trained.

The lop-eared bunny is the oldest kind of domestic rabbit, with the first lops dating back to the 1700s. They have been popular for show and as pets in Europe for many years, but were introduced into the United States only in the 1970s.

The English Lop is the oldest breed, and the Dwarf Lop is one of the most popular pets. But the Holland Lop is the smallest, weighing in at less than 4 pounds (1.8kg). And, just for the record, you feline and canine fanciers, there are more rabbits shown in the United States than cats and dogs!

COLOR MIXES

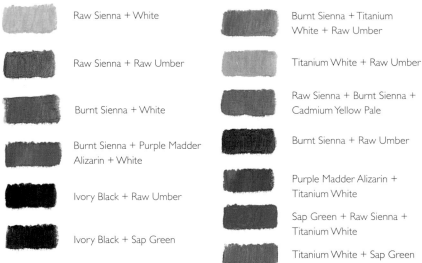

Raw Sienna + White

Raw Sienna + Raw Umber

Burnt Sienna + White

Burnt Sienna + Purple Madder Alizarin + White

Ivory Black + Raw Umber

Ivory Black + Sap Green

Burnt Sienna + Titanium White

Burnt Sienna + Titanium White + Raw Umber

Titanium White + Raw Umber

Raw Sienna + Burnt Sienna + Cadmium Yellow Pale

Burnt Sienna + Raw Umber

Purple Madder Alizarin + Titanium White

Sap Green + Raw Sienna + Titanium White

Titanium White + Sap Green + Raw Sienna

Match and Mix Swatches
Use these swatches when mixing oils or matching to other paint mediums.

MATERIALS

SURFACE
Hardboard (Masonite) panel, 11" x 14" x ⅛" (28cm x 36cm x 3mm)

BRUSHES
No. 0 round
No. 0 red sable liner
Nos. 0, 2, 4 and 6 red sable short brights

ACRYLIC PAINTS
Cadet Grey
English Yew Green
Moss Green
Oyster White
Sachet Pink
Wild Rose

OIL PAINTS
Burnt Sienna
Cadmium Yellow Pale
Ivory Black
Purple Madder Alizarin
Raw Sienna
Raw Umber
Sap Green
Titanium White

OTHER
320-grit wet/dry sandpaper
Acrylic retarder
Cheesecloth
Cobalt drier (optional)
Dark graphite paper
Disposable palette for oils
Krylon Matte Finish no. 1311
Krylon Satin Varnish no. 7002
Odorless thinner
Palette knife
Sponge rollers

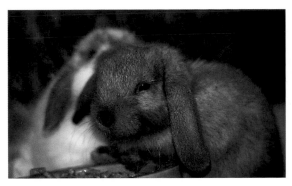

Rabbit Reference Photo

A good reference photo can make or break your painting. It's important to have as much information as you can get in the shot and that it be as sharp and in focus as possible. But sometimes getting that kind of shot is a challenge.

We had a dearth of references for this critter so we went to the pet store at the local mall—baby lops! darling, wonderful and so cute. The photographer grabbed the camera and took this single picture, just before being summarily ejected from the shop by the furious owner. Moral: always ask permission first.

Photo by Deborah A. Galloway

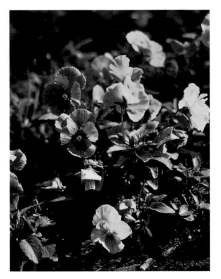

Pansies Reference Photo

Getting the pansy reference can be a whole lot less stressful. Go to a nursery where there are limitless opportunities to shoot all the gorgeous blooms needed.

One last note. Both the rabbits and the pansies were shot from a "bunny's eye" view. Your subjects need to be "on the level" with each other.

Photo by Deborah A. Galloway

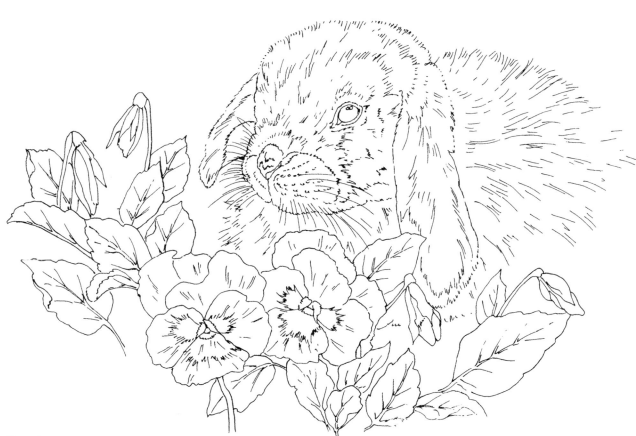

Line Drawing

Transfer this design to the prepared background using dark graphite paper. Be very accurate when transferring the eye, nose and other facial features, as well as the detail of the pansies.

This pattern may be hand-traced or photocopied for personal use only. Enlarge at 120% to bring it up to full size.

1 Apply Base Color

Base a 11" × 14" (28cm × 36cm) Masonite panel with Moss Green, using a sponge roller. Let dry and then sand smooth.

Rebase with the same color, adding a drizzle of retarder to keep the surface workable while adding the other colors. In the upper right corner, drizzle a little Cadet Grey and use the roller to soften it into the background. Then move a little to other areas. In the central area of the surface, drizzle a little Sachet Pink and a little Wild Rose, and repeat the process, blending to soften the colors into the background and moving the colors into other areas to balance. Now on the scrap paper covering your work surface, run a sponge roller into a drizzle of Oyster White. Use this color to highlight around the pinks in the center area of the surface.

Finally, around the edges of the surface, shade a bit with a drizzle or two of English Yew Green, using a clean roller to blend into the background.

Let dry overnight and then sand smooth. Spray with Krylon Matte Finish no. 1311. When using retarder, allow extra drying time before sanding and spraying.

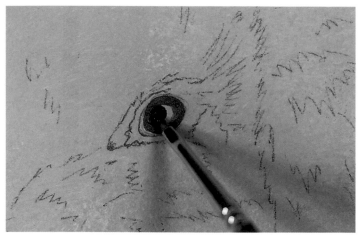

2 Base the Iris

Base the Iris with Raw Umber, using a no. 0 liner. Around the ends of the iris in the corners of the eye, place a small area of Burnt Sienna + Titanium White. Rinse the brush in thinner, blot dry and load in clean Ivory Black. Base the pupil carefully.

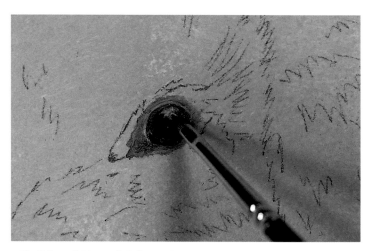

3 Blend Pupil Edges Into Iris

Dry the brush and use the corner to blend the very edges of the pupil into the Raw Umber iris.

Now lay a narrow band of Burnt Sienna + Raw Umber + Titanium White entirely around the eye. Lay the pupil lowlight using Titanium White + Raw Umber. Blend the edges into the pupil. Do not overwork.

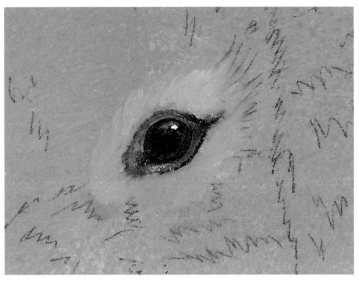

4 Begin Eye Details

On top of the lightest lowlight value in the pupil, place a dot of clean Titanium White, using the liner brush.

Lay a fine line of Ivory Black around and just inside the iris edge, using the liner brush. Blend the inner edge of this line slightly into the Raw Umber iris using the point of the liner.

Using the no. 0 bright, outline the eye-ring around the eye with a little Raw Umber. Then shade in front of and behind the eye with the same color. Highlight the skin area around the eye with a little Titanium White + Raw Umber.

Base the fur area that comes up to the eye-ring with Raw Sienna + Titanium White.

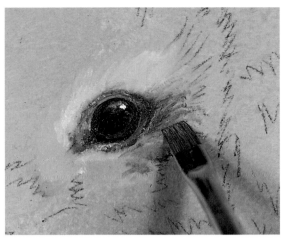

5 Shade and Add Fur

With the no. 2 bright and Raw Umber, add additional shading behind the eye on top of the pale fur basecoat. Blend just a little. Highlight the fur above the eye with Titanium White. Then with the corner of the chisel, connect the fur edge into the eye-ring edge to soften the line where they meet.

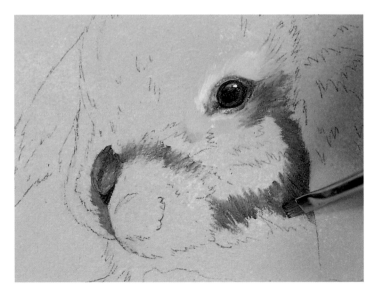

6 Add Nostril and Apply Shadows

Using a no. 2 bright, base the darkest nose value with Raw Umber and the lighter areas with Raw Sienna + Raw Umber. Add the nostril with Ivory Black. Place a shadow under the nose with Burnt Sienna + Titanium White.

Begin applying shadows on the face from the nose around the cheek, using Raw Umber + Raw Sienna and a no. 4 bright. Extend this shadow up under the eye until it meets the dark shading previously placed behind and under the eye.

Vary stroke length with hair length in each of the areas of the face and body.

7 Highlight and Paint Whisker Pads

Highlight the bottom of the nose with White, blending in tiny choppy strokes with the no. 0 bright.

Lay on Raw Sienna below the nose at the whisker pad edges. Then add pale Raw Sienna + Titanium White where shown: around the bottoms of the whisker pads, and next to and around the umber areas above the nose and on the cheek.

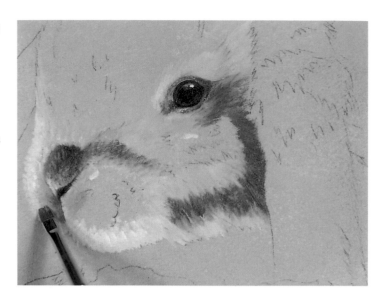

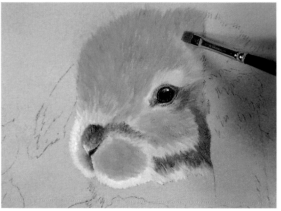

8 Base Head

Base the remainder of the head with Raw Sienna + Burnt Sienna + a tiny amount of Cadmium Yellow Pale using the no. 4 bright. Chop the colors on with the chisel of the brush, following the lie of the hair carefully, and making sure the stroke length is compatible with the hair length in each area.

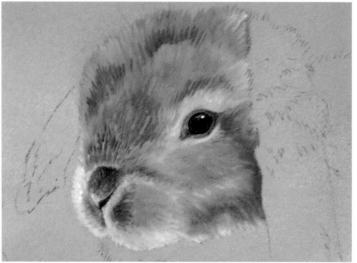

9 Blend and Add Highlights

Blend between value areas with the chisel edge of the brush, walking strokes back and forth across the line where values meet. Add shading with Burnt Sienna + Raw Umber, and, in the deepest areas, with just Raw Umber.

Add highlights with Raw Sienna + Titanium White, chopping light values on in the same manner as you did the basecoat. Then, add a little pinkish accent by the mouth below the nose with Purple Madder Alizarin + Titanium White.

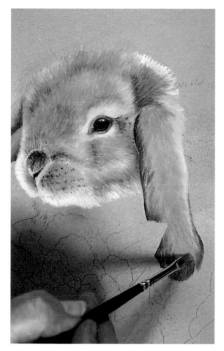

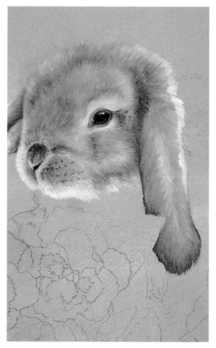

11 Blend With Growth Direction

Before blending the ears, note the growth direction: hairs do not necessarily conform to the lengthwise line of the ear, but rather come off to the side at an angle in several places, and straight back toward the back at the top of the ear. Using the chisel, blend between the values, using the chisel to create brush marks that indicate the correct lie and length of the rabbit's hair.

Then apply any additional shading needed with Raw Umber, and highlight down the center line of the near ear and at edge of the far ear using Raw Sienna + White.

10 Finish Blending

Work the brush between values to connect them. To help achieve contour and form, be sure the lie of the hair is correct.

Add whisker marks with Raw Umber on the liner brush. Break up the edges of the head, pulling out fine strokes of the color in each area. Add soft, strong lights on the chin, cheek and top of the head with Titanium White on the round brush.

Using a no. 4 bright, base the ears, using Raw Umber for the darkest value and Burnt Sienna + Purple Madder Alizarin + White (adding a tad of Raw Sienna to dull the mix a bit) for the pinkish mid value. Fill in the palest areas with Raw Sienna + Titanium White.

Use Raw Sienna + Burnt Sienna + a bit of Cadmium Yellow Pale above the ear in the mid-value warm area, a little Raw Umber to the left of it for a darker value and Raw Sienna + Titanium White for the lightest value, on top of the head.

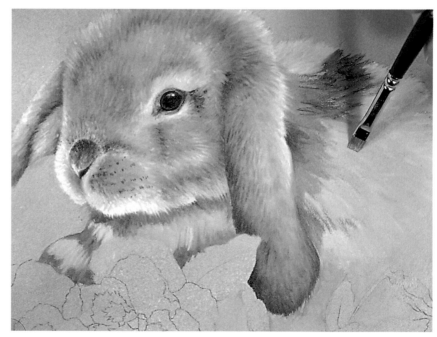

12 Blend and Begin Chest and Body

Blend the shading and highlighting on the ears. The rest of the chest and body is based in three values: Dark—Raw Umber, Medium—Raw Sienna + Burnt Sienna + a tad of Cadmium Yellow Pale, Light—Raw Sienna + Titanium White.

Note once again that brush strokes, as you apply color, should follow the lie of the hair and reflect the hair length. Some areas you'll want to use the no. 4, others the no. 6.

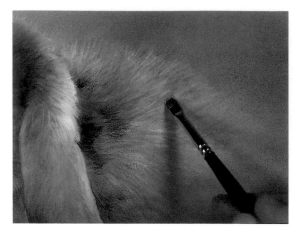

13 Blend Basecoats of Body

Using the brushes with which you applied the basecoats, begin blending on the line where the values meet. It is as important to achieve good gradations between values as it is to have those values. Insufficient blending will make your bunny look spotty rather than contoured.

Fluff out lighter values using a no. 4 bright with Titanium White + Raw Sienna. Let some of these hairs soften the body edges as they did on the face. Guard hairs give a fluffy feeling to the fur, but must not be overdone.

Using the no. 4 bright, add additional shading on the back next to the ear, using Raw Umber.

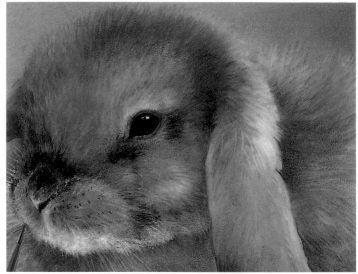

14 Blend and Add Whiskers

Blend the shading on the back. Next, add additional Raw Umber + Raw Sienna for more depth on the chest where the rabbit's body is behind the pansies and leaves, where the ear folds over the head and around the eye. Then, shade with Raw Umber above the nose. Thin a little Titanium White and apply long whiskers with the round brush. Don't pull whisker lines over the pansies; remember, they're in front of the rabbit.

15 Blend and Finish Eye

Blend the shading applied in the previous step with the growth direction, using the no. 4 bright.

Give the eye its final shape, using the liner and a bit of Ivory Black + Raw Umber to break the eye-ring in front of the eye into the tear area. Add additional Raw Umber shading if needed to make sure the eye is seated well within the fur around it.

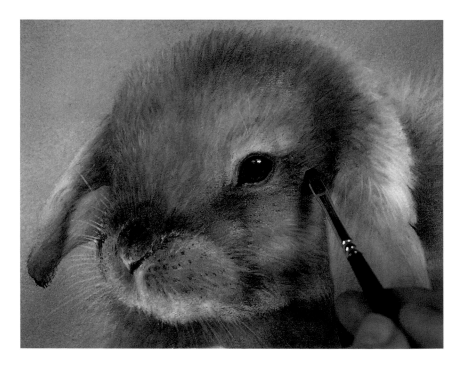

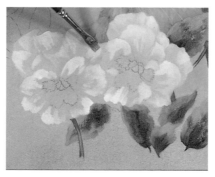

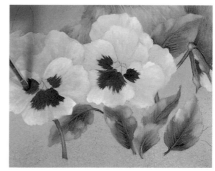

16 Begin Basecoat

Basecoat the pansy petals with Raw Sienna + Titanium White, using the no. 2 or no. 4 bright. Base the dark values on the leaves and the stems with Ivory Black + Sap Green.

17 Highlight and Fill in Leaves

Highlight overlapping edges, the tops of rolls, as well as some petal edges with Titanium White. Use a no. 2 bright and apply sparse paint with pressure. Do not continue white all around the edge of a petal; apply light hits in areas, but not in outlines.

Fill in remaining areas of leaves with the light value of Sap Green + Raw Sienna + Titanium White. Highlight the stems with the same mix, pulling a line down the center of each stem, then blending on the edges of it just a bit to create a little value gradation between the light value and the dark basecoat.

18 Blend Highlights and Basecoat Pansy Face

Blend the white pansy highlights in the growth direction, using the chisel edge for natural texture.

Base the pansy face with Purple Madder Alizarin.

Using the light green leaf mix, lay a rough central vein in each leaf as a blending guide. Now blend the leaves from edge to center vein at the lateral vein angle, using the chisel edge of a dry no. 2 or no. 4 bright. If leaves appear too textured, lower the brush angle. Place leaf highlights with Titanium White + Sap Green + Raw Sienna, using the no. 4 bright.

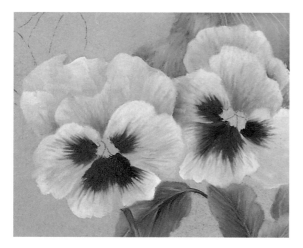

19 Blend and Add Details

With a very dry no. 2 bright, cut the corner of the chisel into the edge of the face color. Do not blend the colors together with the flat of the brush, but rather use the chisel to skizzle back and forth just on the line where the colors meet. Here and there, pull a chisel line or two out from the dark to give definition to the petal.

Then, using the same brush, which will have a little dirty Purple Madder Alizarin on it, shade a bit on the back petals to help them recede. Blending should follow the growth direction of each petal.

Blend the leaf highlights. Add a little Purple Madder Alizarin accent color, if desired. Blend with a chisel stroke, just as you did in the other steps. Add final vein structure with the light value mix.

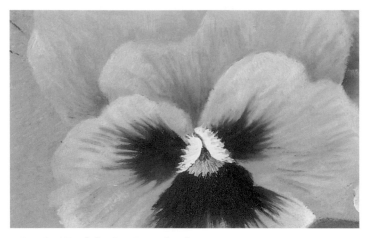

20 Highlight Petal Edge

The white that surrounds the pansy center is actually the petal edge, which rolls over so that you can see the other side. Apply these fuzzy areas of white with the liner.

At the top of the upside down V, add a tiny triangle of Sap Green + Ivory Black. Below that, add a small scallop of Cadmium Yellow Pale. Then, with the round brush, blend just a bit between the green and yellow areas.

The edges of the yellow and the white should be fuzzy and broken where they fall over the petals.

21 Mix Glaze

If you've never done this kind of glazing before, you may wish to spray the finished painting lightly with Krylon Matte Finish no. 1311 prior to antiquing. Then the painting is totally safe, even if you put on and take off the glaze several times.

Two mixes are used for antiquing on the finished painting. On the right is a slightly thinned patty of Raw Umber, and on the left you see a mix that is half Sap Green and half Raw Umber, also slightly thinned. A drop of drier may be added to each to speed drying time.

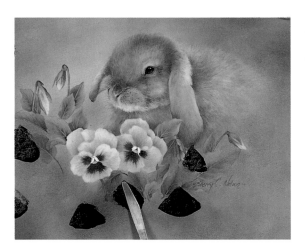

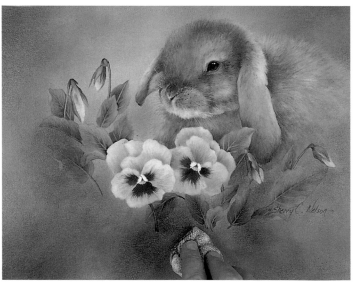

22 Scrape Glaze

Using the palette knife, scrape thin swatches of each mix here and there on the surface where I want to increase the depth or simply add more interest.

23 Blend Scrapes

Use a soft pad of cheesecloth to blend the edges of each scrape of paint, leaving some areas darker and removing more paint in other areas for lighter values. It's perfectly acceptable if some of the glazing gets into the design area; simply buff it off with the cheesecloth. Or if you like the effect, let it be.

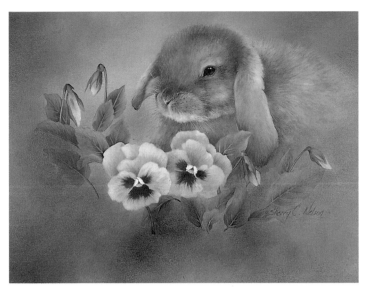

24 Warm Flowers and Finish

Take a bit of Raw Sienna on a no. 4 bright and scruff a bit over the shadow areas in the back petals and where the front pansy overlaps the back one. Then buff off the excess Raw Sienna. Look at the photo of the finished painting; you can see how the warmer tones in the foreground flowers make the overall look of the painting much softer.

When all glazing is dry, the painting may be sprayed with a final finish of Krylon Satin Varnish no. 7002.

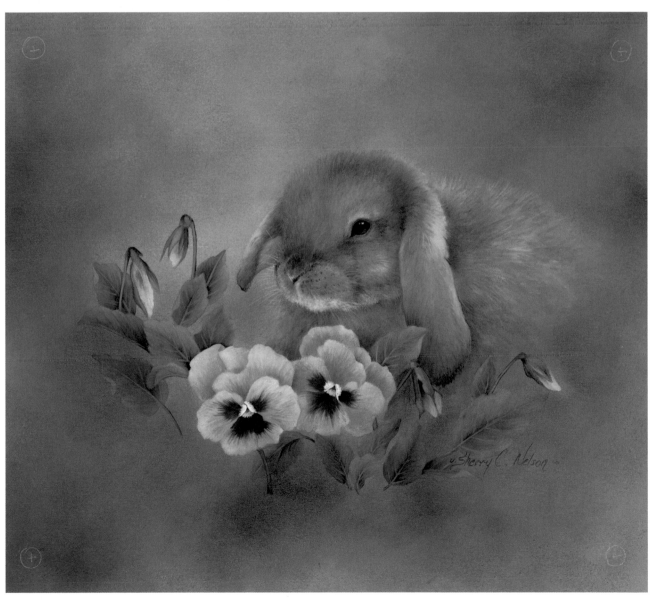

Lop-Eared Rabbit and Pansies
Sherry C. Nelson
Oil on hardboard panel
11" × 14" (28cm × 36cm)

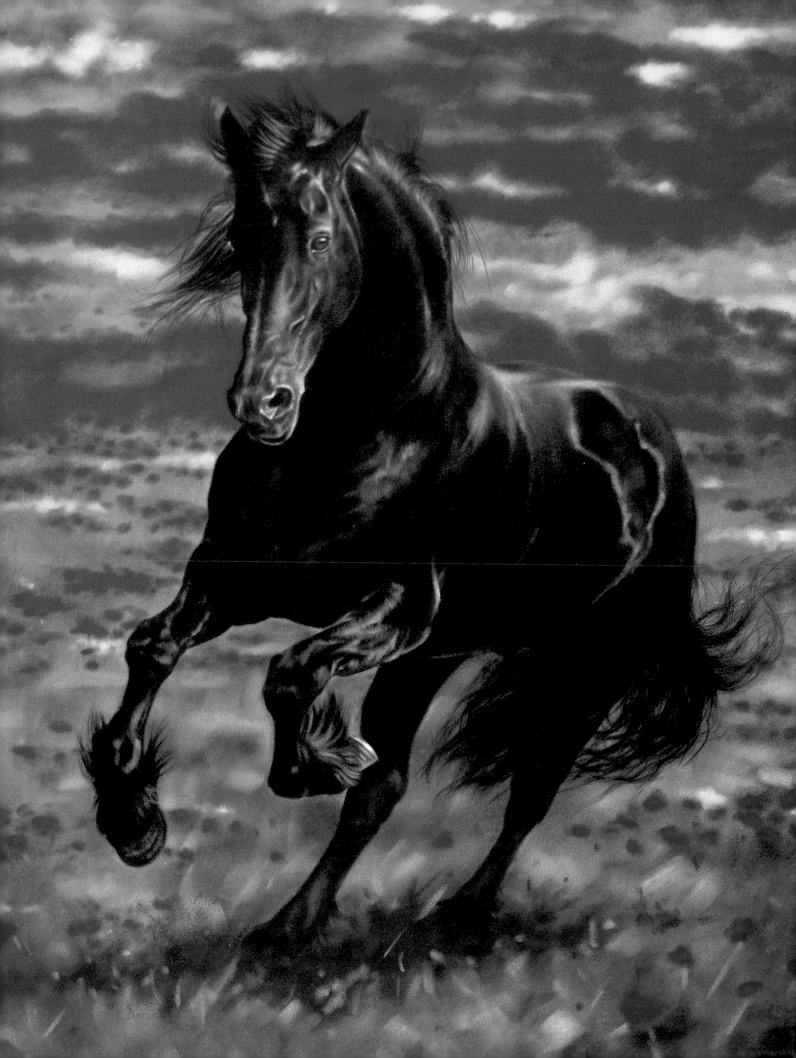

Chapter FOUR | Large Mammals

In this chapter we'll zero in on some of the things about drawing and painting horses and large mammals that make them so intimidating to paint. If we break them down in parts and work on those parts, the whole animal should be much easier to tackle. Working on eyes, legs and the other features individually should help build your confidence in painting these gorgeous creatures.

Bold and Beautiful
Lesley Harrison
Pastel on velour paper
22" × 16" (56cm × 41cm)
Private collection

Colored Pencil
CHESTNUT HORSE
DEMONSTRATION

BY ANNE deMILLE FLOOD

The shy, intelligent eye of this chestnut-colored horse and the sunshine and fur color just say warm. In this demonstration you will learn how to capture the effect of this sun-drenched horse by layering warm, golden colors and burnishing shiny areas. A few very deep value areas are first defined, then you will layer gradually from light to dark. You will see the fur pattern and shadows develop as you build color, defining the animal's shape.

Surround this horse with a background that is a subtle combination of cool blues and green that complement its warmth. Notice how the background is darkest at the top of the picture, contrasting with the parts that are bathed in sunlight, and gradually lightens up against the darkest areas of the neck and face.

MATERIALS

SURFACE
One piece of Rising Stonehenge paper

PRISMACOLOR PENCILS
Apple Green
Black
Burnt Ochre
Chartreuse
Cream
Dark Umber
French Grey 10%
Goldenrod
Indigo Blue
Jasmine
Parrot Green
Peacock Blue
Peacock Green
Pumpkin Orange
Terra Cotta
True Blue
Tuscan Red
Warm Grey 90%
White

OTHER
Drafting Brush
Graphite pencil
Kneaded eraser
Stylus or embossing tool

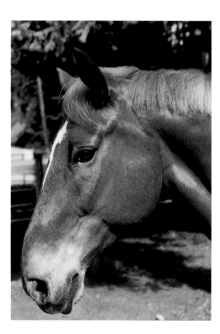

**Chestnut Horse
Reference Photo**

Chestnut Horse Line Drawing
Enlarge the line drawing to the size you would like your finished piece to be. Transfer the line drawing by gently tracing the image onto the paper with a graphite pencil. Blot the graphite lines with a kneaded eraser and sweep the paper with the drafting brush to ensure a clean working surface. Emboss a few hairs that overlap the background at the top of the head. Also, emboss a few hairs inside the right ear.

 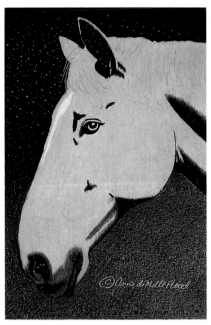

1 Establish the Darkest Areas

	Point	Pressure	Stroke
Indigo Blue	S	3-4	X

Shade the background with Indigo Blue full value at the top and gradually lighten near the bottom.

Dark Umber	VS	4	L

Fill in the darkest shapes of the eye including the pupil. Leave a highlight.

Dark Umber	S	4	L

Fill in the darkest shadow areas of the fur including inside the ear.

Dark Umber	S	4	L

Fill in the darkest shapes in the nostrils and mouth.

2 Establish the Fur; Begin Nose and Mouth

Indigo Blue	VS	4	L

Layer the eyeball and build the shape of the lids around the eye.

Cream, Tuscan Red	S	3	LS

Establish a basecoat of fur with Cream except for the blaze and dark areas. Layer the darkest areas with Tuscan Red.

Indigo Blue	S	3-4	L

Build the shape of the mouth and nostrils.

3 Building Color

Peacock Green, Tuscan Red	S	4	X

Darken the upper background with full-value Tuscan Red and Peacock Green.

Jasmine	S	3	C

Wash the iris with an even layer.

Jasmine	S	3	LS

Layer the fur of the entire horse using a directional stroke. Do not cover the areas of highlights.

French Grey 10%	S	3	L

Layer the light areas of skin around the nose and mouth. This is the transition area between the fur and the skin.

POINT		PRESSURE		STROKE	
D–Dull	**SD**–Semi-dull	**1**–Very Light	**2**–Light	**V**–Vertical Line	**X**–Crosshatch
S–Sharp	**VS**–Very Sharp	**3**–Medium	**4**–Full Value	**C**–Circular	**B**–Burnish
				ST–Stipple	**LS**–Loose Scribble
				L–Linear	

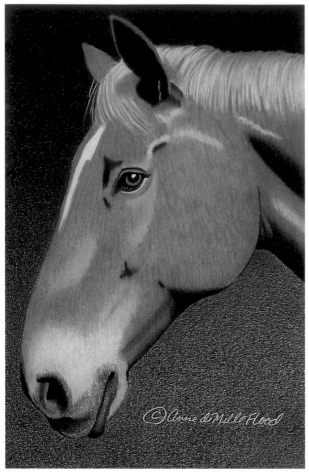

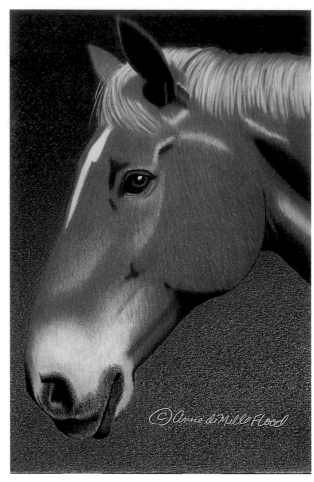

4 Layer the Background and Fur

	Point	Pressure	Stroke
Apple Green	S	3	X

Wash the lower background with Apple Green.

	Point	Pressure	Stroke
Goldenrod	VS	3	C

Layer the iris with Goldenrod.

	Point	Pressure	Stroke
Goldenrod	S	3	LS

Layer the fur with Goldenrod, leaving the highlights free of color.

5 Build the Fur, Model the Nose and Mouth

	Point	Pressure	Stroke
Parrot Green	S	3	X

Layer on the lower portion of the background.

	Point	Pressure	Stroke
Pumpkin Orange	VS	3	C

Layer the eye.

	Point	Pressure	Stroke
Pumpkin Orange	S	3	LS

Layer the fur.

	Point	Pressure	Stroke
Warm Grey 90%	S	3	L

Continue to create the shape of the nose and mouth by modeling them with Warm Grey 90%.

EVALUATE YOUR FINISHED PIECE

The shine of this horse is achieved through the layering process and also by burnishing areas that have been left free of color. If your horse does not look glossy, ask yourself if you left enough highlight to give it a glow. Rich, dark shadows will also contribute to the effect of shine. Blending the fur colors as they are layered will achieve an overall look of glossy, glowing fur.

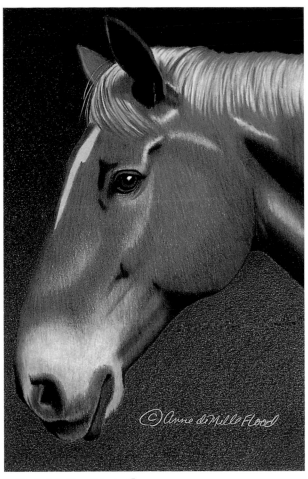

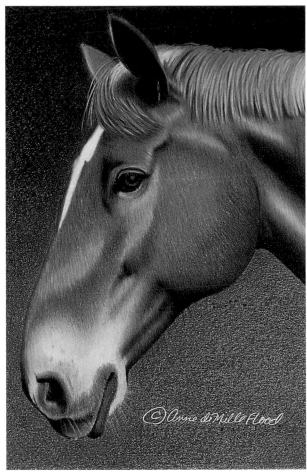

6 Add the Details

Chartreuse, True Blue S 3 X
Layer the lower portion of the background with Chartreuse and True Blue.

Terra Cotta VS 3 C
Layer the iris.

French Grey 10% S 4 B
Burnish the lower edge of the eye.

Terra Cotta S 3 LS
Continue to model the fur.

French Grey 10% S 4 B
Burnish the nose and mouth. This layer should soften and blend those areas.

7 Finishing Touches

Peacock Blue S 3 X
Wash the background for the last time.

Black, Peacock Blue VS 3 L
Reinforce the dark shapes in the eye with Black. Add Peacock Blue to the highlight and rim.

Dark Umber, Black S 4 L
Reinforce the dark shadows in the fur with Dark Umber and Black.

Burnt Ochre, Tuscan Red S 3 LS
Blend Tuscan Red and Burnt Ochre into the midtone areas.

White S 4 B
Burnish highlights into the fur with White.

Black S 4 L
Reinforce the dark shapes in the nose and mouth with Black.

White, Warm Grey 90% S 4 B
Add fine hairs with White. Add freckles with Warm Grey 90% then burnish them with White.

Acrylic
PAINT **HORSE**
DEMONSTRATION

BY JEANNE FILLER SCOTT

MATERIALS

SURFACE
Gessobord

BRUSHES
Nos. 1, 3, 4, 5 and 7 rounds

OTHER
Kneaded eraser
No. 2 pencil
Wax Paper

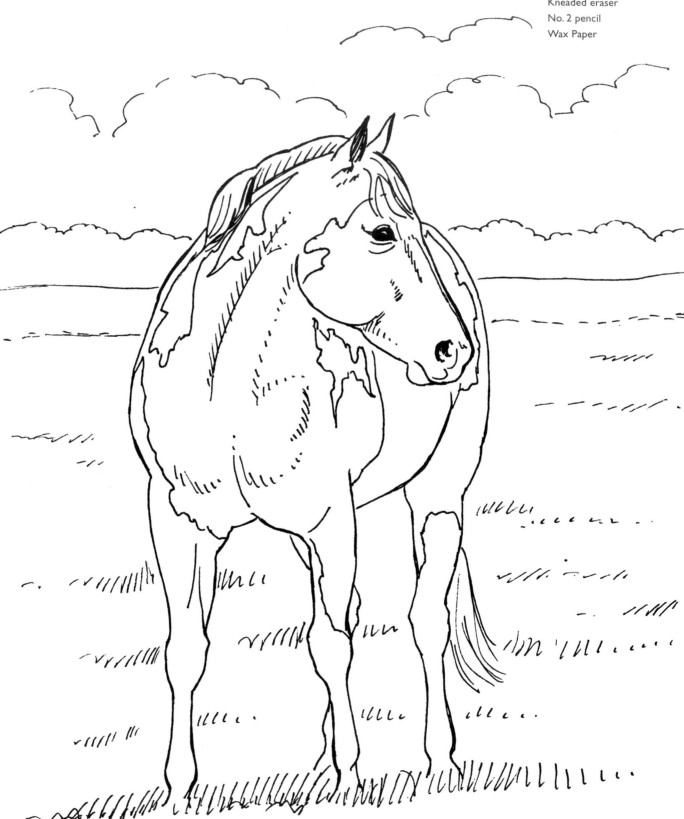

Pigments

Payne's Gray

Raw Sienna

Burnt Umber

Burnt Sienna

Ultramarine Blue

Titanium White

Scarlet Red

Cadmium Orange

Cadmium Yellow Light

Yellow Oxide

Mixtures

dark brown

bluish shadow color

warm pink shadow

red

lighter blue shadow

pink for the horse's nose

eye

eye highlight

warm white

highlight red

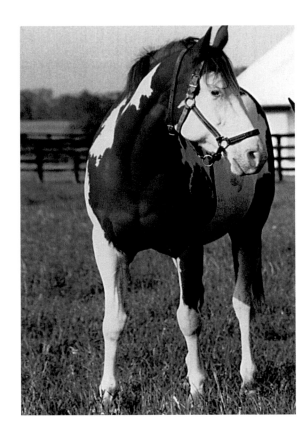

1 Establish the Form and Dark Values

Draw the horse lightly in pencil, using a kneaded eraser to make corrections or lighten lines that are too dark. With Payne's Gray thinned with water and a no. 4 round, paint the main lines and form.

Mix a dark brown for the shadowed parts of the red coat with Burnt Umber, Burnt Sienna and Ultramarine Blue. Paint with a no. 3 round. When the first layer of paint is dry, add another coat.

Mix a bluish shadow color for the white parts of the horse with Ultramarine Blue, Burnt Sienna and Titanium White. Paint with a no. 3 round.

Mix a warm pink shadow color for the nose with Titanium White, Burnt Sienna, Scarlet Red, Cadmium Orange and Burnt Umber. Paint with a no. 3 round.

2 Paint the Middle Value Colors

Mix the red for the horse's coat with Burnt Sienna, Cadmium Orange and Scarlet Red. Paint with a no. 5 round.

Mix the lighter blue shadow color with Titanium White, Ultramarine Blue and a small amount of Burnt Sienna. Paint with a no. 5 round.

ADJUST AS YOU GO

It's okay to make changes in a painting as you go along. Including the nearer fences that appear in the reference photo would have distracted from the openness of the landscape behind the horse.

3 Paint the White Parts of the Horse and Details

Mix the pink for the horse's nose with Titanium White, Raw Sienna, Scarlet Red and a touch of Cadmium Orange. Paint with a no. 3 round. Blend the edges where the pink meets the darker color on the nose with a no. 1 round and some of the warm pink shadow color from step 1.

Mix the eye color with Burnt Umber and a bit of Burnt Sienna. Paint the eye with a no. 1 round, adding another coat when it's dry. Mix Titanium White with a touch of Ultramarine Blue for the highlight, and paint in a curved arc with a no. 1 round. Correct and blend with the dark eye color and a no. 1 round.

Mix a warm white for the white parts of the horse on a piece of dry wax paper with Titanium White and a touch of Yellow Oxide. Paint with a no. 3 round, switching to a no. 1 round for the smaller details. Use a no. 3 round with the neighboring color to correct and blend the edges. If the paint begins to dry on the wax paper, add water.

4 Add Finishing Details

Mix a highlight color for the red parts of the coat with Titanium White, Cadmium Orange, Yellow Oxide and Cadmium Yellow Light. Paint with a no. 3 round, following the contours with parallel brushstrokes. With a fresh no. 3 round, blend the red coat color with quick, light strokes. Adding the red will also warm up the highlights.

Use a no. 7 round and a wash of Burnt Umber and water to paint a shadow on the horse's belly and on the shadowed white part of the left hind leg. With a no. 3 round and the bluish shadow color, add a little more detail to the white parts of the horse's head and body. Use a small amount of paint and fine, parallel lines. Soften with a separate no. 3 round and the warm white.

Sturdy Paint
Jeanne Filler Scott
Acrylic on Gessobord
10" × 8" (25cm × 20cm)

DARKEN SELECTIVELY

At times, you will need to use your artistic license to make something stand out that blends into the background in your reference photo— for example, the right hind leg of the horse. Selectively darken the shadows and the highlights on the leg so it stands out from the front leg.

Acrylic
FOAL
DEMONSTRATION

BY JEANNE FILLER SCOTT

MATERIALS

SURFACE
Gessobord

BRUSHES
Nos. 1, 3 and 5 rounds

OTHER
Kneaded eraser
No. 2 pencil

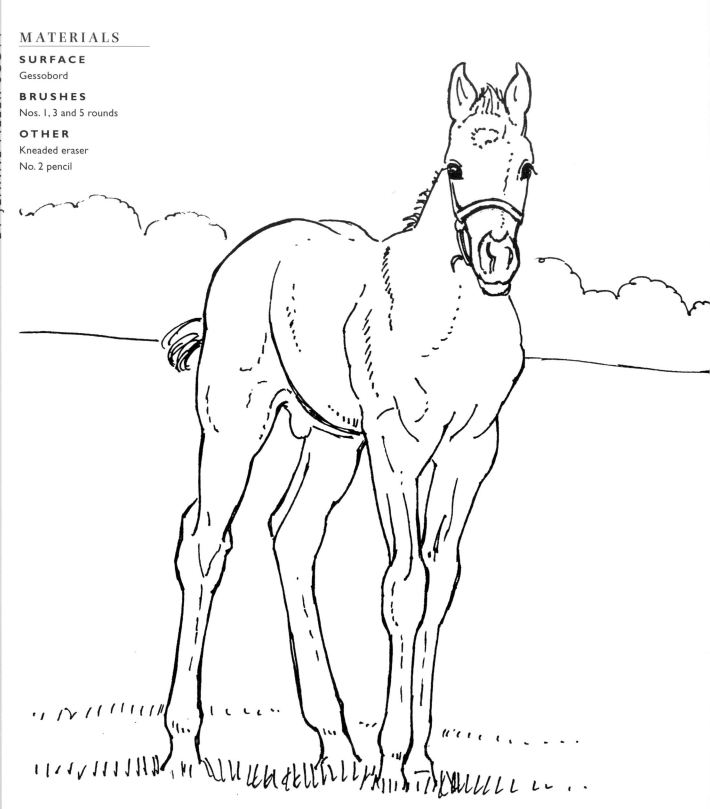

Pigments

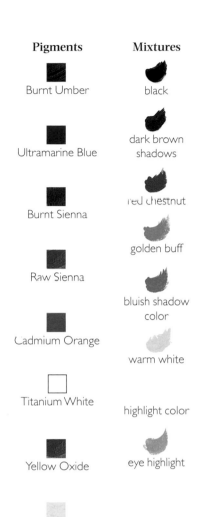

Burnt Umber

Ultramarine Blue

Burnt Sienna

Raw Sienna

Cadmium Orange

Titanium White

Yellow Oxide

Cadmium Yellow
Light

Mixtures

black

dark brown
shadows

red chestnut

golden buff

bluish shadow
color

warm white

highlight color

eye highlight

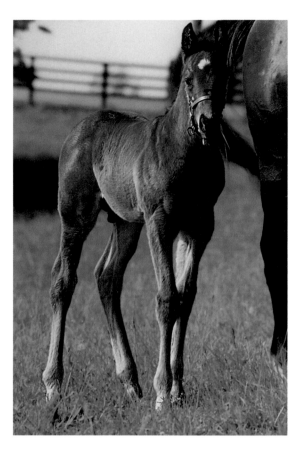

Reference
This handsome colt lives on a horse farm in central Kentucky. Even at this young age, you can already see the regal stance of the thoroughbred.

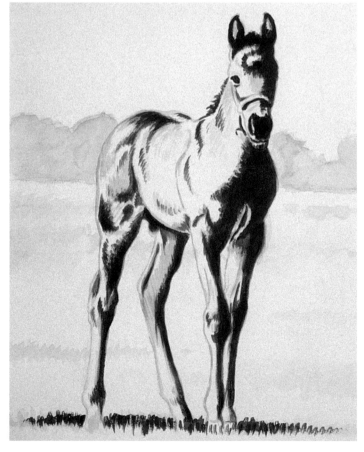

1 Establish the Form and Add the Dark Values

Draw the foal lightly in pencil onto your panel, using a kneaded eraser for any corrections. With a no. 3 round and Burnt Umber thinned with water, paint the main lines of the foal, indicating the light and dark areas.

Mix Burnt Umber and Ultramarine Blue for the black for the ears, eyes, muzzle and darker body shadows. Paint with a no. 3 round.

Mix Burnt Umber, Burnt Sienna, Raw Sienna and a small amount of Ultramarine Blue for the dark brown areas of shadow. Paint with a no. 5 round, using a no. 3 round for the smaller details. Use a no. 3 round to paint black accents over the dark brown on the lower legs, chest, etc.

2 Paint the Middle and Lighter Values

Mix a red chestnut for the foal's coat with Burnt Sienna, Cadmium Orange and Titanium White. Paint with a no. 5 round, following the hair pattern with parallel strokes.

Mix a golden buff color for the lighter parts of the foal's coat with Titanium White, Yellow Oxide and Cadmium Orange. Paint with a no. 5 round.

Mix the bluish shadow color for the coat with Titanium White, Ultramarine Blue and Burnt Sienna. Use a no. 5 round for the legs and a no. 3 round for the halter, muzzle and eyelids.

Mix the warm white for the legs and the white star on the forehead with a portion of the golden buff color mixed with more Titanium White. Paint with a no. 3 round.

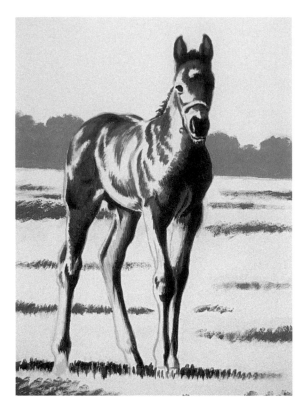

3 Add Detail to the Foal

Blend the foal's coat using separate no. 3 rounds for the red chestnut and the golden buff. Blend where the two colors meet, using a small amount of paint and light-pressured strokes. Use the same technique to blend the foal's other colors—dark brown and red chestnut, and red chestnut and bluish shadow colors. In some areas, such as the upper part of the left hind leg, blend by painting thin parallel strokes of red chestnut over the bluish shadow color. Use these same brushes and colors to add detail to the foal.

Paint the tail with dark brown and a no. 3 round, with slightly curved strokes. Use a separate no. 3 round and the bluish shadow color to paint a subtle highlight on the top of the tail, softening the edges.

ADD A TAIL

Although it doesn't show in the reference photo, you can use your artistic license to paint the foal's tail. This gives the painting a more lifelike quality, as if the foal had just swished his tail.

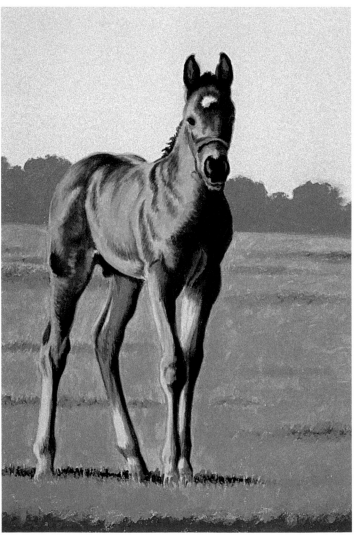

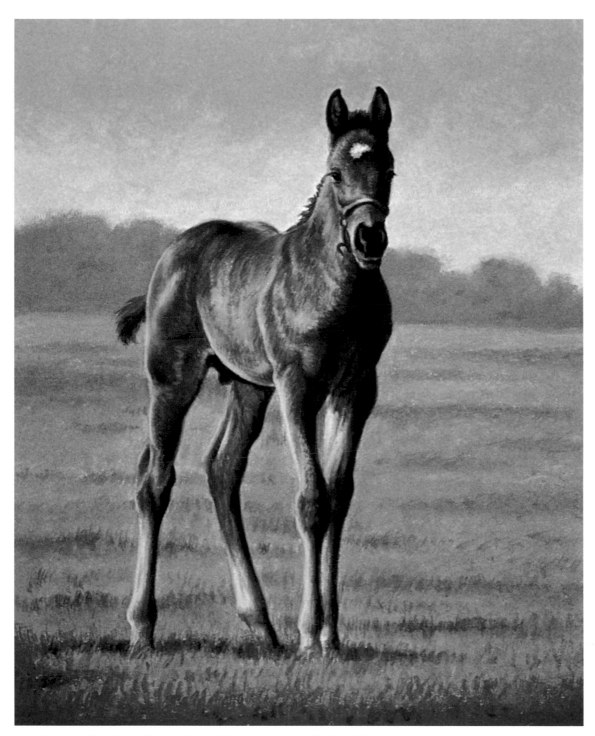

4 Paint the Finishing Details

Mix a highlight color for the foal with Titanium White and a touch of Cadmium Yellow Light. Paint with a no. 3 round.

Mix a bit of Titanium White, Ultramarine Blue and a touch of Yellow Oxide with a touch of Burnt Umber. Use this mixture to paint highlights in the eyes with a no. 1 round, with small strokes.

Chestnut Colt
Jeanne Filler Scott
Acrylic on Gessobord
10" × 8" (25cm × 20cm)

USE LIGHTER COLORS IN THE BACKGROUND

To make the background look farther away than the foreground, use colors that are lighter in value and more bluish. This is called atmospheric perspective.

Pencil, Colored Pencil and Watercolor
CATTLE

As you can see from the preliminary drawings below, cattle have very box-like trunks when seen in profile. The heads are triangular. Note that the top line is much straighter across from head to tail than that of a horse.

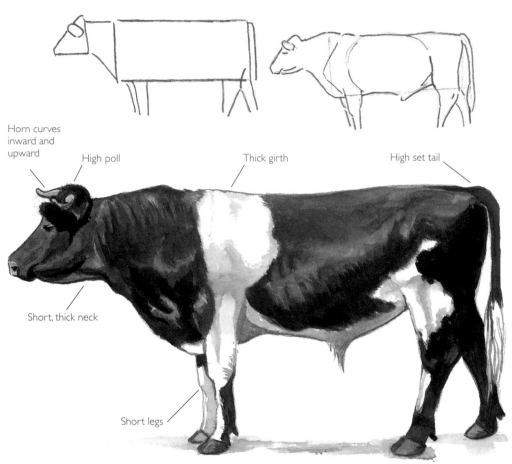

Horn curves inward and upward

High poll

Thick girth

High set tail

Short, thick neck

Short legs

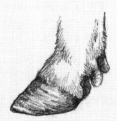

Cloven hooves

Hair Direction
The exaggerated hair marks on the dairy cow below show the direction the hairs grow. The red dots indicate whorls and cowlicks where the hair changes direction.

A full udder may extend down past the hocks

Animals seen at a distance are represented by simplified shapes and toned down values and colors.

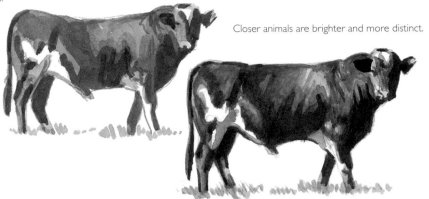

Closer animals are brighter and more distinct.

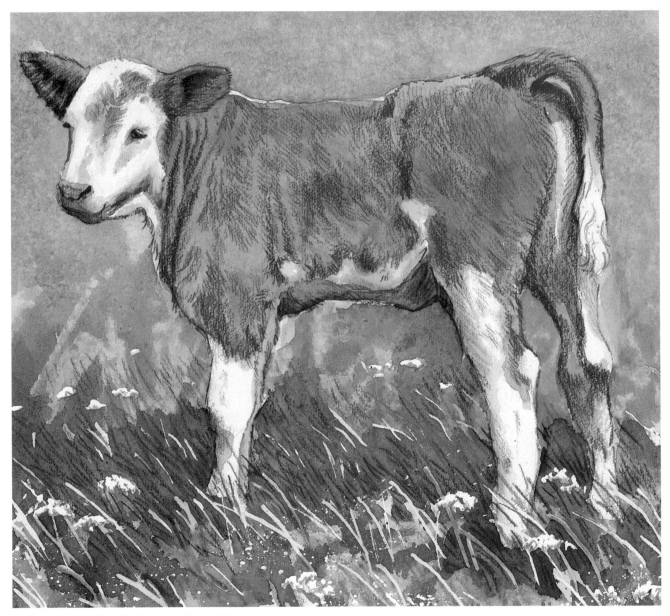

Watercolor Washes With Colored Pencil Details
This Hereford calf was blocked in with watercolor washes and detailed with colored pencil. The Queen Anne's lace and grass blades in the foreground were protected with masking fluid.

Pen and Ink
PIGS

Swine, with their comical flat snouts, large fan-like ears, rounded backs, short legs and curly tails are the most unique of the farm yard animals.

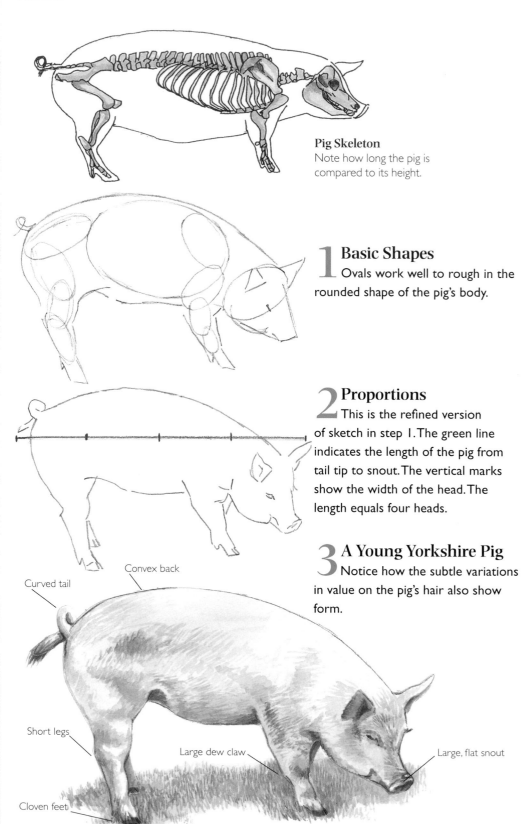

Pig Skeleton
Note how long the pig is compared to its height.

1 Basic Shapes
Ovals work well to rough in the rounded shape of the pig's body.

2 Proportions
This is the refined version of sketch in step 1. The green line indicates the length of the pig from tail tip to snout. The vertical marks show the width of the head. The length equals four heads.

3 A Young Yorkshire Pig
Notice how the subtle variations in value on the pig's hair also show form.

Curved tail

Convex back

Short legs

Large dew claw

Large, flat snout

Cloven feet

Right Front Foot

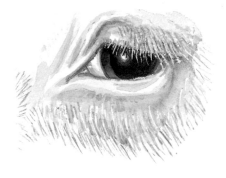

Pig's Eye
A pig's eye is almost human looking in shape and design.

Burnt Sienna Ink Sketch
The pig's nose is leathery and most often wet since swine perspire through their snouts. The nose is reinforced with gristle under the skin to allow the pig to use it as a rooting tool.

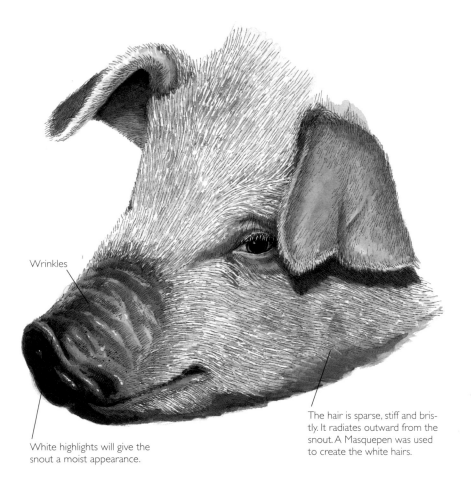

Wrinkles

White highlights will give the snout a moist appearance.

The hair is sparse, stiff and bristly. It radiates outward from the snout. A Masquepen was used to create the white hairs.

Brown Ink Work
The ears of a pig may stand erect or fold gracefully over his face like large leaves. There is a fringe of hair along the outer edges.

Front View of the Nose

Pencil, Pen, Ink and Watercolor
GOATS

Goats are the jesters of the farm yard, their comical poses provide great sketching material.

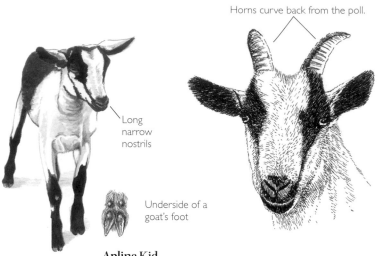

Horns curve back from the poll.

Long narrow nostrils

Underside of a goat's foot

Apline Kid
Spots and muzzle stripes are common coat patterns for the Alpine young.

Saanen Goats
These goats are usually white or cream colored.

Hair direction is upward from the nose and to the side.

Cone shaped head.

Beard

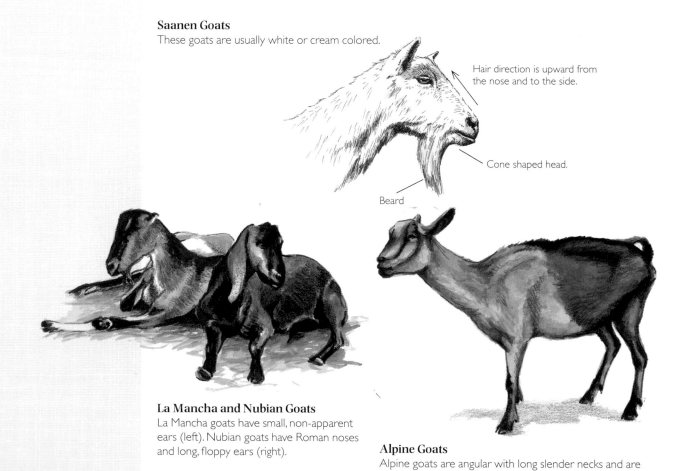

La Mancha and Nubian Goats
La Mancha goats have small, non-apparent ears (left). Nubian goats have Roman noses and long, floppy ears (right).

Alpine Goats
Alpine goats are angular with long slender necks and are often one color in the front and a different color in the rear.

LLAMAS

The llama is a member of the camel
family, originating in South America.

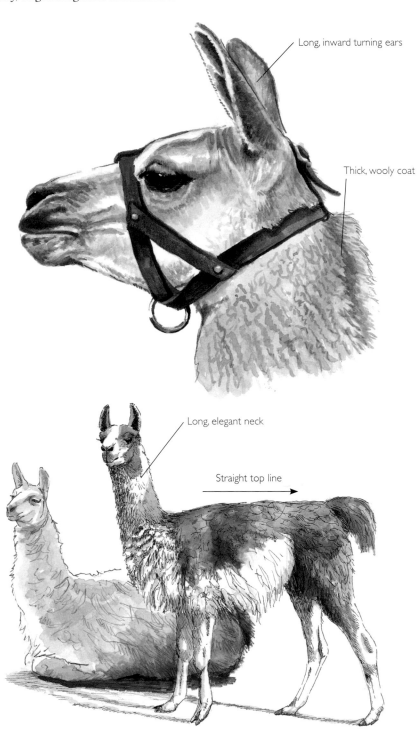

Long, inward turning ears

Thick, wooly coat

Long, elegant neck

Straight top line

Two Approaches
At left is quick sketch using a pencil and a simple watercolor
wash. The standing llama at right is a pen-and-ink sketch with
a more elaborate watercolor wash.

Large Eyes
Llamas have large eyes in comparison
to their head size. The pupils are capsule
shaped with a fringe of corpora nigra
along both edges. The eye lashes are
long and thick.

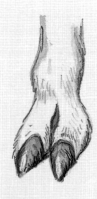

Llama Foot
Under the foot and the two horn-cov-
ered toe nails are leathery pads.

Pencil
DEER AND **SHEEP**

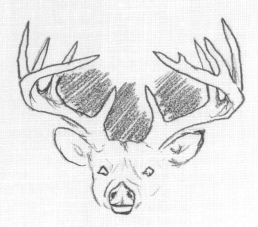

Deer Family Antlers
Elk, caribou and moose also grow ant-lers. Antlers may vary greatly among members of the deer family. The only way to know them is to study and draw them.

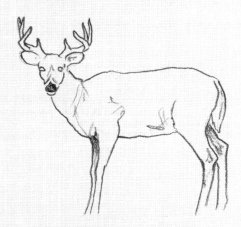

Deer Antlers
Deer grow and shed their antlers annu-ally. While these antlers are growing, they are covered in skin (called "velvet") that protects and nourishes the bone.

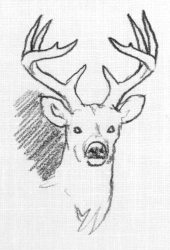

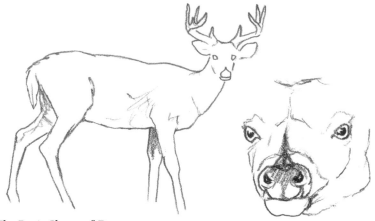

The Basic Shape of Deer
Deer are sleek, delicately built animals with long, thin legs.

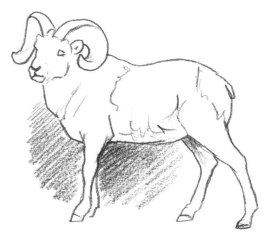

The Basic Shape of Sheep
Sheep are stocky, muscular animals. They are proud, magnificent high-country dwellers, and their wild nature and remote habitat make it challenging to take good reference photos of them.

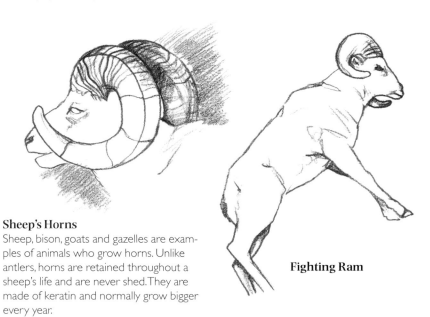

Sheep's Horns
Sheep, bison, goats and gazelles are exam-ples of animals who grow horns. Unlike antlers, horns are retained throughout a sheep's life and are never shed. They are made of keratin and normally grow bigger every year.

Fighting Ram

WHITE-TAILED DEER

The white-tailed deer has a broad white tail and a coat that is reddish tan in the summer and grayish brown in the winter. A mature white-tailed buck has antlers that sweep forward on a main beam, with tines pointing upward.

White-Tailed Buck, October in Texas
The best time to draw and paint deer (as well as sketch and photograph them in the field) is when their coats and antlers are in their prime, normally during the fall and winter. Different climates result in different "prime times" for deer around the world, but October and November seem to work well for obtaining references. Of course, spring is when the fawns are born, and you don't want to miss that!

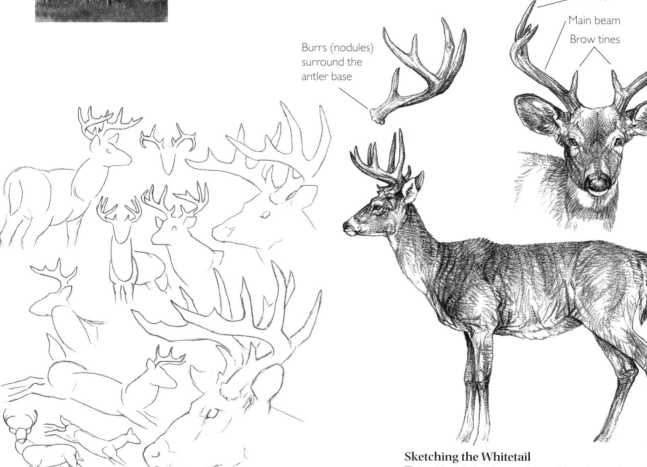

Burrs (nodules) surround the antler base

Tines

Main beam

Brow tines

Catching Poses
This is a sketch of a deer moving about in a field in Oklahoma. Try to capture many different poses for reference.

Sketching the Whitetail
This whitetail sketch was done with a charcoal pencil and blended in the shaded areas with a tortillion. Be careful in rendering individual hairs—make them more obvious in the areas where the hair is slightly longer and darker such as the neck, shoulder and tail. For contrast, let some paper show through in these areas.

Pencil
STUDY: **FACE AND ANTLERS**

A whitetail's antlers usually grow in a circular direction. That is, the main antler beams normally curve outward from their base and then back inward, thus forming something of a hoop that you could drop a ball into. All antler forms vary, but thinking of them holding a round ball can help you visualize their general form.

New antlers grow during the spring and summer months and are shed after the deers rut in late fall or winter. The antlers grow from pedestals on top of the buck's skull. The base of the antlers is usually surrounded by burrs or nodules.

Use a tortillion to shade and round the antlers. Remember, when light strikes a round object (like an antler) from the front, the round object will have the darkest shadows on its top and bottom. In antlers, this will be where they curve around to the back. If the light source is higher, the shadow will be confined primarily to the bottom. A tortillion helps to soften these shadows as they merge from light to dark.

This type of antler is considered atypical because of its odd shape

Antler tops form a hoop

Antlers in velvet

HB charcoal pencil with some tortillion blending

Drawing Antlers
Remember, all antler formations are different. This study is a quick sketch of various shapes. Not much detail or shading was done—it's primarily an exercise in the antlers' forms.

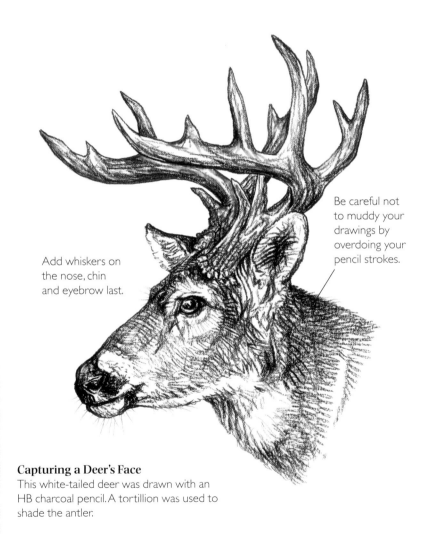

Add whiskers on the nose, chin and eyebrow last.

Be careful not to muddy your drawings by overdoing your pencil strokes.

Capturing a Deer's Face
This white-tailed deer was drawn with an HB charcoal pencil. A tortillion was used to shade the antler.

Reference Photos

Note how the antler points are rounded due to the velvet covering, which also gives them a softer, padded appearance.

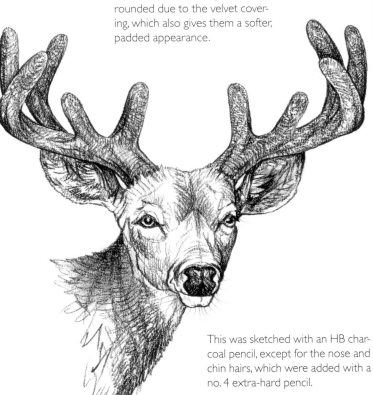

This is how the antlers will look after the velvet is shed.

This was sketched with an HB charcoal pencil, except for the nose and chin hairs, which were added with a no. 4 extra-hard pencil.

Velvet can be drawn by making short pencil strokes to indicate the hairlike surface of the growing antlers.

Pencil
STUDY: **BIGHORN RAM**

A Rocky Mountain bighorn ram has massive, curved horns and can weigh over 300 pounds (136kg). A mature ram has a shoulder height of over 3 feet (91cm) and a length of about 6 feet (183cm). A large, heavy-horned ram is one of nature's most impressive wild creatures, and drawing one is both a joy and a challenge. Practice drawing the horns from various angles to understand their curvature and flare. The horns are truly a difficult subject. Gathering as much reference material as you can on them will be a great help to your drawing.

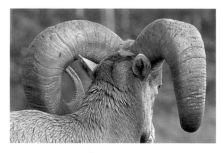

Ram in September
This photo shows the rear of the ram's horns.

Creating the Illusion of Depth
These illustrations of a bighorn's head show that even the faces of animals have curves, ridges and creases. Draw the hair in different directions to suggest these facial structures.

The illustration at the bottom shows how to project the ram's horns forward by heavily shading the face. Study how the horns curve not only in a C-shaped pattern, but also curve outward.

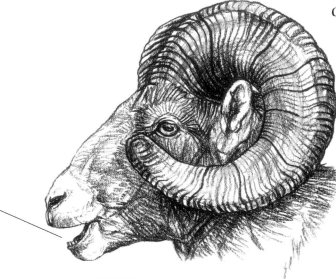

A ram's bottom teeth will show when its mouth is open. Sheep have no upper front teeth.

You can determine the age of a sheep by counting the winter (dark) growth rings on the horns.

Horn tips are often broken off (broomed) on older rams.

Heavy shading makes the horns appear to come forward.

STUDY: **BIGHORN EWE**

The bighorn sheep ewe has slender, short horns and can weigh up to 200 pounds (91kg). Mature ewes have a shoulder height of over 30 inches (76cm) and a length of about 5 feet (152cm). The little squiggles and sketches here are only suggestions … do what you like!

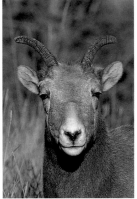

Ewe Horns
Ewe horns don't grow longer than a half curl, whereas ram horns are often longer than a full curl.

Pay Attention to the Tips
Horn tips are normally dulled and the ridges on the horns are less noticeable toward the tips.

Save the Darks for Last
When drawing bighorns, save your darkest pencil strokes for the nose, hooves, tail and deep shadow areas around the body.

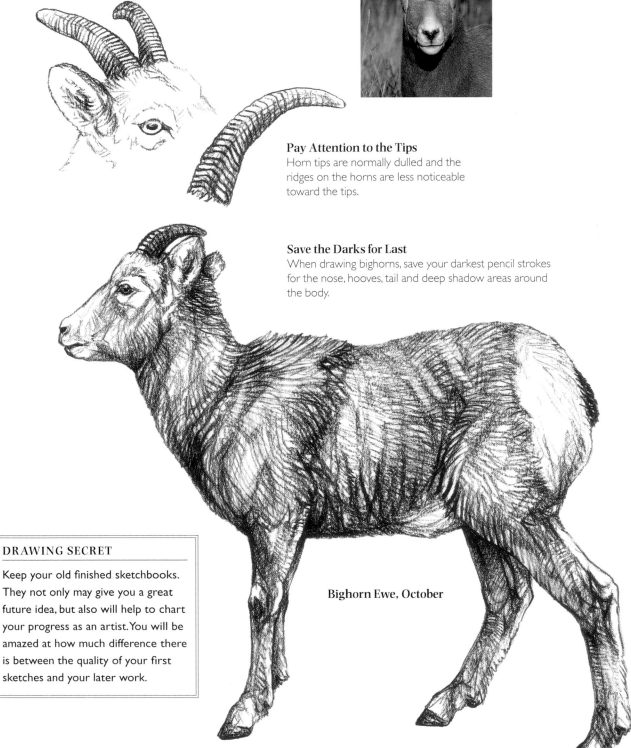

DRAWING SECRET

Keep your old finished sketchbooks. They not only may give you a great future idea, but also will help to chart your progress as an artist. You will be amazed at how much difference there is between the quality of your first sketches and your later work.

Bighorn Ewe, October

Pencil
DALL **RAM**
DEMONSTRATION

BY DOUG LINDSTRAND

North America's Dall sheep are confined mainly to Alaska and the Yukon. They are referred to as thin horn sheep because their horns are slender, less massive and more flared than the bighorn's. Their coats are white, so they don't have the distinctive white rump of the brown-coated bighorn. The Dall's horns are a yellowish brown, and their body weight is about a third less than the bighorn's.

MATERIALS

SURFACE
Drawing paper of choice

PENCILS
HD Charcoal
HD Graphite

OTHER
Kneaded eraser
Spray fixative
Tracing paper

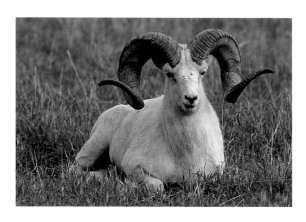

Dall Ram, September

1 Create the Initial Sketch
Doodle to establish the basic form and pose.

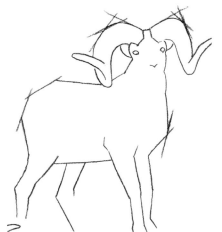

2 Refine the Animal's Shape
Use tracing paper overlays to refine the animal's shape. This will help you more easily and accurately create a realistic drawing.

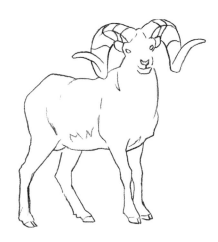

3 Finalize Your Outline
Use another overlay to finish sketching the outline of the ram. Add the outline of the nose, mouth, hooves and indicate the direction of hair growth. Map out the horns' growth rings. Transfer the drawing to your final surface.

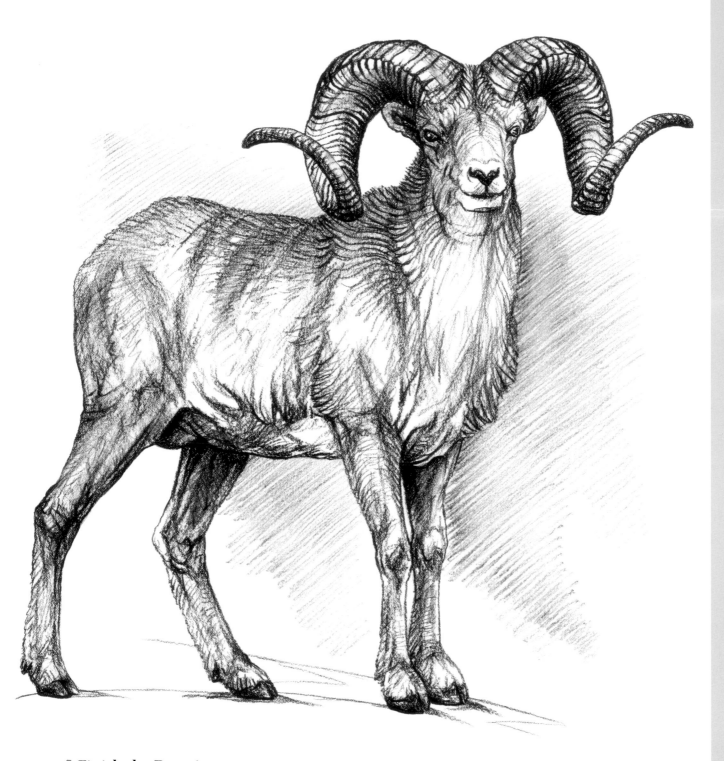

4 Finish the Drawing

Keep pencil lines to a minimum on the white coat, but use dark, heavy lines to indicate the hair's direction and thickness and to suggest musculature. Blend where appropriate. Pull out highlights with a kneaded eraser, using only the clean parts of the eraser so you do not muddy the white coat. Add the darkest darks to the shadow areas, clean up any smudges and spray with fixative.

Pencil
ADULT GIRAFFE
DEMONSTRATION

BY DOUG LINDSTRAND

This adult giraffe displays a common pattern of spots. Of course, they are not really spots, but more like variously shaped mosaic pieces. Markings can vary greatly in giraffes from different areas of Africa.

MATERIALS

SURFACE
Drawing paper of choice

PENCILS
HD Charcoal
HD Graphite

OTHER
Kneaded eraser
Spray fixative
Tortillion

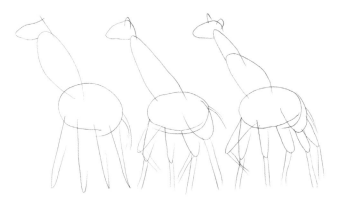

1 Doodle to Achieve the Correct Proportions
Draw the basic shapes to determine the correct proportions and pose. Keep doodling until you have a fairly accurate shape.

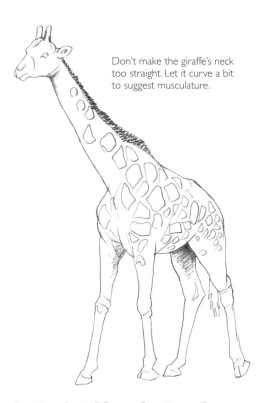

Don't make the giraffe's neck too straight. Let it curve a bit to suggest musculature.

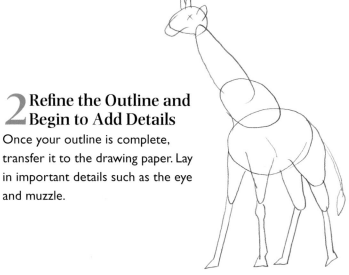

2 Refine the Outline and Begin to Add Details
Once your outline is complete, transfer it to the drawing paper. Lay in important details such as the eye and muzzle.

Notice the back leg is lifted to suggest movement. This makes the drawing more interesting than if the giraffe were standing flat-footed.

3 Finish Adding the Details
Begin to lightly pencil in the giraffe's markings and features such as the eye, ear, mane and horns. Using light strokes will make it easier for you to erase mistakes, if necessary. Outline the spots with irregular edges. Keep layering in the spot pattern until you have covered the entire giraffe.

ANIMAL SECRET

Both male and female giraffes have horns.

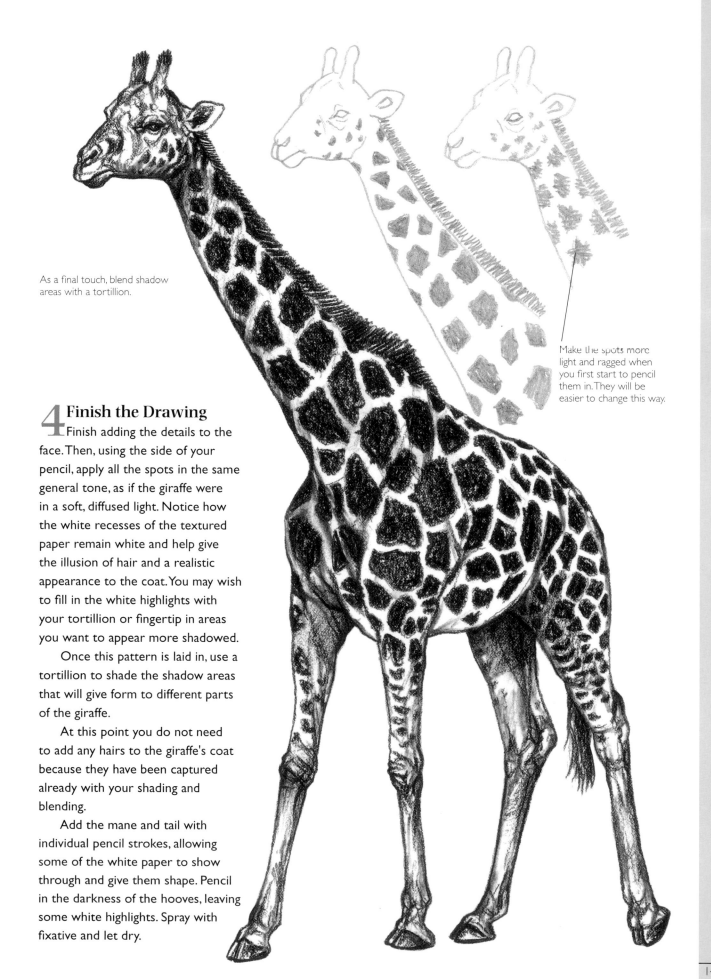

As a final touch, blend shadow areas with a tortillion.

Make the spots more light and ragged when you first start to pencil them in. They will be easier to change this way.

4 Finish the Drawing

Finish adding the details to the face. Then, using the side of your pencil, apply all the spots in the same general tone, as if the giraffe were in a soft, diffused light. Notice how the white recesses of the textured paper remain white and help give the illusion of hair and a realistic appearance to the coat. You may wish to fill in the white highlights with your tortillion or fingertip in areas you want to appear more shadowed.

Once this pattern is laid in, use a tortillion to shade the shadow areas that will give form to different parts of the giraffe.

At this point you do not need to add any hairs to the giraffe's coat because they have been captured already with your shading and blending.

Add the mane and tail with individual pencil strokes, allowing some of the white paper to show through and give them shape. Pencil in the darkness of the hooves, leaving some white highlights. Spray with fixative and let dry.

Pencil
BEARS

Bears are members of the Ursidae family, which comprises nine different species in the Americas and Eurasia. Although they are all distinctly different, they also share many common characteristics. Drawing realistically means including the small but necessary details that distinguish individual animals. Grizzly bears have a muscular, densely furred body, small rounded ears and a concave, or dish-shaped, face. They possess a prominent shoulder hump and have long, slightly curved claws. They can range in color from almost white to almost black, depending on heredity, sun bleaching and molting.

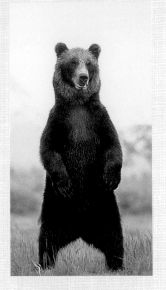

ANIMAL SECRET

The grizzly bear often stands on its hind legs to improve its view or to smell the air.

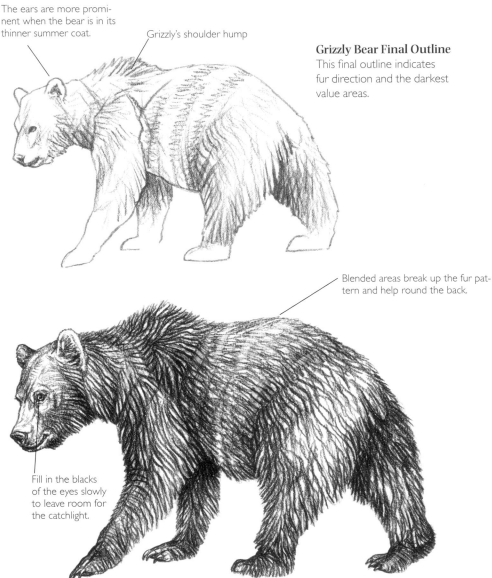

The ears are more prominent when the bear is in its thinner summer coat.

Grizzly's shoulder hump

Grizzly Bear Final Outline
This final outline indicates fur direction and the darkest value areas.

Blended areas break up the fur pattern and help round the back.

Fill in the blacks of the eyes slowly to leave room for the catchlight.

Lifting the bear's front and back foot gives the impression of movement and makes for a more interesting pose.

Grizzly Finished Drawing
This final drawing was sketched with an HB charcoal pencil. Before it was sprayed with a fixative, a few swipes were made with an eraser to lighten the bear's back. These slight highlights help to round the animal's body. Also, a slight rubbing with a tortillion darkened the area under the bear's head and helped add depth to the drawing. This bear is in its summer coat, so the fur is not as full and thick as it would have been had the bear been in its winter coat.

BY DOUG LINDSTRAND

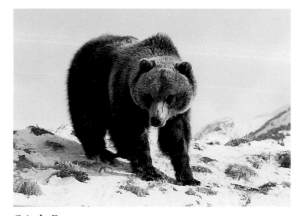

Grizzly Bear

This grizzly's interesting pose can work for almost any purpose, whether as a simple illustration or as a reference for a painting. It is a difficult pose to draw accurately because of the complex shading required by the turned head. Profile drawings are easier, but not as interesting. Moreover, this pose emphasizes the grizzly's distinguishing features: the humped shoulder, the round, dish-like face and the long front claws. As you draw the fur, keep your individual pencil lines as clean and distinct as possible to illustrate how the bear's fur changes direction around its body.

MATERIALS

SURFACE
Drawing paper of choice

PENCILS
HD charcoal
HD Graphite

OTHER
Kneaded eraser
Tracing paper

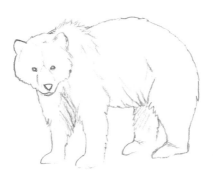

1 Establish An Accurate Outline

Once you've used basic shapes sketches to establish correct proportions, use tracing paper overlays to create the outline. Lightly transfer this to the final surface.

2 Add the First Layer of Fur

Lightly pencil in the bear's fur, making sure it follows the direction of the bear's body.

3 Fill in More Fur

After you have the first layer of fur lightly applied in the proper direction, you can begin to overlay more fur. As you fill in your drawing, slightly change the angle of your fur strokes to make your image look more natural.

4 Finalize the Drawing

Add the facial details and the paws before adding any shading. Notice the face is lighter on the left side to show the direction of the light. Put in the darkest areas, which are the shadows behind the face, under the chin and under the back legs. Making these areas the darkest darks will emphasize the head.

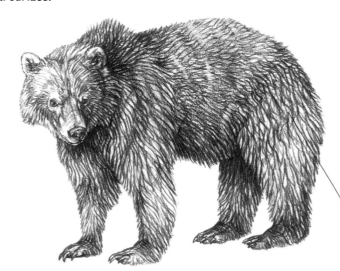

The final fur lines are not straight but are more squiggly.

Watercolor
ELEPHANTS
DEMONSTRATION

BY LIAN QUAN ZHEN

This demonstration will teach you the Color Pouring and Blending technique to paint elephants. If you paint with the traditional method, you can use large brushes to create washes for the foreground and background. Pouring the colors on the paper gives you an unexpected but very beautiful blending effect. There are no brushstrokes so the foreground and background colors smoothly reflect each other—great for illuminating and diffusing landscapes. Pouring also creates a unified color scheme for the entire painting.

Preparing Colors for Pouring
Mix each of the three primary colors with water in three small cups. Stir the colors with brushes until they completely dissolve in the water. There are two rules for making the color liquids: (1) The darker the background, the more pigment; the lighter the background, the more water. (2) Never mix the Yellow lighter than its midtone or it will be muddy after the colors mix with each other. For this color pouring demonstration, prepare midtone color liquids. The ratio between color and water is approximately 1 to 15.

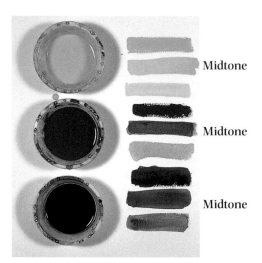

Midtone

Midtone

Midtone

MATERIALS

SURFACE
140-lb. (300gsm) cold-pressed watercolor paper, half sheet

BRUSHES
1-inch (25mm) flat
Nos. 4 and 8 rounds

PIGMENTS
Cadmium Yellow Light
Permanent Red Deep
Ultramarine Blue

OTHER
Masking fluid
Masking pick-up eraser (optional)
Packing tape
Paper towels
Pencil
Table salt
Three small dishes (containing the three midtone primary color liquids)
Spray bottle

1 Sketch the Composition and Mask Out Negative Space

Sketch a group of elephants onto your paper, leaving room for grass in the foreground and sky in the background. Block the negative spaces with masking fluid: the sky and the spaces between the elephants. Also mask the tusks and the foreground grasses. After the masking fluid dries, wet the paper with water using the spray bottle. This allows the colors to gracefully blend into each other.

2 Pour the First Color

Since this will be a warm background—either a sunrise or sunset—use more Cadmium Yellow Light and Permanent Red Deep than Ultramarine Blue. First pour the Cadmium Yellow Light on the tops of the elephants' heads and bodies.

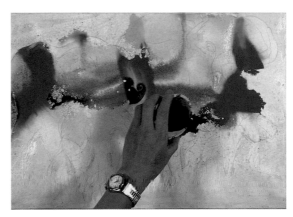

3 Pour the Second Color

Immediately pour the Permanent Red Deep next to the Cadmium Yellow Light. Let the colors blend into each other. Help the colors blend by spraying more water on them, blowing them into each other, and using a large brush like the 1-inch (25mm) flat or the no. 8 round to mix them together.

4 Pour the Third Color

Pour the Ultramarine Blue below the Permanent Red Deep, on the middle and lower parts of the elephants. Try to create a darker color value here.

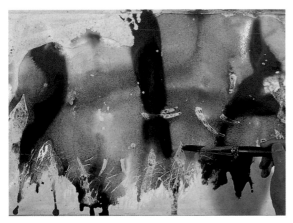

5 Direct the Colors and Avoid Mud

Direct the blending of the colors around the paper with a 1-inch (25mm) flat. Also use the brush to bring the colors to the bottom part of the painting. Do not brush too much in one spot or you will overmix the colors and make that area muddy.

6 Tilt the Painting

Tilt your painting down toward you so the colors flow down the paper. This gets rid of the excess liquid while letting the colors mix gracefully. Tilt the paper in one direction only or your painting will get muddy.

7 Add Texture

As you are tilting the painting, spray water from the top of the painting down, creating light rays. Drop some table salt on the painting to create a dusty effect. Notice this effect on the bottom of the elephants.

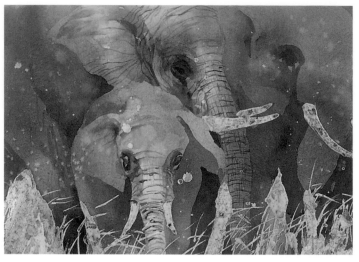

8 Define the Elephant Shapes

When the painting is dry, use the nos. 4 and 8 rounds to define the shapes of the elephants. Use the no. 4 round to paint and the no. 8 round to blend the colors. Apply colors that are darker than the existing colors to create the details. Use brown and dark brown on the elephant foreheads because the original color is orange.

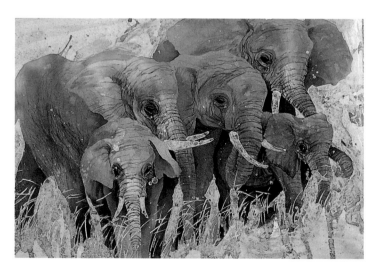

9 Enhance the Details

Apply darker values to contrast the light values so the elephants stand out.

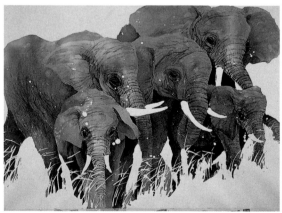

10 Remove the Masking

After the paint dries, remove the masking. You can use a masking pick-up eraser. I use 1- to 2-inch (25mm, 51mm) pieces of packing tape. Hold the nonadhesive side of the tape with your thumb and index finger and press the adhesive side against the masking and pull it up.

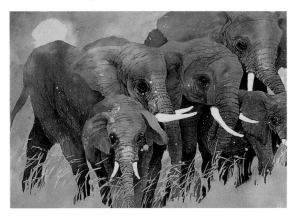

11 Paint Sky and Grass
Wet the sky and the grass area with the 1-inch (25mm) flat. Leave a dry circular area on the upper left for the sun. Paint the sky using a mixture of Cadmium Yellow Light and Permanent Red Deep. Paint the grass with Cadmium Yellow Light.

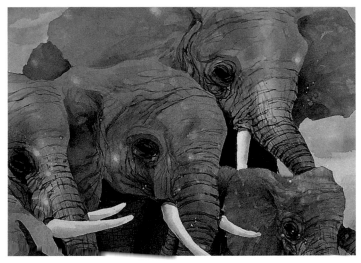

12 Create Dust
Use a paper towel to soften the hard edges of the salt spots (added in step 7) near the eyes of the elephants. Wet the towel and use it to scratch the white spots until the hard edge is gone, giving the impression of dust.

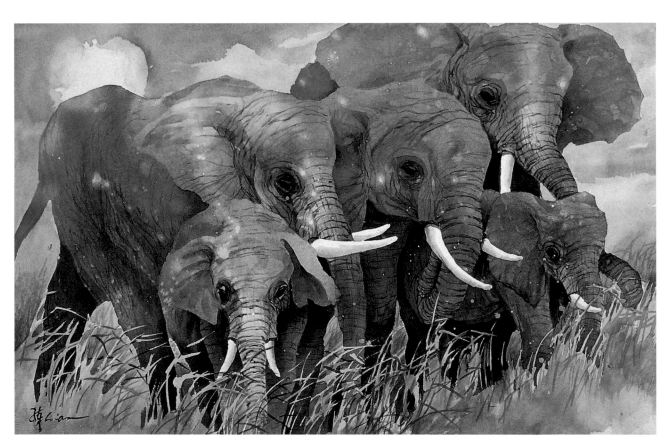

13 Add Final Details
Use the no. 4 round to paint the brownish grass in the front and the purplish color in the background. Sign your name at the lower left corner, not the right corner, because the elephants are walking toward the right and the composition needs space for their movement.

Elephants
Lian Quan Zhen
Watercolor on paper
11" × 15" (28cm × 38cm)

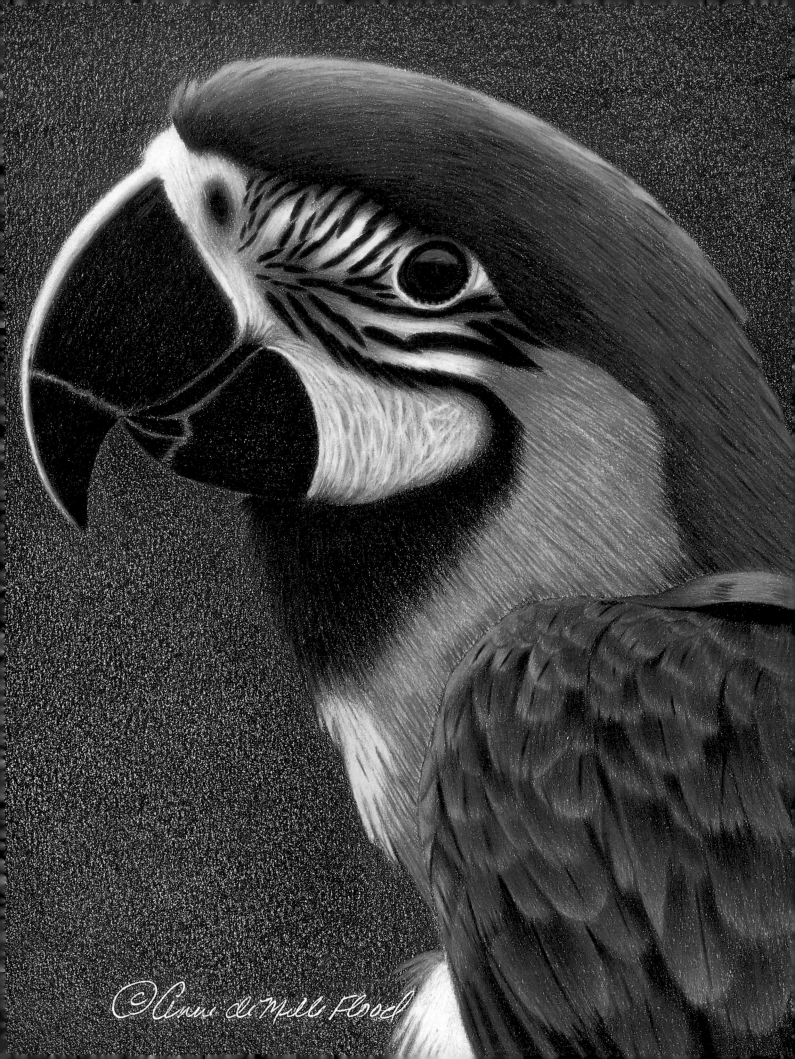

Anne di Mele Flood

Chapter FIVE | **Birds**

The incredible variety of the animal kingdom is no more clearly evident than in the avian world. Feathers offer an intriguing excercise for rendering texture and birds' body variations are a lesson in the sleek mystcry of nature. The range of color, shape, size in birds is almost limitless.

Blue and Gold Macaw
Anne deMille Flood
Colored pencil on paper
14" × 11" (36cm × 28cm)
Collection of the Artist

Colored Pencil
BIRD BEAK **COLOR SAMPLES**

Birds vary extensively in color and so do their beaks. Beaks also range widely in texture, size and shape; however, their diversity does not mean that they are difficult features to render. You can see from the samples shown here that often you only need to apply a few colors to achieve the desired effect and the process can be quite simple and quick. Look at these samples and use the information to apply to other situations, and remember, simplicity is the key.

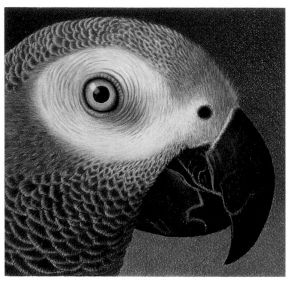

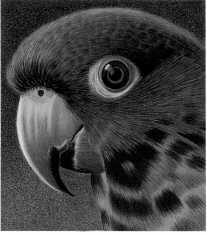

African Gray Parrot
This beak is easy to render in just a few quick steps. It has some cracks that you have to pay attention to, but other than that it is not difficult. First, establish the value pattern with a tonal foundation of Black using medium- to full-value pressure. Leave some crooked lines free of color to denote the cracks in the beak. Next, wash the entire beak with a medium-pressure layer of Black Grape and Indigo Blue, even over the cracks. Be careful to follow the curve of the beak with linear strokes. Then reinforce the darkest areas of the beak with full-value Black and burnished White over the cracks. Use your White pencil to add some areas of shine on the beak.

Kimbaroo
Anne deMille Flood
7" × 8" (18cm × 20cm)
Private Collection

Red-Throated Conure
For this conure, start with a wash of French Grey 10% on both the upper and lower sections of the beak. Next, establish the dark markings, again on both the upper and lower sections with French Grey 70% and Black. Then apply a wash of Beige to the light areas, and Light Umber to create the streaks in the upper section. Wash the lower section with Light Umber. Finally, layer Mineral Orange over the Light Umber and burnish on White streaks. Touch-up with the Black pencil to darken the space between the two sections of the beak.

Poquita
Anne deMille Flood
10" × 8" (25cm × 20cm)
Private Collection

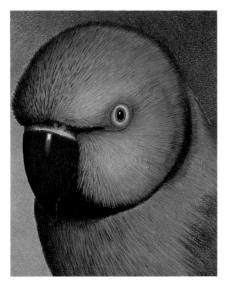

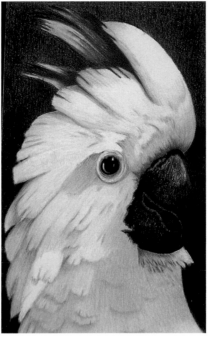

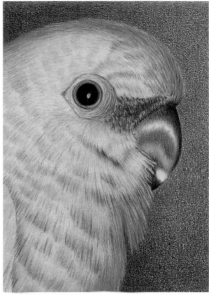

Ring-Necked Parakeet

This is another example of a beak that can be rendered in a few simple steps. First, establish the shadow areas by layering them with Indigo Blue. Then apply three consecutive washes of Carmine Red, Crimson Red and Magenta to the entire beak with the exception of the highlight. Never use fewer than three layers of color in any given spot. The three shades of red were applied to give it depth. Burnish White over the highlight to make it look shiny and reinforce the dark areas once again with Indigo Blue.

Oscar
Anne deMille Flood
10" × 8" (25cm × 20cm)
Collection of the Artist

Moluccan Cockatoo

This is a beak that appears cracked and also a little dusty. Cockatoos are called "powder birds" because of the powdery effect you often see on their beaks. Develop this beak by applying Indigo Blue and Black Cherry as your first washes. Then apply Black to darken portions of the beak, creating the effect of texture. Finally, burnish White all over to create the powdery effect and apply Indigo Blue to darken where necessary.

Molucca
Anne deMille Flood
14" × 11" (36cm × 28cm)
Collection of the Artist

Goffin Cockatoo

There is quite a bit of shine on this cockatoo beak, so it is important to leave a large, light area and to build the colors up around it to create contrast and make it appear shiny. Start with a wash of French Grey 10% over the entire beak and then apply a layer of French Grey 70% to darken the tip and upper edge of the beak. Then apply a wash of Rosy Beige over the entire beak with the exception of the shiny area. Layer Blue Violet Lake over most of the Rosy Beige, but not all. Apply Indigo Blue to darken the tip and upper edge. Finally, burnish White over the light area to give a smooth, glossy highlight.

Miki
Anne deMille Flood
10" × 8" (25cm × 20cm)
Collection of the Artist

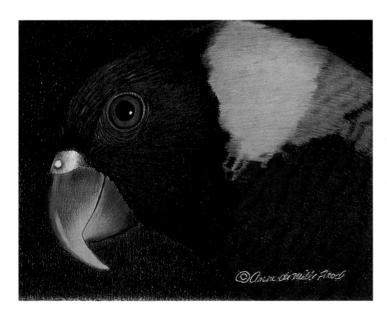

Rainbow Lorikeet

This is an example of a very colorful beak. Start with a first wash of Spanish Orange for both the upper and lower sections of the beak. Then model both sections using Pale Vermilion. See how the linear stroke follows the shape of the beak—very important. Burnish the entire beak with Yellowed Orange and apply Poppy Red to just the edges. Burnish a bit of White to add some shine on the upper section of the beak.

Tango
Anne deMille Flood
8" × 10" (20cm × 25cm)
Collection of the Artist

Pencil and Watercolor
CANARIES AND FINCHES

These song birds are similar in build. Both are small, rather delicate and have feet built for perching. Three long slender toes face to the front and the fourth toe points to the back.

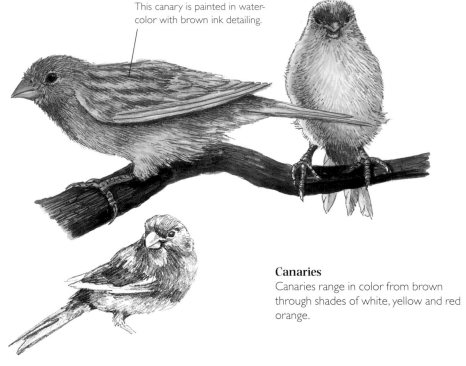

This canary is painted in watercolor with brown ink detailing.

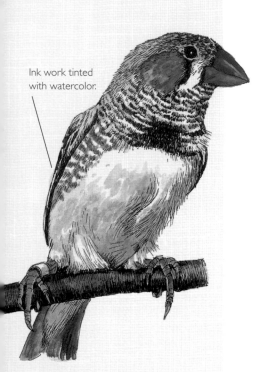

Ink work tinted with watercolor.

Zebra Finch
The popular zebra finch is named for the black and white stripes on the neck of the male.

Canaries
Canaries range in color from brown through shades of white, yellow and red orange.

This is a watercolor study of a cordon bleu finch.

This Gouldian finch wears all of the primary and secondary hues. His lower breast is bright yellow.

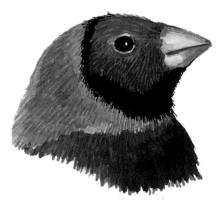

Finches
Finch bills are shaped like short, thick cones. Note that the bottom of the eye lines up with the bill opening.

BUDGIES AND COCKATIELS

Budgerigars, often referred to as parakeets, are native to Australia. The wild coloration is green, yellow and black.

Here is a step-by-step blue budgie to practice painting.

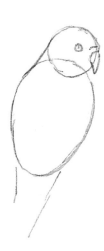

1 Basic Shapes
Begin with a circle and egg shape in pencil.

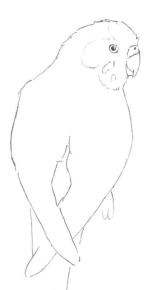

2 Enhance Drawing
Refine the pencil drawing.

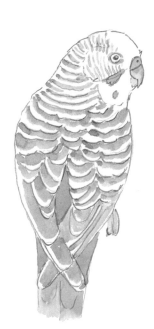

3 Add Feathers
Lightly pencil in rows of feathers across the head and back. Lay down the preliminary washes of color.

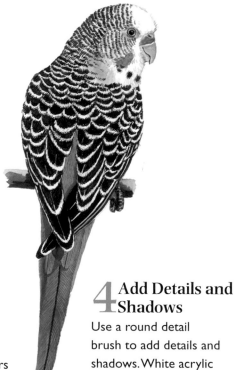

4 Add Details and Shadows
Use a round detail brush to add details and shadows. White acrylic paint can be used to fill in lost feather edges.

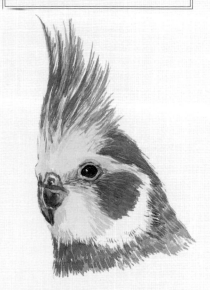

Cockatiels
These are also Australian natives. They are larger than budgies and sport a feathered crest.

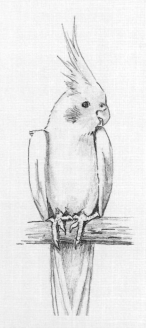

Lutino Cockatiel
These birds have four toes, two to the front and two to the rear.

Water-Soluble Oil
CARDINALS
DEMONSTRATION

BY BART RULON

This painting demonstrates how to combine birds from two different photos to make one cohesive painting of a cardinal pair. This demo is a good example of learning what to leave in and what to take out of your photos. Both the male and female cardinal were photographed near a bird feeder in central Kentucky. Both birds were photographed on the same day. The photo blind was positioned directly under the feeder so that the birds would approach it with caution and land in the trees nearby for a natural background.

MATERIALS

SURFACE
12" x 9" (30cm x 23cm) hardboard panel primed with gesso

BRUSHES
(Grumbacher Renoir 626-R)
No. 10 filbert sable
Nos. 4 and 7 round sables
(Winsor & Newton Monarch)
Nos. 00 and 0 rounds

PIGMENTS
(Max Grumbacher Oils)
Burnt Sienna
Cadmium-Barium Red Light
Cadmium-Barium Yellow Light
Ivory black
Permanent Blue
Raw Sienna
Raw Umber
Thio Violet
Titanium White

OTHER
Plastic wrap
Water used as a painting medium with each painting mixture

Reference photos for the birds and branches.

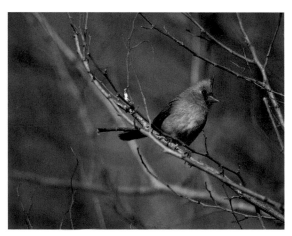

Additional reference for the branches.

Idea Sketches and the Drawing
Draw simple outlines of the birds and place them in a variety of positions to come up with the best composition.

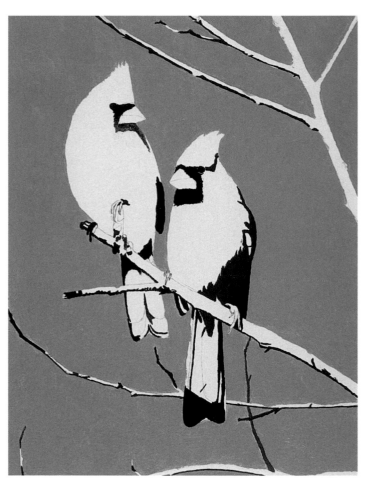

1 Block In Colors

In order to keep the focus on the birds in this painting, take out the busy background shown in the photos and replace it with clear blue sky. Keep the main branches shown in the foreground on the photo of the female. Block in the sky with a mix of Permanent Blue, Titanium White and Thio Violet using the no. 10 filbert. Use the no. 4 round for the rest of this step. Paint the undersides of the branches using various mixtures of brown consisting of Raw Umber, Permanent Blue, Burnt Sienna, Ivory Black and Titanium White.

For the shadows on the undersides of the cardinals' tails mix Raw Umber, Burnt Sienna, Thio Violet, Cadmium-Barium Red Light and Ivory Black. Add more Cadmium-Barium Red Light to this tail mix for the red on the male's lower belly. Mix Ivory Black, Raw Umber, Permanent Blue and a touch of Titanium White for the black bib around the male's beak. Add more Raw Umber and Titanium White to the mix for the female's bib. Block in the eyes on both birds with a mix of Burnt Sienna, Raw Umber and Ivory Black.

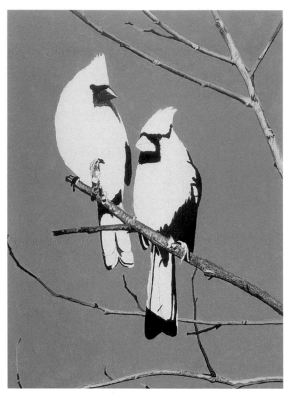

2 Paint and Blend the Branches

Create seven different mixtures of paint for the branches, ranging from the lightest lights to the darkest darks. The mixtures should contain various amounts of Raw Sienna, Thio Violet, Permanent Blue, Burnt Sienna, Raw Umber, Ivory Black and Titanium White. Use the no. 4 round to paint the colors on the branches wet-in-wet, blending colors where needed. Start with the dark colors on the branches and blend lighter colors on top of them. Underpaint the female's beak with a mix of Cadmium-Barium Red Light and a touch of Cadmium-Barium Yellow Light.

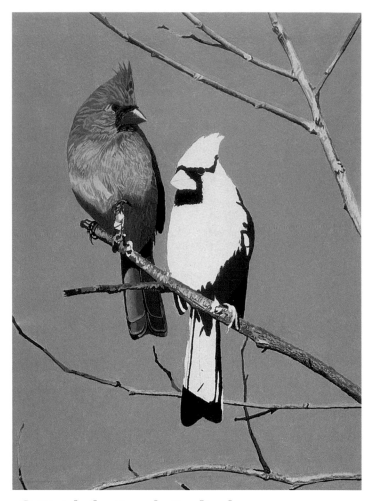

3 Finish the Female Cardinal

Use the no. 7 round to block in the color on the head and neck of the female cardinal with a mix of Raw Sienna, Raw Umber, Permanent Blue and Titanium White. Make a darker mixture for the lower belly by adding less Raw Sienna and less Titanium White to the previous mix. Paint the dark feather details on the bib around her beak with a mix of Ivory Black, Raw Umber and Titanium White, using the no. 00 round. Use the no. 00 round and a mix of Ivory Black, Raw Umber and Permanent Blue to paint the dark pupil and the outside edges of the eye. Mix Cadmium-Barium Yellow Light, Raw Sienna and Titanium White for the base color on the chest. Blend to a lighter mix, with Raw Umber added, for the middle belly. On top of this base you will paint darker and lighter colors wet-in-wet with the no. 00. Pay close attention to the feather directions shown in the photo and concentrate on the patterns caused by the feathers. Continue working on the tail with a mix of Cadmium-Barium Red Light, Thio Violet, Burnt Sienna, Raw Umber and Ivory Black for a base color. Then, add more Titanium White and Cadmium-Barium Red for the lighter areas, mixing wet-in-wet.

4 Finish the Male Cardinal

Start by painting the underside of the beak with a mixture of Cadmium-Barium Red Light, Thio Violet, Burnt Sienna and Ivory Black. Use a mix of Cadmium-Barium Red Light, Cadmium-Barium Yellow Light, Thio Violet and Titanium White for the lighter parts of the beak. On the beak, use enough water mixed in with the paint so you can paint thinly enough for the white gesso to show through and brighten the colors.

For the red plumage of the male, create seven different mixtures of red ranging from the darkest red in the body to the lightest highlights. The mixtures should have different combinations of Cadmium-Barium Red Light, Thio Violet, Cadmium-Barium Yellow Light and Titanium White, plus Burnt Sienna and Ivory Black added for the darkest mixtures. Paint a base coat of the medium red color (see the palette photo below) and let this coat dry partially overnight. Put plastic wrap over your palette to keep your colors from drying out. The next day the undercoat should still be a little wet, but thickened, and you can paint the lighter and darker colors wet-in-wet on top of it with the no. 00. Pay close attention to the direction of the feathers indicated in the photo here. Paint the dark pupil and edges of the eye with a mix of Ivory Black and Raw Umber using the no. 00 round brush. Start the tail with a dark mixture of Cadmium-Barium Red Light, Thio Violet, Burnt Sienna and Ivory Black, then work from dark to light, wet-in-wet, adding more Titanium White to the mixture for lighter areas. Use the no. 4, no. 0 and no. 00 rounds for the tail.

Base coat color

Color Mixtures for the Male Cardinal

Pastel
GOSLING
DEMONSTRATION

BY LESLEY HARRISON

A group of Canada geese goslings was seen at a local wildlife center. When they were placed outside next to a small man-made pond, they went berserk! They got all wet and had so much fun running around and pecking at every little thing they could find.

MATERIALS

SURFACE
Beige velour paper

SOFT PASTELS
Beige
Gold ochre
Green
Light gray
Light purple
Lime green
Yellow
Yellow-green

HARD PASTELS
Black
Brownish gray
Dark gray
Light yellow
Medium gray
Reddish brown
White

1 Complete the Sketch
Sketch in the gosling with a black hard pastel, using white to indicate areas you'll add to later.

2 Start Layering
Apply a light basecoat of light gray soft pastel over his little body.

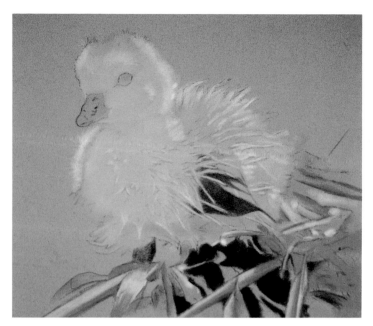

3 Add Color

Lay down yellow soft pastel on top of the gray. Add white hard pastel again for placement so you won't go over where the white is to be later. This little guy had been playing in the water, so some of his brand-new feathers were stuck together. Using a light yellow hard pastel, show where those pin feathers will go so you don't lose some later. Use a dark gray hard pastel to loosely show where his wing will be.

Lightly add some green soft pastel where the reeds and grass will be later, using gold ochre and yellow- and lime-green soft pastels. Shadow some of the greens with a brownish gray hard pastel and dab some white highlights so you can find them easily later.

It's easier in the beginning to lay the basic colors in on all the parts of the painting at once. It seems to make the painting "read" better and helps solidify the composition.

4 Add a Background

It's best to start adding a background before spending too much energy putting detail into the main subject. Otherwise, you may smear the main subject later by trying to add the background last.

For this background use a light purple soft pastel with a little beige soft pastel over the top to represent soft-focused clouds against a blue sky. Our cute little guy is the main focus, so you can put your background in loosely if you like.

5 Start Adding the Detail

Using a medium gray hard pastel, start adding your darks. Use a reddish brown hard pastel for tinting, with dark gray hard pastel on top of that.

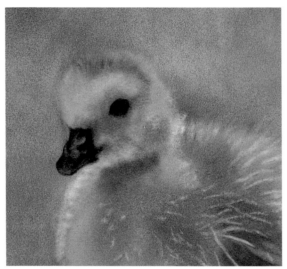

6 Work More on the Face

Apply a base of dark gray hard pastel on his beak. Use the gray on the eye and top of the head, too. Add some light yellow hard pastel.

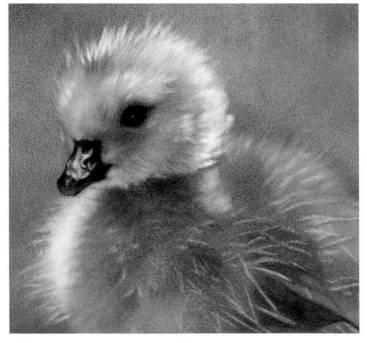

7 Add the Almighty White

Now, get out your white and make this come alive with light! The gosling is backlit, so he'll have a halo of light around him. Use a sharpened white hard pastel to add details on his face. Remember, these are feathers (well, almost, he's still a baby) so the light is reflecting off of each one. We don't want blobs of loose white. Don't forget his beak and a reflection in his eye.

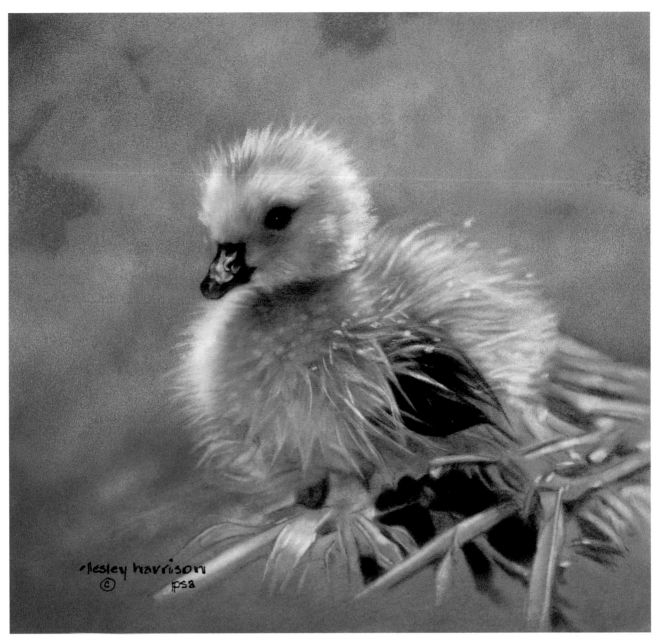

8 Pick Up the Feathers

Use a sharpened light yellow hard pastel to lift up the feathers so the viewer can see them separated from the rest of his body. Add in final strokes of white to highlight feathers on the back and side. Since this is flat work, the only way we can give it dimension is with the light.

New Feathers
Lesley Harrison
Pastel on velour paper
8" × 8" (20cm × 20cm)
Collection of the artist

Ink and Watercolor
CHICKENS

When was the last time you took a close look at a chicken? Take a camera and sketchbook to the poultry barn at a county fair to check them out.

Plymouth Rock Hen
The eye lines up with an imaginary line that runs through the bill opening and ends up just above the point of the bill.

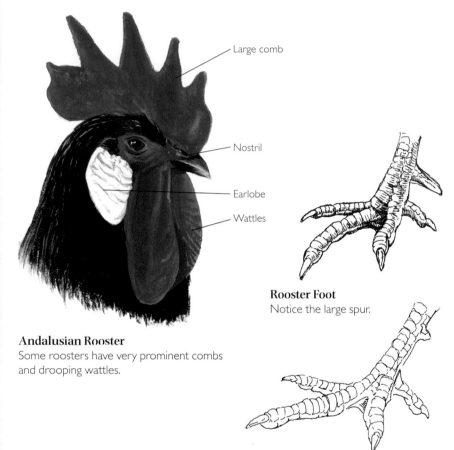

Large comb

Nostril

Earlobe

Wattles

Andalusian Rooster
Some roosters have very prominent combs and drooping wattles.

Rooster Foot
Notice the large spur.

Hen's Foot
A hen's foot lacks a long, pointed spur.

Short Tail Feathers

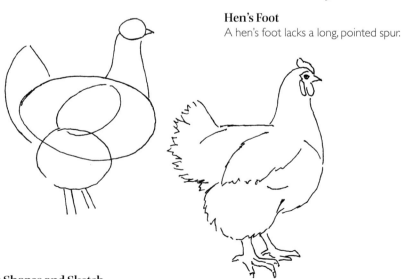

Basic Shapes and Sketch
It's helpful to break down the bird into simpler shapes to see their proportion.

PAINTING ROOSTER **PLUMAGE**

DEMONSTRATION

BY CLAUDIA NICE

Follow the steps shown below and try your hand at using water-color glazing techniques to put the shimmer in a rooster's tail.

MATERIALS

SURFACE
Watercolor paper

BRUSHES
Watercolor brushes (variety)

PIGMENTS
Black
Green
Orange
Phthalo Blue
Red
Red-Orange
Sienna
Violet

OTHER
Pencil
Razor blade

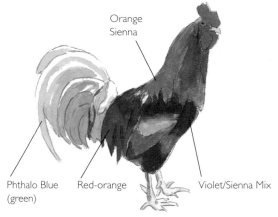

Orange
Sienna

Phthalo Blue (green) Red-orange Violet/Sienna Mix

1 Make Pencil Sketch
Use pencil to sketch the rooster onto a piece of watercolor paper. Make him at least 6½ inches (17cm) high).

2 Add Basecoats
Basecoat the rooster with the brightest color in each area.

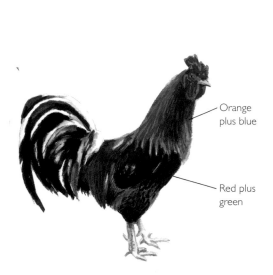

Orange plus blue

Red plus green

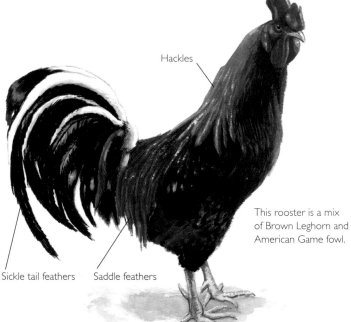

Hackles

Sickle tail feathers Saddle feathers

This rooster is a mix of Brown Leghorn and American Game fowl.

3 Add Shadow Colors
Glaze on shadow colors to form the contours of the feathers. Let the original wash show through where the bright areas are desired. Black was used on the tail.

4 Add Detail and Highlights
Enhance the rooster with some detail work using a fine brush. Add barb texture marks to some of the larger feathers. Use a razor blade to scrape in some white highlights.

Watercolor
ROOSTER WITH CHICKENS
DEMONSTRATION

BY LIAN QUAN ZHEN

In this demonstration you will use a method called *Half Color Pouring and Blending.* You don't start with pouring colors like when you painted the Elephants (page 150). Instead, paint the rooster first, then pour colors around it on the rest of the paper to create the background and foreground.

MATERIALS

SURFACE
140-lb. (300gsm) cold-pressed watercolor paper, half sheet

BRUSHES
½-inch (13mm), ¾-inch (19mm) and 1-inch (25mm) flats
Nos. 2, 4 and 8 rounds

PIGMENTS
Antwerp Blue
Cadmium Red Deep
Cadmium Yellow Light

OTHER
Pencil
Masking fluid
Three small dishes (to hold the three mid-tone primary color liquids)
Tracing paper
Paper towels
Spray bottle

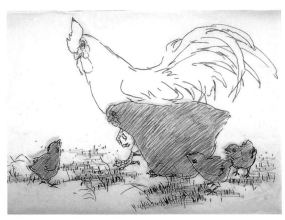

1 Sketch the Composition and Mask Out the Hen, Chicks and Grass

Sketch the composition in pencil on tracing paper; once you've found a good composition, transfer it to your watercolor paper. Mask out the hen, chicks and grass using a no. 8 round. Use the handle of the ½-inch (13mm) flat for the small details and the grass.

2 Start Painting the Rooster

Wet the head of the rooster with a ¾-inch (19mm) flat, leaving scattered dry spots on the top for highlights. Apply Cadmium Yellow Light on the comb, wattle and around the eye.

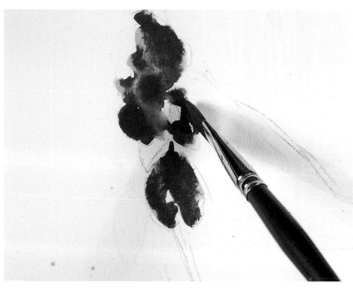

3 Apply Red

Use the ¾-inch (19mm) flat to apply thick Cadmium Red Deep on the Cadmium Yellow Light and let the colors freely mix into each other to get different blending effects.

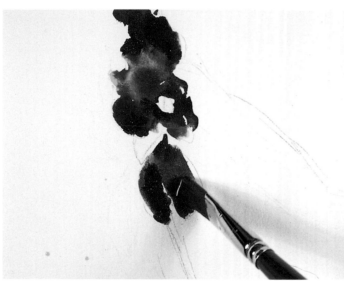

4 Add Depth to the Head

Load the same brush with more Cadmium Red Deep and mix it with a little Antwerp Blue at the tip to obtain the dark red color. Apply this color to the top of the comb, around the eye and below the lower beak, to add depth.

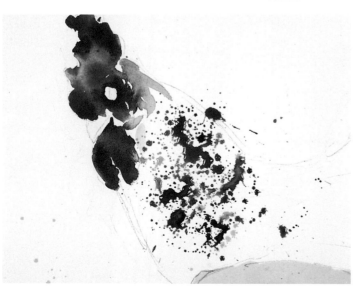

5 Paint the Neck

Using the 1-inch (25mm) flat, splash Cadmium Yellow Light, Cadmium Red Deep and Antwerp Blue on the neck. If some of your colors end up outside the neck, remove them with paper towel or a regular towel.

6 Create Feathers on the Neck

Blow the color splashes with your mouth to create the feathered texture on the neck. When you blow, position your mouth about one inch (25mm) from the colors and blow fast toward the rooster's body.

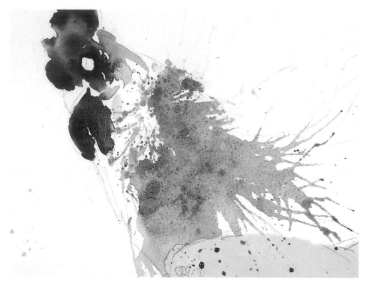

7 Paint the Neck and Chest

Create a dark mixture of Antwerp Blue and a little Cadmium Red Deep and paint the left side of the neck, chest and wing using the 1-inch (25mm) flat. Splash and blow Cadmium Yellow Light, Cadmium Red Deep and Antwerp Blue on the upper body. Use a paper towel to clean up any colors blown outside the rooster's body.

8 Paint the Tail Feathers

Create a dark mixture of Antwerp Blue with a little Cadmium Red Deep at the tip of the 1-inch (25mm) flat and paint the tail. Your brush has colors that range from dark blue at the tip to lighter and lighter blue toward the middle and heel. Paint one stroke for each tail feather. Load more Cadmium Red Deep onto the brush to paint the two red feathers. The key is to not overmix the colors on the palette, simply mix them in the brush. This prevents your colors from turning to mud.

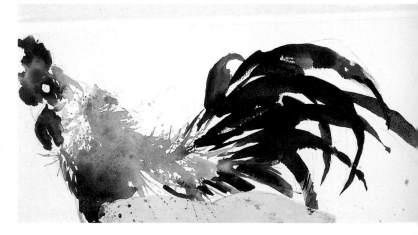

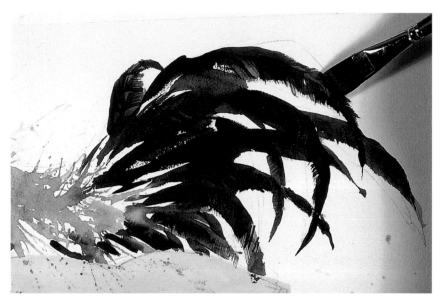

9 Add Texture to the Tail Feathers

Use the ½-inch (13mm) flat to paint the texture of the tail feathers. Lightly wet the brush then load it with a dark mixture of Antwerp Blue and Cadmium Red Deep. Split its tip by dabbing the brush onto a paper towel. Paint the textures on each feather from the center to the edges.

10 Paint the Legs

Mix Cadmium Yellow Light, Cadmium Red Deep and a little Antwerp Blue into a light brownish color using the no. 8 round. Paint the two legs with a few strokes. For example, each toe is one brushstroke. Slightly touch the dark blue color on the front thigh to blend it into the leg.

11 Detail the Legs

When the color on the legs is almost dry, use the no. 4 round to add details to them. Apply a darker blue mixture of Antwerp Blue and a little Cadmium Red Deep for the claws to suggest their hard and sharp character.

12 Pour the Foreground and Background

Paint the foreground and background with the "Color Pouring and Blending" technique (see page 150). First work on the left half of the foreground and background. Use a spray bottle of water to wet most of the area. Use the 1-inch (25mm) flat to wet the area around the chickens so the water does not touch the animals. Pour Cadmium Yellow Light and Antwerp Blue on the upper area where there is grass. Pour Cadmium Yellow Light and Cadmium Red Deep on the bottom where there is dirt and a little vegetation.

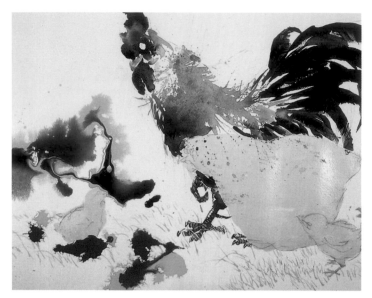

13 Define Animal Shapes

Spray the colors with the spray bottle to make them blend into each other more. Use the 1-inch (25mm) flat to direct the colors to the area next to the chickens. Use the colors to define the shapes of the animals. At the upper and lower left corners, blow the mixed colors to create the illusion of grass.

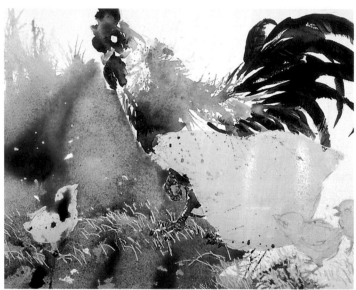

14 Add More Colors

Wet the right side of the foreground and background the same way as the left side. Pour Cadmium Yellow Light and Cadmium Red Deep on the bottom and Antwerp Blue and Cadmium Yellow Light on the middle.

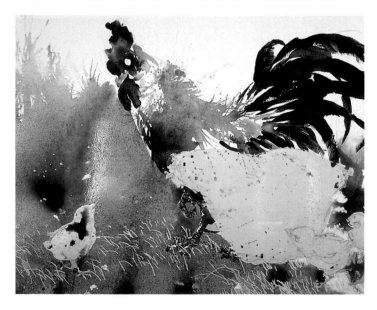

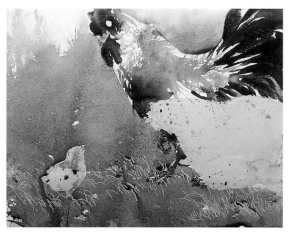
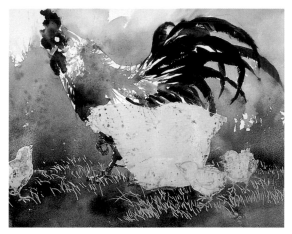

15 Move Colors Around the Painting

Use the 1-inch (25mm) flat to drag the colors to the upper middle. This defines the back of the rooster. Also fill in the areas between the tail feathers. Tilt your painting down, directing the colors to flow toward you. This allows the colors to mix a little more, while the excess liquid flows off your painting.

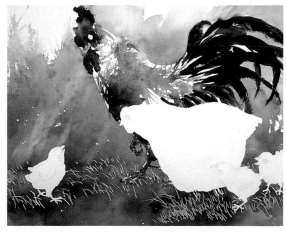

16 Create Light Rays and Remove Masking Fluid

Create a light ray effect on the left side of the background. Wet the 1-inch (25mm) flat with water and brush the background from upper right to lower left. This washes out the colors and the brushed areas become light rays. After the colors dry, remove the masking fluid from the hen and chicks.

17 Paint the Hen Head

Use the nos. 2 and 4 rounds to paint the hen's head much like you painted the rooster's in steps 2–4. Next use the 1-inch (25mm) flat to wet the hen and the front chick, leaving dry areas on upper parts of their bodies.

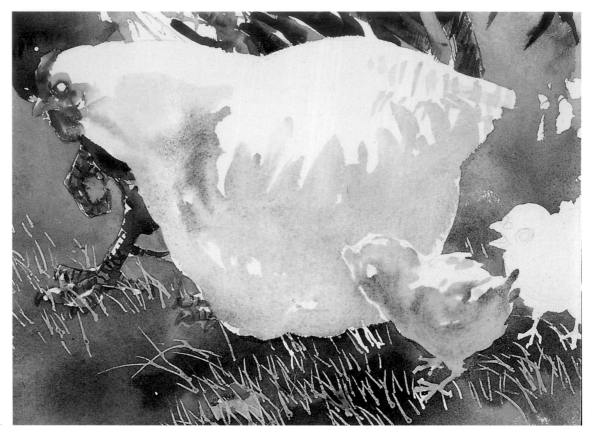

18 Create the Hen and Chick Bodies

Use the 1-inch (25mm) flat to apply Cadmium Yellow Light on the wet areas of the hen and the chick. Let the color blend out gracefully by itself. Immediately use the same brush to add a little Cadmium Red Deep and Antwerp Blue for the wings, tails and the volume of the bodies.

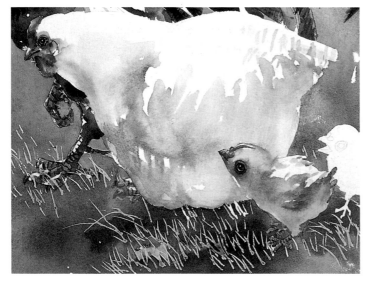

19 Detail the Hen and Chick

Mix the Cadmium Red Deep and Antwerp Blue with the no. 4 round to paint the nostril, beak, little comb and the area around the eye of the chick. Also use the same colors to add a few strokes to bring out its wing and tail. Paint the hen and chick's eyes with the no. 2 round. Apply Cadmium Yellow Light for the eyeballs after the area around the eye is dry. Then add a little Cadmium Red Deep on the upper part of the eyeballs. Wait until the colors are almost dry and create a dark mixture of Antwerp Blue with a little Cadmium Red Deep; paint the pupils, leaving little white spots as highlights.

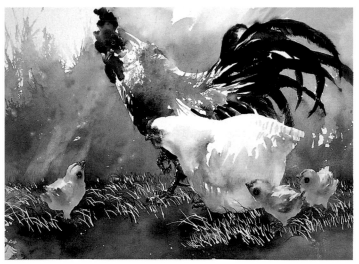

20 Finish Chicks, Remove Masking From Grass

Paint the other two chicks the same way you painted the chick in the front. When the colors are dry on all three chicks and the hen, lift the masking fluid from the grass.

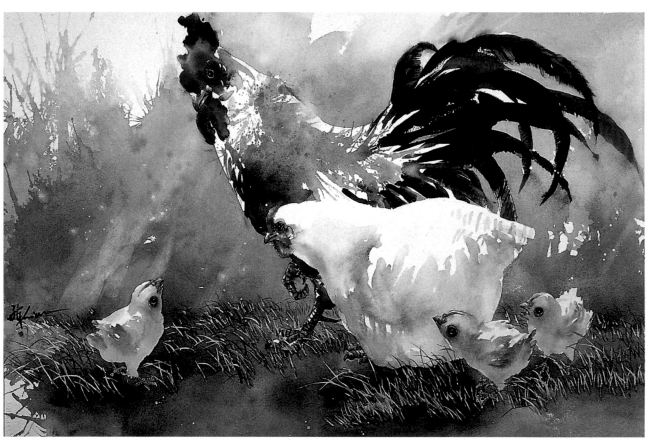

21 Add Final Details

Paint Cadmium Yellow Light on the grass using the no. 4 round; apply Antwerp Blue on the lower part. Sign your name in the lower left corner to balance the composition.

Rooster With Chickens
Lian Quan Zhen
Watercolor on paper
11" × 15" (28cm × 38cm)

Acrylic
CHICKS
DEMONSTRATION

BY JEANNE FILLER SCOTT

MATERIALS

SURFACE
Hardboard panel

BRUSHES
Nos. 1, 3 and 5 rounds

OTHER
No. 2 pencil

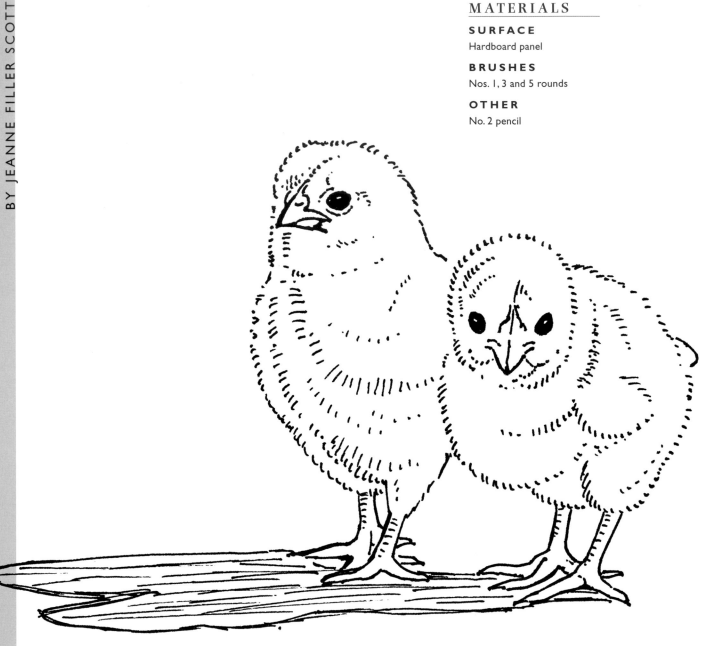

Pigments

Burnt Umber

Raw Sienna

Cadmium Orange

Titanium White

Cadmium Red
Medium

Cadmium Yellow
Light

Ultramarine Blue

Mixtures

dark brown

red-gold

pink

accent color

blue-gray

yellow

warm white

highlight detail

light pink

highlights

dark detail

slate blue

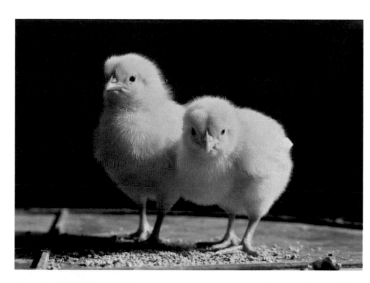

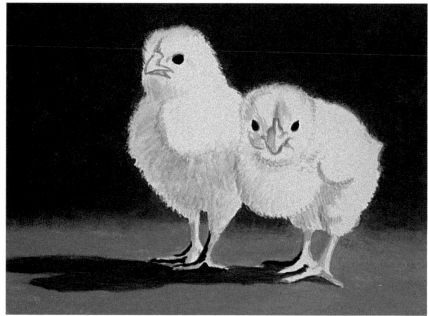

1 Establish the Form and the Darker Values

With a pencil, lightly draw the chicks onto your panel. Use Burnt Umber thinned with water and a no. 5 round to paint the main darks and lights, switching to a no. 3 round for details.

Mix the dark brown for the eyes and the dark shadows on the feet and legs with Burnt Umber, Raw Sienna and Cadmium Red Medium. Paint with a no. 3 round.

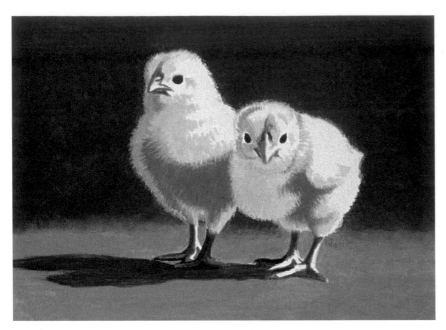

2 Paint the Middle Values

Mix a red-gold for the shadows on the chicks with Cadmium Orange, Raw Sienna and Cadmium Yellow Light. Paint with a no. 5 round, with parallel strokes following the pattern of the down.

Mix a pink for the legs, feet and beaks with Titanium White, Cadmium Orange, Cadmium Red Medium, Cadmium Yellow Light and a touch of Raw Sienna. Paint with a no. 3 round. Then, take a portion of this color and mix with Burnt Umber and Burnt Sienna. Use this color with a no. 3 round to accent the feet, legs and around the beaks.

Mix the blue-gray with Titanium White, Ultramarine Blue and a touch of Cadmium Orange. Paint this mixture on the left side with a no. 5 round.

Mix the yellow for the chicks' down with Titanium White, Cadmium Yellow Light and a touch of Raw Sienna. Paint with a no. 3 round. Begin to blend where the yellow meets the red-gold with a no. 3 round, using small, parallel strokes.

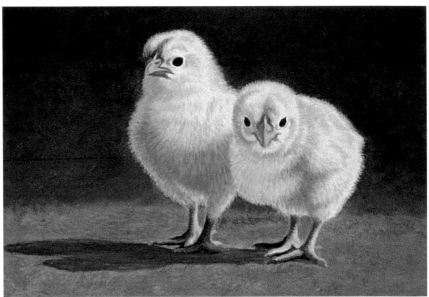

3 Paint the Light Values and Details

Mix a warm white for the highlighted parts of the chicks with Titanium White and a small amount of Cadmium Yellow Light. Paint with a no. 5 round, switching to a no. 3 round for details.

You'll need a detail color for the highlighted areas. For this, mix a portion of the yellow with some of the red-gold from step 2. Use a no. 3 round to paint parallel strokes, then blend.

Mix a light pink for the highlighted parts of the beaks, legs and feet with a portion of the pink from step 2 mixed with Titanium White. Paint with a no. 3 round. Add detail to the beaks, feet and legs using separate no. 3 rounds for the different colors. Add highlights with a bit of the warm white mixed with the yellow. Add dark detail to the beaks with some of the pink mixed with some of the dark brown.

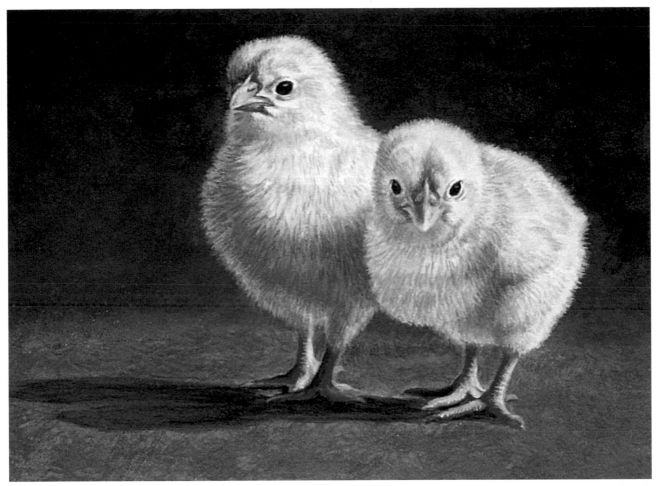

4 Paint the Finishing Details

Mix a slate blue for shadowing on the chicks with Titanium White, Ultramarine Blue, Burnt Umber and Raw Sienna. Paint thin, parallel strokes with a no. 3 round, then blend and soften with the adjacent color.

Transfer some of the warm white to a dry palette so the paint will become thicker. With a no. 1 round, add more detail to the downy coats.

Paint highlights in the eyes with some of the blue-gray, using a no. 1 round to paint small, curved arcs. Refine the beak of the chick on the left with a no. 3 round for each color.

Casa and Blanca
Jeanne Filler Scott
Acrylic on Gessobord
5½" × 8" (14cm × 20cm)

Pencil
BIRDS OF **PREY**

Birds of prey are perhaps the most recognized and majestic birds in the world. These hunters of the sky display sharp beaks and talons, beautiful feather patterns and stern, penetrating eyes. They are also the birds most often drawn and painted by artists young and old.

Layering Feathers

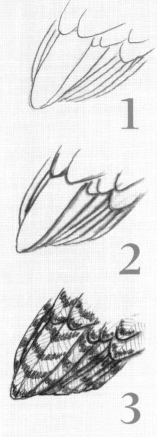

1

2

3

One row of feathers lies on top of another, and each row has feathers of a different size.

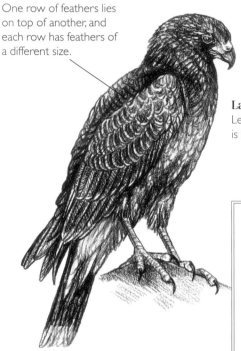

Layers of Feathers
Learning how layers of feathers fit together is half the battle of illustrating birds.

DRAWING SECRET

Photographs are very important to artists who draw birds as they capture the details necessary to illustrate birds accurately. Mounted birds can often be found at taxidermy shops and skins can often be seen at museums or at Fish & Game Departments.

1 Establish the Basic Layout of the Feathers
Draw the basic shape, then outline the feathers.

2 Soften the Lines
Use a tortillion to soften the lines and create shadows between layers.

3 Add Markings and Details
Start with light values, then add the markings unique to the bird and finish with darks.

Blend to distinguish different areas of the body.

Build the darks, then blend and soften them with a tortillion to simulate a smooth feather pattern.

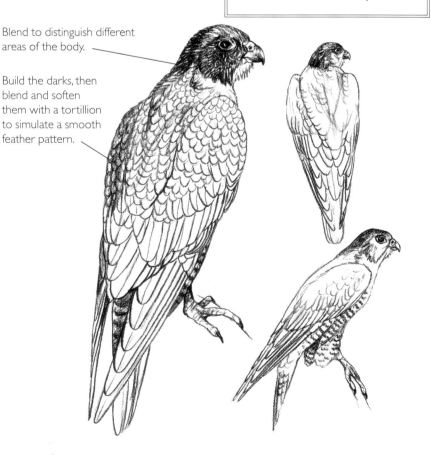

FEMALE SNOWY OWL
DEMONSTRATION

BY DOUG LINDSTRAND

MATERIALS

SURFACE
Drawing paper of choice

PENCILS
HD Graphite

OTHER
Kneaded Eraser
Tracing Paper

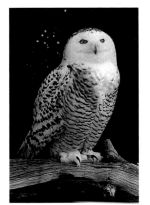

This is a very common pose for an owl. I like it because it shows off the owl's interesting face and bright, intelligent eyes. In your drawing, add a minimum of feather markings or you will make the snowy owl look too dark.

Reference Photo

1 Draw Basic Shapes
Doodle to establish the basic form and to get a pose you like.

2 Refine the Outline
Use tracing paper overlays to refine your outline.

3 Begin to Add Details
Lightly transfer the outline to your drawing paper. Notice how I changed the position of the face. Simply erase the light lines you initially drew and reposition the eyes, beak and major feather markings. Also map out the outline of the wing, the mass of the feathers, the tail feathers and the legs.

4 Finish the Drawing
Add the details to the face. Snowy owls have bright yellow eyes, so leave the irises mostly white. Put in the short feathers of the face, using the most detail for the feathers around the beak and the eyebrows. Add spots to the face. Add the body feathers using the process on page 182. Add the bar markings last.

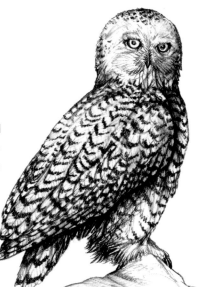

ANIMAL SECRET

Snowy owls are not all white. Adult male snowy owls are much whiter than the heavily barred females, while immature owls have the most markings. Keep this in mind when drawing a family of snowy owls.

Pencil
BALD **EAGLE**
DEMONSTRATION

A profile is relatively easy to draw, but it is a particularly good pose for the bald eagle because it makes it look so dignified. This pose also shows the wing's layout, face profile and talon stance.

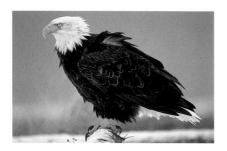

Reference Photo

MATERIALS

SURFACE
Drawing paper of choice

PENCILS
HD Graphite

OTHER
Kneaded Eraser
Tortillion
Tracing Paper

1 Draw the Basic Shapes
Doodle to capture your pose and proportions.

2 Refine the Outline
Use tracing paper overlays to clarify the proportions and basic features. Begin to map out the wing and tail feathers as well as some facial features.

3 Further Refine the Outline
Use another overlay to further refine the outline. Lay in features such as the feather arrangement of the wing and the details of the face, particularly the beak.

4 Add Details
Lightly pencil in the eyes and add further detail to the beak. Begin to outline the direction of the head feathers. Lay in the outline of the wing, chest and tail feathers. Keep your strokes light so you can easily fix mistakes. Transfer this to your drawing paper.

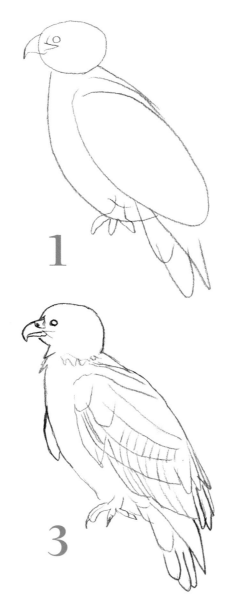

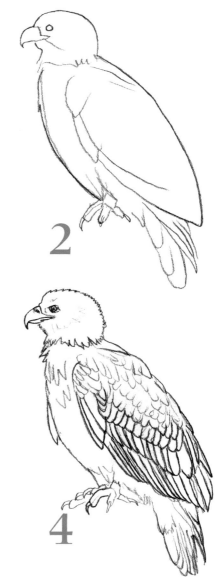

5 Finish the Drawing

Starting with the head, finish the eye and beak. Add a few light lines to suggest feathers and shading, but leave most of the head white. Blend the outline of the feathers (see detail at right). Then darken the lines, following the direction of the barbs and shafts. Continue to build darker layers, placing shadows according to the direction of the light. Then lift out the highlights with a kneaded eraser. Add the darkest darks last.

Detail of Feather Layout
This eagle wing shows how feathers are arranged.

Detail of Blended Lines
Here the lines are softened by blending with a tortillion. Add fine lines to individual feathers to indicate the shaft and barbs.

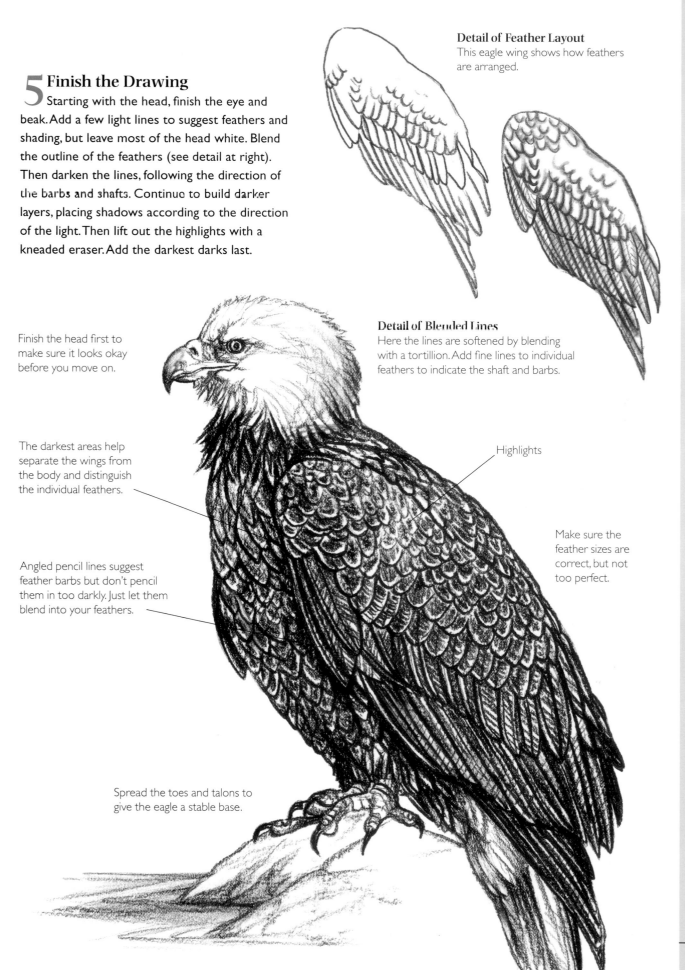

Finish the head first to make sure it looks okay before you move on.

The darkest areas help separate the wings from the body and distinguish the individual feathers.

Angled pencil lines suggest feather barbs but don't pencil them in too darkly. Just let them blend into your feathers.

Highlights

Make sure the feather sizes are correct, but not too perfect.

Spread the toes and talons to give the eagle a stable base.

Acrylic
OSPREYS IN ACRYLIC
DEMONSTRATION

BY BART RULON

This painting demonstrates how to combine several photos to make an interesting painting that tells a story. Choose photos with light coming from the same direction and at the same time of day for consistent lighting and shadows. The idea of the painting is to show the adult female osprey on the nest with the young birds as the adult male returns from a hunt.

MATERIALS

SURFACE
24" x 36" (61cm x 91cm) hardboard panel primed with gesso

BRUSHES
No. 12 flat
Nos. 00, 1, 3 and 5 round
Nos. 8 and 20 filbert

PIGMENTS
(Golden Acrylics)
Burnt Sienna
Burnt Umber
C.P. Cadmium Yellow Light
Mars Black
Raw Sienna
Raw Umber
Titanium White
Ultramarine Blue
(Liquitex Acrylics)
Naphthol Red Light

OTHER
Empty film canister
Water used as a painting medium with each painting mixture

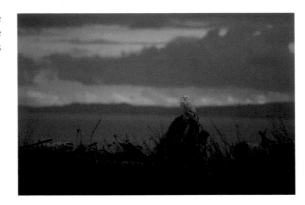

Reference for the clouds

Reference for the pose of the osprey in flight

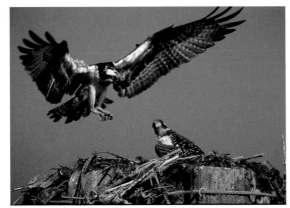

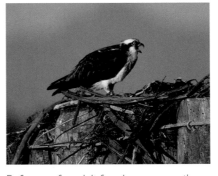

Reference for adult female osprey on the nest

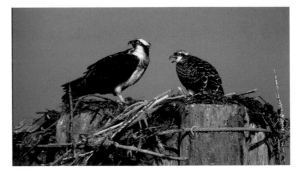

Reference for the nest, pilings and immature bird on the nest

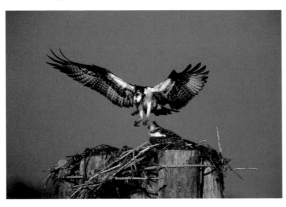

Reference for the lighting and details of the osprey in flight

Reference for immature osprey on the nest

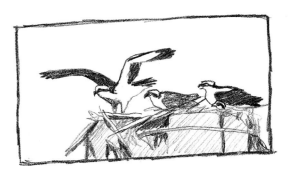

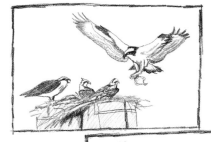

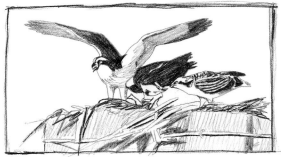

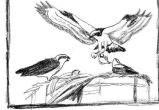

Preliminary Sketches
Test different compositions with thumbnail sketches.

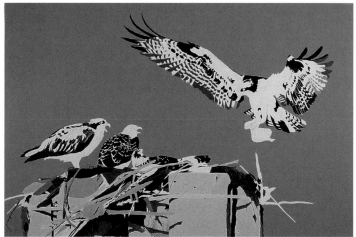

1 Create the Drawing

Work out the anatomy of the birds on scrap paper to make sure they look correct before you transfer them to the board. Be sure to tilt the young bird's head up so that he is looking directly at the male osprey in the air.

2 Block In

Start by blocking in the color of the sky with a mixture of Ultramarine Blue, Titanium White and a touch of C.P. Cadmium Yellow Light. Use the no. 20 filbert and no. 12 flat for the open areas and the no. 8 filbert and no. 5 round as you get close to the edges of the birds and nest. Make enough sky mixture to save for later in the painting. Store the excess paint in an empty film canister with a few drops of water. For the darkest feather colors on the ospreys, mix Mars Black with Raw Umber and paint them with the no. 8 filbert and the no. 5 round. Use the same brushes and dark mixture to block in the shadows in the nest and on the pilings. Block in some of the brown colors in the osprey on the left side with mixes of Burnt Sienna, Burnt Umber, Raw Sienna and Ultramarine Blue. Use this mix with more Ultramarine Blue and some Titanium White added to block in the patterns on the wing feathers of the flying bird with the no. 5 round. Block in a variety of mixes on the nest material, paying attention to the photo and shooting for the average color for each branch or area. Use the no. 8 filbert and the no. 5 round. Block in the color on the pilings with a mix of Raw Sienna and Titanium White.

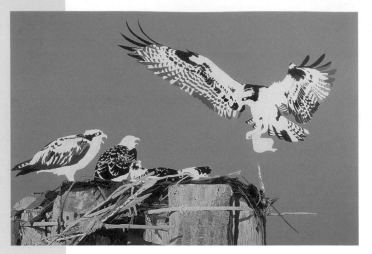

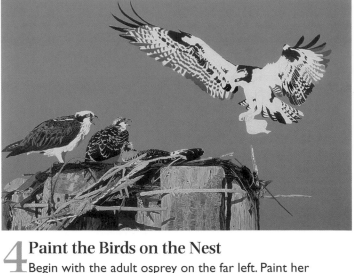

3 Use Dark and Light Colors for the Nest

In this step, you will paint darker and lighter colors on the nest and pilings. Work back and forth between dark and light for each area. There are too many different colors in the nest material to mention them all, but each mixture includes Raw Sienna, which helps warm the colors to indicate late afternoon sun. Paint the bark on the pilings with a mix of Raw Sienna, Ultramarine Blue, C.P. Cadmium Yellow Light and Titanium White for the greenish areas, and Raw Sienna, Burnt Sienna and Titanium White for the brownish areas. Use a variety of brushes, ranging from the no. 8 filbert down to the no. 1 round, to paint the details on the nest sticks. The bluish shadows cast by the nest on the pilings take a mix of Ultramarine Blue, Naphthol Red Light, Mars Black, Raw Umber and Titanium White.

4 Paint the Birds on the Nest

Begin with the adult osprey on the far left. Paint her eye with a mixture of C.P. Cadmium Yellow Light, Titanium White and a touch of Raw Sienna using the no. 1 round. Work from dark to light on the feathers of her back and wings with mixtures of Burnt Sienna, Raw Sienna, Raw Umber, Mars Black and Titanium White using the no. 5, no. 3 and no. 1 rounds. Use less Mars Black and Raw Umber, but more Titanium White and Raw Sienna for the lighter feather areas. Mix Ultramarine Blue, Naphthol Red Light, Raw Umber and Titanium White for the shadows on her belly. Use this same mixture with more Naphthol Red Light added to block in her beak.

The young are different colors than the adults. Paint the eye with the no. 1 round and a mix of Naphthol Red Light, C.P. Cadmium Yellow Light, Raw Sienna and Titanium White. For the feather edges on their backs, wings and the backs of their necks, paint a mixture of Raw Sienna and Titanium White using the no. 3, no. 1 and no. 00 rounds. Paint the feather details on the their heads with a mix of Mars Black and Raw Umber using the no. 00 round. Paint details over the darkest parts of their bodies with a lighter mix of Raw Umber, Mars Black and Titanium White.

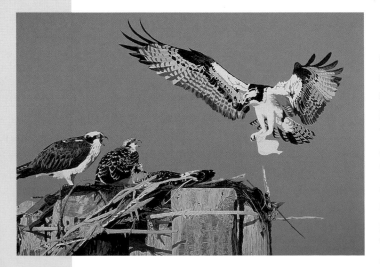

5 Show the Adult Osprey Landing

The photos of the osprey in flight are of the female, but we want to show the male. Male ospreys have no chest streaks, so don't paint the streaks you see in the photo. Paint the shadow areas on the bird's belly, tail and the white of the wing with a mix of Ultramarine Blue, Naphthol Red Light, Raw Sienna and Titanium White using the no. 3 and no. 1 rounds. Paint the warm color on the long wing feathers with a mix of Raw Sienna and Titanium White using the no. 5 and no. 3 rounds. Work in some of the darker feather details in the same feathers by adding Raw Umber, Ultramarine Blue and more Raw Sienna. Fill in the dark pattern on these wing feathers with various colors of brown. Warm up the bird's belly with thin glazes of Raw Sienna mixed with Titanium White. Paint the eye with the no. 1 round and a mix of C.P. Cadmium Yellow Light, Titanium White and a touch of Raw Sienna.

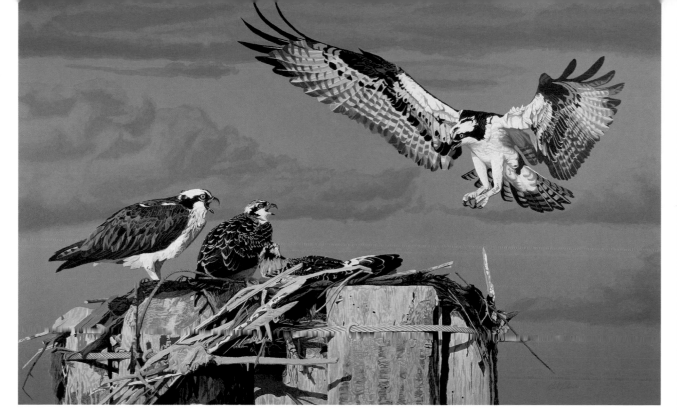

6 Add Clouds and Refine the Details

The sky needs some clouds for interest, and we're going to paint out the fish in the osprey's talons with the sky mixture that was saved back in step 1. Paint over the fish first, then add a little Ultramarine Blue and Naphthol Red Light to the sky mixture. Use this new mix to block in the clouds with the no. 20 filbert and no. 12 flat. Refer to the cloud reference photo to make a pleasing combination of clouds. Add more Naphthol Red Light and Titanium White to the cloud mix to give the clouds form and some light from the sun. Make this lighter mixture subtle, and paint it thinly with the no. 12 flat and no. 8 filbert to keep the clouds soft.

Finish the bird in flight by adding and refining all of the wing patterns and markings, working from dark to light and vice versa where necessary. Pay attention to how the patterns interlock with each other from one feather to the next. Warm up the color on his white belly and the white areas on his wing with the no. 3 round and more thin layers of Raw Sienna mixed with Titanium White. This helps indicate the warmth of the late afternoon sun. Paint more of the subtle shadows on the white underparts with the no. 3 and no. 1 rounds and a mixture of Ultramarine Blue, Naphthol Red Light, Raw Sienna and Titanium White. Add more white for the subtlest shadows. Be sure to stand back often in this step to see if the colors and values work in the picture as a whole. Start the lower legs with a mix of Raw Sienna and Titanium White using the no. 5 round, then add Raw Umber, Ultramarine Blue and Naphthol Red Light to the mix to paint the shadows using the no. 3 round.

Refine the warm feather edges on the backs and wings of the immature birds in the nest by varying their values relative to the sun using the no. 00 round. Clean up these feather edges against the dark parts of the feathers by carefully referring back to the reference photo. Finish the beaks on all the birds in the painting with mixtures that are darker than the base color, using Ultramarine Blue, Naphthol Red Light, Raw Umber, Mars Black and Titanium White and the no. 1 round. Warm up all white parts of the birds on the nest with mixes of Raw Sienna and Titanium White using the no. 3 and no. 1 rounds. Paint this mixture with more Raw Sienna added on the right sides of the birds to help indicate the direction of the sun as indicated in the photos. Finally, paint pure Titanium White highlights in all the ospreys' eyes using the no. 00 round. Be sure to make the direction of the sun consistent in all the highlights.

Return to the Nest
Bart Rulon
Acrylic on hardboard panel
24" × 36" (61cm × 91cm)
Private collection

INDEX